Reading Relationally

Reading Relationally
Postmodern Perspectives on Literature and Art

Laurie Edson

Ann Arbor

THE UNIVERSITY OF MICHIGAN PRESS

2003 2002 2001 4 3 2 1

A CIP catalog record for this book is available from the British Library.

Library of Congress Cataloging-in-Publication Data

Edson, Laurie.
 Reading relationally : postmodern perspectives on literature and
art / Laurie Edson.
 p. cm.
 Includes bibliographical references (p.) and index.
 ISBN 0-472-11175-2 (cloth : acid-free paper)
 1. Art and literature. 2. European literature—20th century—
History and criticism. 3. European literature—19th century—
History and criticism. 4. Art, European. 5. Art, Modern—20th
century—Europe. I. Title.
PN53 .E37 2000
809'.93357—dc21 00-009095
 CIP

For Ellen and Michael

Acknowledgments

Research for this book was funded by grants from the National Endowment for the Humanities, the American Council of Learned Societies, Harvard University, and San Diego State University, and I wish to thank those institutions for their generous support.

I would also like to thank the students in my poetry, theory, and literature and art seminars for valuable and lively discussions. I have benefited over the years from the work, advice, and company of friends and colleagues too numerous to mention, but I would like to give very special thanks to Renée Riese Hubert, whose exemplary work in literature and art has had such an enormous influence on my own, and to Robert W. Greene, whose remarkable commentaries on poets and poetry have always proved inspirational. I would also like to thank Steven Winspur and Tom Cox, who read early versions of the manuscript and provided valuable help.

This book draws on material first published in *Symposium, Romanic Review, Nineteenth-Century French Studies, L'Esprit Créateur, Dada/Surrealism,* and *Visible Language.* I thank the editors of those journals, and Heldref Publications in the case of *Symposium,* for permission to include substantially revised portions of that material here. Part of chapter 1 was published, in revised form, as "Knowing Lol: Duras, Epistemology, and Gendered Mediation," *SubStance* 68, vol. 21, no. 2. © 1992. Reprinted by permission of the University of Wisconsin Press. Chapter 5 previously appeared in my edited collection of essays *Conjunctions: Verbal-Visual Relations.* © 1996. Reprinted by permission of San Diego State University Press. I thank the editors at these presses for permission to reprint.

Finally, this book could not have been written without the support of my husband, Jim Carmody, whose detailed, sympathetic readings of the manuscript at every stage of this project helped bring my arguments into sharper focus.

Contents

Illustrations

Introduction

Reading Relationally is a book about reading and about how reading literature in the context of visual art enriches our conception of what texts do and how texts mean. Through readings of major texts by modernist and postmodernist writers and artists, *Reading Relationally* stages and advocates a practice of reading that directs attention to readers' relationships with texts and to the ways in which our frames of reference and mediating practices shape an object under investigation.

Although artists and writers have been self-consciously undermining realism for more than a century, many readers are still children of realism in their reading practices. Through its detailed readings, *Reading Relationally* probes realist assumptions that persist to this day. By reading relationally across the disciplines of literature and visual art, I provide postmodern interpretations of nineteenth- and twentieth-century texts and set in motion a series of reverberations between verbal and visual material, inviting an appreciation of the accomplishments of well-known writers in radically different ways.

I have organized the book into two parts. In part 1, "Reading the 'Object,'" I introduce the topic of relational reading by looking at a series of verbal and visual texts that thematize *reading* as they draw attention to the relation between a perceiving subject and an object of perception. The texts discussed in these chapters focus attention on the mediating role of the perceiving subject in any attempt at knowledge as they expose some of the "lenses" through which subjects (readers) look at objects (texts), lenses that necessarily condition and determine reading, such as gendered cultural ideologies (Marguerite Duras and Cindy Sherman—chapter 1) and various conventions of representation and reading (Francis Ponge and René Magritte—chapter 2). Framed in

terms of feminism's critique of epistemology, Merleau-Ponty's debate with Sartre, and Sartre's reading of Ponge, these chapters demonstrate how the notion of an "object" is called into question as attention shifts to the mediating practices that govern our attempts at knowledge.

Part 2 of the book extends the arguments of part 1, first by investigating three exemplary texts that focus the general question of relationality. Through my reading of a poem, an artwork, and a novel (Mallarmé, Duchamp, and Calvino—chapter 3), I argue that each artist values looking at relations between things rather than things-in-themselves. Each endorses what I call *relational logic;* each promotes this kind of reading of his own texts. In chapter 4 (Apollinaire and Picasso), chapter 5 (Lautréamont and Dalí), and chapter 6 (Rimbaud and Matisse), I provide three demonstrations of how the strategy of relational reading can shed new light on texts by enabling us to think and see differently and, therefore, bring different textual details into sharper focus; by reading a verbal text through the lens of a visual text constructed according to different codes and read according to different conventions, I show how relational reading can unsettle some of the habitual and/or codified methods of analysis that have governed the mind and the eye. In chapter 7, instead of considering relational reading as a strategy to be used between texts (reading verbal texts through visual texts), I now read relationally within individual texts: I look at examples in which authors and artists incorporate a combination of words and images in their texts to draw attention to reading conventions and provoke certain reactions on the part of readers (Duchamp, Miró, Apollinaire, Lichtenstein). This chapter investigates how various relationships between words and images necessitate differing reading strategies.[1]

My choice of texts in these pages is dictated by personal preference: modernist and postmodernist "open works" (in Eco's sense) that seem to invite the collaboration and active participation of readers in the production of meaning. All of these texts appear to thematize perception, play with conventions of representation and thereby disrupt expectations, or inscribe the reader's anticipated response in the problematics proposed by the text.

It should be clear that I could have chosen other examples, that the ones appearing in this book are certainly not privileged or exclusive in any way, and that they make no claims to be the best or the most

authoritative ones available. Although the yoking of verbal and visual texts in the various chapters may, at first glance, appear arbitrary, this initial impression has more to do with our ingrained habits of thinking than with any a priori legitimation; our categories for organizing knowledge have conditioned our expectations about how knowledge will and should continue to be organized.[2] We may feel relatively comfortable, for instance, accepting the legitimacy of studies tracing influences precisely because stories of influence have historically dominated the fields of literature and art history and therefore seem natural. We may also feel relatively comfortable comparing authors and artists who have worked in the same time period, as if their inclusion in a "period style" were ample a priori justification for a rapprochement.[3]

This book, however, is neither a study of influences nor a study of period style. Nor is it organized principally around authors or artists, concepts that have become increasingly problematic, especially after Foucault's proposal in "What Is an Author?" that we not assume, behind a multiplicity of texts written at different times and under different conditions, the existence of a single, stable author or "subject" whose "vision" can de described.[4] Instead of focusing on authors and artists, the present study analyzes individual texts. Verbal and visual texts are related in different ways from one chapter to another in an attempt to avoid a systematic, scientific rigor that W. J. T. Mitchell associates with the closing off of possible discoveries: "The key thing, in my view, is not to foreclose the inquiry into the image/text problem with presuppositions that it is one kind of thing, appearing in a certain fixed repertoire of situations, and admitting of uniform descriptions or interpretive protocols."[5] Instead of relating verbal and visual texts in a uniform way, I have preferred a more eclectic, experimental approach.

From one perspective, the term "eclectic" might seem to imply that one's work or thinking lacks rigor, organization, or serious grounding. At the beginning of the twenty-first century, though, when conventional groundings have been scrutinized and called into question in a wide variety of disciplines across the humanities, the social sciences, and the natural sciences, an eclectic approach seems more productive. While such an approach might seem, to some, to signal a stepping out of history, from another quite different perspective it will be seen as a symptom of a period of history—a time marked by shifting paradigms, new understandings, and a general reevaluation of what counts as

knowledge. Foucault is one theorist among many who has questioned what he calls the humanist desire to totalize or explain the present by dissolving singular events into ideal continuities.[6] According to Foucault, an ideology that desires, at the outset, to discover influences, origins, teleologies, models, groundings, or any other type of continuity remains bound to a metaphysics of presence and will never be able to recognize difference, discontinuity, or disparity. Whenever a continuity is desired, a frame can be established that will inevitably valorize certain information and devalue other information. More often than not, inquiring subjects "frame" their field of inquiry according to accepted and available modes of framing. These modes of framing and discursive practices are themselves products of cultural, historical, and political contexts that require critical examination. Rather than situating texts solely within the continuities or discourses favored in their particular fields, this study proceeds by a series of experimental interartistic rapprochements whose purpose is to unfreeze the conditions that have determined how we read and interpret well-known literary texts. I should emphasize at this point that in this study I read as a literary scholar, and that in all instances the visual images work in the service of the text.

In conclusion, then, my title, *Reading Relationally*, refers to the two distinct but related projects of the book. First, following the lead of the authors and artists in question, it is meant to keep attention focused on the relation between readers and texts and the ways in which inquiring subjects (readers) shape and construct objects of knowledge (texts). Through exemplary readings, I demonstrate how interpretation is contingent and dependent on a given interpreter's array of cultural ideologies, habits of reading, frames of reference, reading conventions, and conventions of representation. I use the terms *reader* and *text* in Barthes's sense, regardless of whether I am dealing with literature or visual art—as Barthes argues, a spectator is necessarily a "reader." At the same time, I am aware of the slippery nature of the terms, especially when we remember that for Barthes, the reader is also a "text," not an innocent subject, but already a locus of intertextuality, a crisscrossing of many prior texts:

> *I* is not an innocent subject, anterior to the text, one which will subsequently deal with the text as it would an object to dismantle or a site to occupy. This "I" which approaches the text is already itself a

plurality of other texts, of codes which are infinite or, more precisely, lost (whose origin is lost).[7]

Indeed, in my first chapter, various "readers" become the "texts" under scrutiny. For the sake of clarity, however, I use the term *reader* to refer to the inquiring subject and *text* to refer to the object under investigation.

Second, my title, *Reading Relationally,* refers to my own textual practice of reading literature and visual art side by side in each of the chapters. Throughout the book I proceed by a series of exemplary rapprochements whose purpose is to unsettle the more habitual, codified terms of analysis associated with the individual fields and to suggest ways in which we might revise or expand our habitual ways of seeing, thinking, and organizing knowledge. This strategy has to do with a desire to put the reading of verbal texts in a "strange" (nonverbal) context in order to highlight issues that have remained unexplored in more conventional approaches. This desire to unsettle habitual terms of analysis and to "frame" an object of study differently is one of the driving forces in the book, and it relates directly to Russian and Brechtian "estrangement"—an aesthetic and/or critical tool for refreshing perception. Especially in the second part of the book, I provide examples that demonstrate how reading literature in the context of ("through the lens of") visual art enriches our conception of what texts do and how texts mean.[8] Barthes is one critic who has argued for the value of this kind of interdisciplinary reading in that it loosens the grip of outdated habits and conventions of reading and causes the object under study (the text) to appear different: "[I]nterdisciplinarity begins *effectively* . . . when the solidarity of the old disciplines breaks down—perhaps even violently, via the jolts of fashion—in the interests of a new object. . . . "[9] Since how we read determines what we see, my critical practice of yoking together writers and artists and of reading literature in the context of art allows for Barthes's "new object" to come into being, paving the way for a new understanding of old texts as well as a questioning of the boundaries separating the fields of literature and visual art. As Mitchell puts it in *Picture Theory:*

[The impulse to think across the disciplines corresponds to] some sort of authentic critical desire to connect different aspects and dimensions of cultural experience. The challenge is to redescribe the

whole image/text problematic that underwrites the comparative method and to identify critical practices that might facilitate a sense of connectedness while working against the homogenizing, anaesthetic tendencies of comparative strategies and semiotic "science."[10]

It is my hope that the kinds of critical practices performed in *Reading Relationally* might be a move in this direction.

Part 1

Reading the "Object"

Against the Objectifying Lens: Duras, Sherman, and the Politics of Gendered Mediation

The reevaluation of "knowledge" that has been occurring simultaneously in the natural sciences, the social sciences, and the humanities constitutes an extremely rich and diversified area of investigation. In numerous fields, antifoundational theorists have rejected the possibility of a nonbiased grounding from which to claim access to truth, demonstrating that all groundings are already embedded in historical, cultural, and political contexts that shape, in advance, the forms that any inquiry into knowledge will take. Nor is "knowledge" an unproblematic term, for what counts as knowledge is itself contingent, as Foucault has amply demonstrated in his analyses of the power-knowledge relation. Theorists proceed from the assumption that "knowledge" is already "situated" and "knowers" already "biased," not disinterested or distanced. In other words, "knowers" are already enmeshed in the problematics of reading as they seek to gain knowledge about ("read") an object under investigation.

Convinced that Western epistemological models have been rooted in masculine understandings of masculine experience, feminist theorists have contributed to the work of their male counterparts by introducing the category of gender in their reevaluations of the assumptions on which models have been based. The work of Evelyn Fox Keller, Jane Flax, Nancy Hartsock, Sandra Harding, and Susan Hekman, to name just a few, has been instrumental in exposing the field of epistemology

to new scrutiny. In France, feminist theorists like Luce Irigaray and Hélène Cixous have demonstrated how epistemological models have led to oppositional thinking and the creation of a host of dualisms—culture and nature, subject and object, reason and emotion—in which one term of the dualism is privileged at the expense of its devalued "other"; these dualisms, they argue, derive from the overriding dualism of male and female. In the United States, Evelyn Fox Keller and others have investigated what they see as science's ambition to dominate nature, pointing out that while the supposedly neutral observer has been historically coded as male, the object of his investigations, or that which is "objectified," has been coded as female. Feminist theorists from disciplines such as sociology, psychology, literature, and film have challenged epistemological models and demonstrated how the female has been historically constituted by male desire.

Like their counterparts in theory, feminist writers and artists have incorporated critiques of male-based epistemological models into their work. In the arts, particularly in postmodernist texts, one of the most effective strategies used by feminists to expose and simultaneously undermine the masculinist bias on which knowledge is grounded has been through the use of what Irigaray has called "mimicry," a playing with mimesis itself:

> To play with mimesis is thus, for a woman, to try to recover the place of her exploitation by discourse, without allowing herself to be simply reduced to it. It means to resubmit herself—inasmuch as she is on the side of the "perceptible," of "matter"—to "ideas," in particular to ideas about herself, that are elaborated in/by a masculine logic, but so as to make "visible," by an effect of playful repetition, what was supposed to remain invisible. . . .[1]

What was supposed to remain invisible, of course, are the operations by which various epistemological moves and discourses of power "objectify" the feminine as lack, to be constituted by male desire; the process of mimicry enables women to expose those operations without repeating the same logic. Theorists have pointed out, however, that such mimicry is not without political risks: in order for mimicry to be effective, it must be recognized as mimicry and not just a replication of the same.[2]

This chapter investigates Marguerite Duras's well-known novel *The*

Ravishing of Lol Stein and selected photographs by Cindy Sherman as postmodern texts that employ mimicry in order to expose habits of patriarchal thinking and epistemological assumptions of objectifiability and knowability.[3] In her novel, Duras has quite deliberately established a less-than-omniscient narrator named Jacques Hold whose obsession is to "know" Lol. Jacques, then, is like a reader of a text: he "reads" the text that is Lol in order to "know" her, and the story that he tells about her (his narrative) is based on his own (gendered) reading. All our knowledge about Lol's psychology and history is filtered through Jacques. What Duras has presented in this novel, I will argue, is not the story of a female subject, as many critics have maintained, but a story of gendered mediation, male desire, and, ultimately, of epistemological crisis: the story of the way a male attempt at knowledge, in objectifying a female subject, mediates and determines ("produces," to use Foucault's term) what can be known.

When I say that *The Ravishing of Lol Stein* is not the story of a female subject, I do not mean to imply that Lol is not a subject in her own right; I mean, rather, that Jacques, in his very desire to know her, to figure her out, simultaneously effaces her status as subject by objectifying her and is thus incapable of recognizing her as subject. Jacques's very project of learning about Lol influences and determines what he can know. Exploring the problem of knowledge, then, Duras's text constitutes an exemplary critique of the epistemological models that have come to dominate Western culture, models based largely on objectifiability and knowability.

Like Duras, Sherman uses mimicry in her work to expose and undermine the operations through which "woman" has been constructed in our culture through male desire. Parodying various male-biased "objectifying lenses," which include cinema, advertising, magazine centerfolds, and, in her more recent work, art history, Cindy Sherman's photography is less about females as subjects than it is about the male discourses and "gazes" that have functioned to objectify and constitute the female. "The male half of society has structured the whole language of how women see and think about themselves," Sherman has said.[4] Like Duras's text, Sherman's art is designed to shift attention away from the object of representation (the woman) toward the act of objectification—the process of representation itself—and the way in which gender mediates that process. In other words, Sherman's art, like Duras's, is concerned with exposing how "gendered mediation" has

functioned in our culture. Interestingly enough, as we shall see, Sherman and Duras have been misread by their critics in similar ways. (At this point, I should make it clear that when I speak of "gender," I am referring to something that is itself already mediated, so that "gender" should be understood in the sense in which Teresa de Lauretis used the term in *Technologies of Gender:* "the product of various social technologies . . . and of institutional discourses, epistemologies, and critical practices, as well as practices of daily life."⁵)

Instead of attempting, like Jacques, to "read" Lol in order to "know" her psychology and history, I propose shifting the field of inquiry from the object of the narrative gaze (Lol) to that narrative gaze itself (I use the word *gaze* because the narrator is also a voyeur, as I discuss below). In fact, any critical reading of Lol can only echo Jacques's thoroughly subjective reading of her, since he is the medium through which all our information about Lol is filtered.

Nevertheless, Jacques's account of Lol has all too frequently been accepted at face value, as if Jacques were not an interested party in his own right, overwhelmed with desire and trying to solve a puzzle and "master" the problem that Lol represents. In a very astute psychoanalytical account of Lol's desire, for instance, Mary Lydon writes that "Lol . . . spends the rest of her ostensibly 'normal' life trying to re-create, in fantasy, the scene from which her fiancé's betrayal has irremediably excluded her: his lovemaking with her rival."⁶ Lydon's account of Lol's desire, however, suppresses the crucial presence of Jacques as mediating voice; she speaks as if Lol were an unmediated subject. Even critics who see this text as a male narrative in which narrative authority is undone sometimes speak as if Jacques's words were truth and Lol's story were not mediated. Martha Noel Evans, to take an example of a critic who has emphasized Jacques's mediation, seems to slide away from her own position when she, like Jacques, attempts to diagnose Lol's psychology: "With a need to find the answer to this question, to understand who she has now become, Lol is driven ceaselessly in her imagination to that moment of transfer when she was replaced by another woman."⁷ How can we know anything at all about what Lol wants or does, except through Jacques's mediation, which Evans has already called into question? Any such psychoanalytical reading of Lol can only duplicate Jacques's (mis)reading of her. By focusing attention on Jacques's narrative gaze instead, it will become clear that what is

revealed in *The Ravishing of Lol Stein* is precisely the ravishing effects of gendered mediation, of the gendered narrative gaze.[8]

Once Jacques has decided to "know" Lol, he arbitrarily establishes the parameters of his inquiry without any concern for how the very setting of parameters simultaneously determines what he can know. He does not care to know much about her adolescence, he says, because "the presence of her adolescence in this story might somehow tend to detract, in the eyes of the reader, from the overwhelming actuality of this woman in my life" (4). In other words, he is not interested in Lol as a subject in her own right, but as an object *for him*, in his life. Although he admits in the opening pages that the story he tells about Lol is his, not hers—"I shall relate my own story of Lol Stein" (4)—he nevertheless subsequently relates events in the novel and interprets them with the authority of an objective narrator. Statements such as "I had to know her, because such was her desire" are nothing but fantasy, perhaps even wishful thinking, on the part of the narrator (75). He would very much like to be the object of her desire, and many of his statements are designed to persuade the reader that he is, indeed, desired: "[Lol] seems to be listening, listening for something that Tatiana cannot hear: my movements to and fro along the walls" (86). Jacques would like to think that he is at the center of Lol's universe. He would like to believe that he has the power to "capture" Lol and succeed where others have failed: "Who could Lol have found, who could ever have captured her so completely?" (71). His desire to know her is also a desire, as he puts it, "to ensnare her, immobilize her, keep her from constantly moving to and fro from one end of time to the other" (97). As we shall see, psychoanalytic theory has provided an interesting explanation for this desire, one that sheds light on Jacques's obsession with knowing Lol.

Epistemology and Object Relations Theory

Many feminist theorists committed to the reinterpretation of culture and history have questioned the assumptions of epistemology by rereading the texts of the "founding fathers" through the lens of developments in psychoanalytic theory. In particular, object relations theory has proven especially useful for reevaluating the scientific ideal of objectivity and science's privileging of the distance between

knower and known. Evelyn Fox Keller, for example, draws on object relations theory in an influential article called "Gender and Science" when she outlines how a boy's acquisition of gender identity (unlike a girl's) depends on maintaining distance from his first "object," his mother; she then proposes that this paradigm of maintaining distance, learned early in the male child's life, unconsciously informs scientific inquiry.[9] Jane Flax, too, draws on object relations theory to show the acts of repression and denial of the female operating in the philosophies of Plato, Descartes, Hobbes, and Rousseau.[10] Probably the most interesting study in this vein for my purposes here is Susan Bordo's "The Cartesian Masculinization of Thought," in which she applies concepts from modern developmental psychology—separation and individuation—to gain new insights into Cartesian objectivism.[11] Arguing that cultural transformations during the seventeenth century resulted in a heightened awareness of the inner self, and thus a heightened sense of distance from the "not-I," the world, Bordo proposes that Descartes's seeming triumph over the epistemological insecurity of the first two *Meditations* be seen as a defensive response to an acute "cultural separation anxiety" (451). While a sense of relatedness between the self and the world characterized the ancient Greek and medieval world, in the seventeenth century Descartes's highly self-conscious self is separated from the world that now lies in the realm outside the self. The ideal now becomes a distinct sense of the boundaries of the self but, as Bordo maintains, "[t]he Cartesian reconstruction of the world is a defiant gesture of independence from the female cosmos—a gesture that is at the same time compensation for a profound loss" (451).

In the next section of this chapter, I explore a similar "reconstructive" gesture, also compensating for a profound loss, in the story that Jacques Hold tells about Lol Stein. The loss, however, is not Lol's loss, as many critics have maintained, but Jacques's, whose sense of loss results from his feeling excluded from what he imagines to have been Lol's passion for Michael Richardson. Ostensibly, Jacques feels excluded not only from that imagined passion but also from what he takes to have been that supremely intense moment years ago when Lol's fiancé abandoned her at the ball and left with another woman. Instead of talking about his own exclusion, however, Jacques tells a story of what he imagines to be Lol's exclusion.

Exclusion and Narrative Gaze

As Jacques sees it, this moment of Lol's exclusion, when Lol sees herself replaced by another woman at the ball, is the one that Lol seeks to "reconstruct" as she wanders aimlessly through the streets: "Each day Lol goes ahead with the task of reconstructing that moment. . . . Again she goes out walking. She sees more and more clearly, precisely, what she wants to see" (37). According to Jacques, Lol's supposed desire to see herself effaced is also the reason she lies in the rye field and watches the lovers in the hotel room. In his words, "She must have shivered with delight to feel as excluded as she wished to be" (113). As readers, however, we have no indication other than Jacques's words that Lol wishes to feel excluded, since all of our knowledge and perceptions are filtered through the mediating narrator, his interpretations, and his inventions. We do not even know if Lol is really in the rye field, since her presence there is simultaneously called into question by the narrative. Instead of suggesting, as many critics do, that Lol's presence in the field allows her to fantasize about being replaced, why not conclude that Jacques fantasizes her presence in the rye field so that he can imagine himself, once again, being watched and thus important? Jacques's pronouncements on Lol's psychology are not to be taken as truth but should rather be seen as his own way of understanding, his own way of seeking to know the unknown. The axis of exclusion-inclusion belongs more to Jacques's psychology than to Lol's, although he attributes it to her in a movement of projection.

A careful reading of the text reveals the extent to which Jacques himself is preoccupied with being excluded. Toward the end of the novel, for instance, when he accompanies Lol in the train back to the site of the ball, Jacques finally acknowledges his ulterior motive in what is perhaps the most stunning revelation of the text: "In the future it will be today's vision she will recall, this companion beside her in the train" (165). He wants to insert himself in Lol's memory in order to replace the memory he believes she has of that great passion of her life, Michael Richardson. It is Jacques (rather than Lol) who is obsessed with Michael Richardson throughout the text, and it is Jacques who wants to be included in that passion from which he feels so definitively excluded. In his desire to "know" Lol and understand her psychology, he effaces her and substitutes his own psychology for hers. At one point in the

text he wonders sadly: "What did she go looking for at the seashore, where I am not, what sustenance? so far from me?" (141). His awareness of exclusion is clear: Jacques Hold cannot bear the thought that he might be less important to Lol than he believes himself to be.[12]

In retrospect, then, many of Jacques's lines must be read differently, especially his pronouncements and questions about Michael Richardson. Early in the novel he fantasizes that he resembles this other man, but he carefully attributes the thought to Lol, not to himself: "Yes, Lol decided, he did have, there emanated from him, that initial expression that Michael Richardson had had, the one that Lol had known before the ball" (43). In this pronouncement, Jacques is pretending that Lol sees the resemblance rather than recognizing that this is his own obsession. Jacques's obsession with Richardson haunts him yet again when he first touches Lol: "Just as my hands touch Lol, the memory of an unknown man, now dead, comes back to me: he will serve as the eternal Richardson, the man from Town Beach, we will be mingled with him . . ." (103). Jacques can never forget that he is not the first man to have touched Lol. Here he sees himself as mingled with the Other Man; later their co-presence will become untenable and he will attempt to replace this Other.

Finally, at the end of the novel, as Lol and Jacques return home by train after having spent the night together at Town Beach, Jacques asks Lol to tell him about Michael Richardson, which she does. "Each word is a shaft of pain wracking my whole body," Jacques admits. "Again I urge her to continue. . . . I want to know still more" (180). As she continues talking, Jacques suddenly feels no more pain, and tells her so. He has now, at the end of the novel, succeeded in exorcising the ex-lover. All of his storytelling, all of his inventions and hypotheses have led to this moment: the moment when he is finally free from the obsession with the Other Man who has functioned throughout the story as his competition—the great passion of Lol's past.

Jacques exorcises his obsession, but we still know nothing at all about Lol. She remains as enigmatic as she was at the beginning of the text; the text has revealed nothing about her and much about Jacques. As I said, we do not even know for sure if she actually lies in the rye field watching the lovers in the hotel window, as Jacques claims, or if this is yet another one of Jacques's inventions. After all, Jacques is the voyeur in this story, not Lol. He is the one who follows her on walks, looks through the windows in her home, watches her every move

obsessively. Yet he attributes the voyeurism to her and sets himself up as the one being watched, the center of attention.

Voyeurism and Knowledge

The voyeurism that obsesses Jacques in this text is linked to the problem of knowledge itself, which, in Western culture, has come to depend to a large extent on the visual. In an important article entitled "The Mind's Eye," Evelyn Fox Keller and Christine Grontkowski have examined the philosophical moves that gave rise to the dual tenets of modern science—objectifiability and knowability—by investigating the persistence of the visual metaphor for knowledge and by showing how knowledge and vision have become interconnected and ennobled in Western thought.[13] Science's belief in the knowability of nature derives from Plato, for whom man was originally part of the divine structure. Since our souls still partake of that divine structure, according to Plato, we have a kinship with the universe and thus are able to "know" everything again (this is his theory of *anamnesis*—that all learning is recollection). Like knowability, the concept of objectifiability also derives from Plato, who effected a separation between subject and object when he based his model for perception on the assumption that light emanating from the eyes sympathetically interlocks with an object. (Light emanating from the eyes is equated with light emanating from the sun, so that "light" and "truth" also become intertwined in Plato.) With modern theories of optics developed by Descartes, however, the eye becomes a passive lens, no longer emitting its own stream—a model that nevertheless perpetuates the concept of objectifiability, where the knower can "know" without contaminating. Descartes is able to retain the visual metaphor for knowledge as well as the conception of knowledge as active (even though the physical eye is passive) by separating the mind from the body and associating knowledge with "the mind's eye," no longer tainted by the body. In this way, then, vision continues to assume priority over the other senses, and the visual metaphor for knowledge is retained. Indeed, for Newton, "[t]he ideal of science was to 'see' what God 'saw.'"[14]

Because vision depends on distance, it lends itself to a model of truth based on distance between knower and known, subject and object. As Keller and Grontkowski note, vision's "apparent disengagement from

action, experience, and dynamic interaction invites and lends itself to a model of truth which transcends the more body bound, materially contingent senses" (219). The authors explore the suspicion that "the pervasive reliance on a visual metaphor marks Western philosophy as patriarchal" and cite feminists who have proposed that the logic of the visual is a male logic (207). "Woman's desire," according to Irigaray, "does not speak the same language as man's desire. . . . In this logic, the prevalence of the gaze . . . is particularly foreign to female eroticism. Woman finds pleasure more in touch than in sight. . . ."[15] Hélène Cixous, too, questions Freudian and Lacanian theories of sexual difference because of the "strange importance accorded to exteriority and to the specular in the elaboration of sexuality. A voyeur's theory, of course" (95).[16]

By creating a male character whose basis for knowledge depends on vision and objectification of a female character and whose resulting knowledge remains so glaringly inadequate, Duras calls into question the objectivist epistemological models on which Western culture has relied. Even the very desire to solve the enigma of woman involves the pursuit of Truth, which Sarah Kofman sees as a traditionally masculine enterprise:

> [T]o speak of a riddle of femininity and to try to solve that riddle are a strictly masculine enterprise; women are not concerned with Truth, they are profoundly skeptical; they know perfectly well that there is no such thing as "truth," that behind their veils there is yet another veil, and that try as one may to remove them, one after another, truth in its "nudity," like a goddess, will never appear.[17]

Abandoning the search for Truth, present-day theorists recognize concepts such as "truth" and "woman" not as essentialist notions but as *effects* of cultural discourses and practices. Recognizing any "story" that seeks to explain, legitimize, or appropriate as a construct whose persuasive power lies in its ability to hide its subjectivity, theorists have shifted attention to the politics of interpretation, contextualizing such stories in order to study the ways in which inquiring subjects "frame," or mediate, their particular fields of inquiry. In representing a male narrator who is ostensibly unable to represent a female character, Duras has ingeniously represented unrepresentability while foregrounding the inevitable failure of any quest to solve the enigma of woman

and/or truth. In this sense, her art exemplifies not only what Irigaray has called "mimicry," but also what Kristeva has called feminist practice:

> [A] feminist practice can only be negative, at odds with what already exists so that we may say "that's not it" and "that's still not it." In "woman" I see something that cannot be represented, something that is not said, something above and beyond nomenclatures and ideologies.[18]

Not only is Jacques the real voyeur in this story, but in his obsession with exclusion, he enjoys inventing stories of complicity between himself and Lol from which other people are always excluded. When Lol first appears at the home of Tatiana, her old friend from school, Jacques fantasizes that Lol is looking for him, not for Tatiana (63). Later, at the party at Lol's house, he watches the intimate conversation between the two women and symbolically inserts himself into it by fantasizing that Lol deliberately opens the window to facilitate his eavesdropping:

> Her look, which was meant for Tatiana, falls upon me: she notices me outside the bay window. . . . She opens it. . . . Suddenly, here are their voices, interwoven, tender, diluted by the night, similarly feminine voices which seem but one voice when they reach me. I can hear both of them. That is what Lol wanted. (83)

We have no way of knowing if this is what Lol wanted, nor does the narrator. Again, he attributes actions and motives to her for his own ends.

Jacques maintains throughout the novel that Lol's supposed madness has its origin in that one night at the ball at Town Beach. If we believe Jacques, then it is easy to read the train ride to Town Beach as Lol's attempt to retrace her madness to the origin, the municipal casino where the ball was held. But the textual evidence does not support this conclusion. On the contrary, when Lol and Jacques emerge from the train, Lol is bubbling with joy and curiosity at having rediscovered the town of her childhood: "Lol sticks her head into every opening and laughs, as if she is enjoying this game of exploring the past" (169). This seems to be a town of happy memories, not traumatic events. When she leaves the train, the text clearly says that she "looks in both directions,

hesitating which way to go" (167). She is not obsessively drawn to the municipal casino; it is Jacques who obsessively pushes her to it: "I start walking, taking her with me, in the direction of the casino" (167). Lol laughs as she explores her past; Jacques is fixated on the ballroom.

Duras has written that her heroines are "invaded from the outside, traversed, perforated all over by desire," and critics of this text usually interpret "desire" to mean the female protagonist's own desire rather than, for example, another character's desire (in this case, male desire) or the reader's desire.[19] As we have seen, Jacques's pronouncements are not truths but the interpretations of one "reader," where interpretation itself has much to do with the cultural values, psychology, and historical situation of that male interpreter. Just as Jacques reads Lol through the lens of his own context as subject, interpreters of *The Ravishing of Lol Stein* necessarily read Duras's text through their own situations and experiences. It is perhaps for this reason that the psychoanalyst Jacques Lacan, in a totally uncharacteristic *hommage* to Marguerite Duras, understood the central character to be Jacques Hold, not Lol. It is perhaps also for this reason that French feminist and psychoanalyst Michèle Montrelay finds not one but two equally important characters in Duras's text (Jacques and Lol); because she is working from a structuralist grid based in oppositional thinking, Montrelay needs to posit two focal characters in order to work through her binary opposition of non-thing-ness (Lol) and thing-ness (Jacques).[20]

As I suggested earlier, *The Ravishing of Lol Stein* is not the story of the human subject that is Lol, but the story of the way any story of a human subject is mediated by cultural codes—language, desire, discourses of power, and epistemology itself. Montrelay, however, neglects the importance of mediation in this text when she accepts Jacques's words at face value in order to diagnose what she calls Lol's "problem" as her inability to suffer. But if, as Montrelay claims, Lol cannot suffer because she is nothing but a "zone of insensitivity" (13), then Jacques's interest in her becomes doubly perverse. Not only will he "allow" her finally to suffer (in other words, he knows what she *really* wants, even if she does not), but he will also be able to accomplish what no one else has ever been able to do: "save" her from insensitivity. But again, we are dealing with Jacques's narcissism and not Lol's subjecthood. In fact, as Duras occasionally shows us, the two are in direct conflict. In order for one to exist, the other must necessarily cease to exist. As Jacques remarks on the train: "[Lol] is completely preoccupied by her effort to recognize

things. This is the first time she has deserted me so completely" (164). In other words, when Jacques acknowledges for once that Lol might be her own person with her own thoughts, he feels totally abandoned and must reinsert himself into her story, displacing her as the center of her own universe. As readers, we witness Jacques's inability to tolerate Lol as subject; since he is our narrator, we, by extension, cannot see her as subject either. For that, we will have to turn to a novel like *L'Amante anglaise,* in which Duras changes her form, abandons her narrator, and, through a series of direct interviews, does away with narrative mediation and lets the woman subject speak for herself (*L'Amante anglaise* is, in fact, also a play and was performed uncut, without textual adaptation, in a production directed by Duras). And even though the female subject in texts such as *L'Amante anglaise* still must speak through language that is itself mediated, Duras makes it very clear that *her* language is not *his* language.

Cindy Sherman and Gendered Mediation

The same attention to the dynamics of gendered mediation that is embedded through a strategy of mimicry in Duras's text is also the subject of the photography of Cindy Sherman. Like Duras, Sherman uses mimicry to expose and undermine the way male desire has mediated the construction of "woman" in our culture. Through her parodies of film stills and other genres, her photographs, like Duras's text, are less about the object of representation (woman) than they are about gendered discourses and "gazes" that have functioned to objectify and constitute the female.

As Sherman relates in an interview with Gerald Marzorati, the inspiration for her "Untitled Film Stills" came from leafing through a batch of old pornographic pictures in David Salle's loft: "They seemed like they were from 50s movies, but you could tell that they weren't from real movies. . . . They were women in these situations."[21] With those pictures in mind, Sherman created about seventy-five black-and-white photographs between 1977 and 1980 that portray various stereotypes of women, always in specific situations that help invoke the stereotype (see fig. 1). Through makeup, wigs, costumes, props, backgrounds, lighting, and camera techniques, she creates "the suburban housewife," "the innocent young girl," "the career woman," "the femme fatale,"

"the socialite," and others. Cindy Sherman is the actress in her shots (she is also the set designer, costume designer, lighting designer, and makeup artist), and the stereotypes she creates through her role-playing are easily recognizable because we have seen them so often in B-grade Hollywood movies of the 1950s and early 1960s. In fact, as Douglas Crimp has noted, it is this obvious stereotyping that alerts us to the fact that Sherman means to draw attention to the status of her photographs as representations: "The clichéd female role and situation insists that these photographs function as representations instead of appearing to be 'natural.'"[22]

Craig Owens has gone one step further in noting that those stereotypes explicitly address the issue of gender: "Sherman's photographs . . . reflect back at the viewer his own desire (and the spectator posited by this work is invariably male)—specifically, the masculine desire to fix the woman in a stable and stabilizing identity."[23] Owens has interpreted this masculine desire to "pin down" the woman's identity as a desire to master, through representation, the threat posed by the female. This desire to master, he has suggested, in turn accounts for the male privileging of vision above the other senses, since vision allows the perceiving subject to "objectify" and feel a sense of power in relation to the object of perception, the female. By representing stereotypes, Sherman is not only pointing to the fictional nature of these images, as Crimp has suggested, she is also implicating the male desire that has created those stereotypes in the first place.

In a sense, it can be said that Sherman parodies the conventions of Hollywood movies, especially the film noir, in the way that Roy Lichtenstein parodies the conventions of comic strips (see chap. 7). The agendas of these two artists, however, are radically different. As a feminist, Sherman's postmodern parodies—mimicries—are politically motivated in two related ways. First, she is involved in showing how images and ideas of women as they have been propagated through various technologies such as cinema are nothing but constructs, no more "real" or "natural" than the constructs she herself is inventing through her role-playing; second, she is drawing attention to the fact that these constructs have traditionally been created by and for men.[24] Although many critics have understood her photographs as parodies of a genre of representation (cinema, magazine centerfolds), not all have understood that what is addressed by the parody is the male gaze that has informed representation, as well as the male gaze for whom those rep-

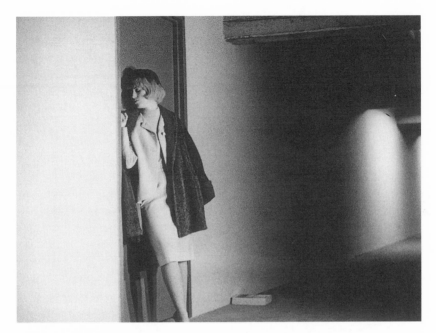

Fig. 1. Cindy Sherman, *Untitled Film Still #4*, 1977. Black and white pho-
tograph. 10" × 8". (Courtesy of the artist and Metro Pictures, New York.)

resentations are intended. As we shall see, as a result of their failure to
understand how gender functions in Sherman's work as a category of
analysis, several critics even duplicate the gender-based assumptions
that Sherman's photographs undermine.

Before analyzing the range of critical interpretations that Sherman's
film stills have provoked (in other words, Sherman's "readers" are the
texts under scrutiny here), it is important to stress that for many years,
a film still was an advertisement whose function was to seduce poten-
tial moviegoers into buying tickets. As such, it can be equated with the
jacket of a paperback novel or, indeed, any advertising image, as
Arthur Danto reminds us:

[Stills] are steeped in the strategies of provocation. . . . The still . . . is
seductive, enticing, and meretricious, and the taker of stills must
therefore be an astute psychologist of the narrative appetite, a visual
Sheherazade. The still must tease with the promise of a story the
viewer of it itches to be told.[25]

If the film still's function is one of seduction, it is no wonder that Sherman chose to create stills portraying women in mimicry of the way advertisers of all kinds use women and their bodies to seduce the public and market their commodities.

To heighten her parody of the seductive function of the film still, Sherman portrays her women in emotional or potentially menacing situations that are likely to stimulate narrative fantasy on the part of the spectator. These are the stories that the viewer "itches to be told," as Danto says; through these representations Sherman astutely conveys how "woman as vulnerable object" has traditionally functioned in the cinema to tantalize the male gaze. Ken Johnson is only one of many critics who have called Sherman's women vulnerable, exposed to danger, apprehensive: "In [the stills], Sherman plays a girl who seems to be nervously yet passively waiting for something to happen. She has a somber, quizzical look; things are beyond her control."[26] This representation of woman as vulnerable and powerless is, of course, one that Hollywood has propagated for years, and as a result, many filmgoers have automatically come to accept it as the norm, both in fiction and reality. The promise of a certain kind of narrative—of watching a vulnerable woman slip into danger—is, unfortunately, what people have been conditioned to expect and what continues to captivate anesthetized audiences. (In this context, it is interesting to note that Sherman has never played "the mother" in her photographs—mothers just don't tantalize in our culture.) By creating her film stills, Sherman challenges us to think not only about the ways women have been used to seduce viewers, but also about how we—men and women alike—have mindlessly allowed media images to condition our thinking about women.

Untitled Film Still #83 (see fig. 2) provides one of the clearest examples of how the male gaze is figured in Sherman's film stills, for what is shown is not only the woman but also the voyeuristic gaze itself. By positioning the camera between two buildings, behind a stairway, Sherman clearly indicates that someone is hiding and watching this woman. Because of the way we have been conditioned by the cinema, it is difficult to imagine anyone other than a man doing the looking. This photograph conveys the force of Owens's comment that vision allows the perceiving subject to "objectify" and feel a sense of power in relation to the object of perception. Because the woman is unaware of being watched, she seems less powerful and therefore vulnerable; her

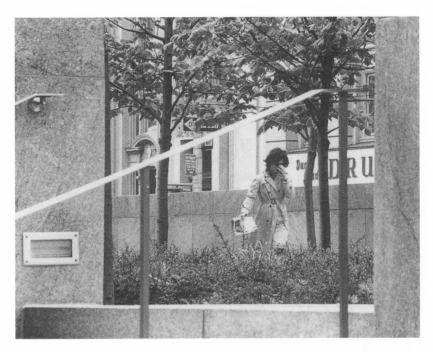

Fig. 2. Cindy Sherman, *Untitled Film Still #83*, 1980. Black and white photograph. 10" × 8". (Courtesy of the artist and Metro Pictures, New York.)

vulnerability is not "natural" but rather created by that voyeuristic gaze. Susan Sontag reminds us of the predatory nature of a photography that replicates this kind of gaze: "[T]here is something predatory in the act of taking a picture. To photograph people is to violate them, by seeing them as they never see themselves, by having knowledge of them they can never have; it turns people into objects that can be symbolically possessed."[27] Sherman duplicates the male gaze through her mimicry of cinematic conventions precisely to show that such voyeurism is "victimizing" rather than neutral observing.

The "Untitled Film Stills" have been widely reproduced and written about by numerous critics ("readers"), although critical interpretations have varied significantly. One group of critics has attempted to "pin down" the real Cindy Sherman, to find, behind the multiplicity of poses, a unifying psychology in the artist herself. Ken Johnson, for instance, unmindful of the political nature of the gender issues that

Sherman's work raises, accounts for the multiplicity of poses by suggesting that Sherman faces the "disturbing truth" about herself: that she finds the "ultrafemininity" of the 1950s "compelling":

> In the pseudo-1950s images, Sherman plays with seeing herself in humorously dated, stereotypical roles. She is poking fun at the infantilized baby doll or the *femme fatale*. But she is starting out on something deeper, too. . . . Through satire, she can admit to herself how compelling she finds the ultrafemininity of the 1950s . . . and she can accept that it is an ingredient in her own psychological makeup. (In fact, throughout her career, satire has enabled Sherman to face disturbing truths.) (49)

It is difficult to understand Johnson's interpretation as anything other than a projection of his own attitudes toward "ultrafemininity." And instead of understanding how he, as spectator, is already implicated in her critique of the male gaze and the will to mastery, Johnson prefers to stand "outside" and master the object through the stereotypical gesture of assuming that the woman "really wants it." This fiction, of course, says more about the male gaze (the "reader's" activity) than about the female as subject.

In the same article, Johnson explicitly reveals his condescending attitude: "Through fictional identification, she is acknowledging something in herself that the hard-nosed professional artist would resist: that in some important way she shares with these women their loneliness and their shameless craving to be romantically loved" (49). In revealing psychological truths about herself, according to Johnson, Sherman in less than professional—the *real* professional artist would not let the self contaminate the art, but would be in a position of mastery with respect to both self and art. Sherman, as a woman with a woman's desire to be loved, cannot master her self—or her art— enough to hide her feelings, Johnson implies; she is therefore not a professional. Unfortunately, the psychological truths that Johnson finds in Sherman are the ones that he put there in the first place; his gesture, conditioned by gender-based cultural ideologies, is precisely the one that she criticizes in her work.

A second group of critics has interpreted Sherman's work as deconstructing either the idea of a "self" or the notion of "femininity,"

although even within this group there are differences as to what such deconstruction entails. Douglas Crimp, for instance, notes the connection in Sherman's work between undermining the idea of self and undermining the idea of the author:

> Even though it is always Sherman who poses for them [her photographs], they disclose nothing about Sherman or her feelings. . . . [Her photographs] use art not to reveal the artist's true self, but to show the self as an imaginary construct. There is no real or true Cindy Sherman in these photographs; there are only the various guises she assumes. And she does not create these guises; she simply chooses them in the way that any of us do. The pose of authorship is dispensed with. . . . (88)

Crimp's ideas that Sherman shows the self as an imaginary construct and that she does not "create" but rather "selects" have less to do with gender issues than with the question of originality in art.

Even critics within this second group who choose to focus on gender issues (usually women) disagree about what Sherman's deconstruction entails. At one end of the spectrum, Lita Barrie conveys a pessimistic view:

> [T]he identity given woman in masculine fictions is really a non-identity. Since woman can only impersonate this non-identity, her sexuality becomes a form of masquerade. . . . Sherman exposes the way woman is trapped in the masquerade. . . .[28]

Barrie's rhetoric conveys very well that in her view, "masquerade" has negative connotations, while having an "authentic self" would be positive. When she says that woman is "trapped in the masquerade," she is implying that woman does not want to be there, that she is a victim of something that masculine fictions have done to her. She implies that women are schizophrenic (that is, not whole and authentic), that the masculine gaze is responsible for their schizophrenia, and that this is what Sherman's photographs portray:

> Her early impersonations of *film noir* characters from '50s B-grade Hollywood movies were explicitly concerned with the way woman

is positioned as victim of a controlling masculine gaze, to suggest the schizophrenia women experience in the roles men have invented for them. (23)

She also implies, of course, that being trapped inside schizophrenia is the "essence" of all women.

At the other end of the spectrum is Judith Williamson, who draws a parallel between Sherman's work in the "Untitled Film Stills" and a woman rummaging through her wardrobe in the morning, trying to decide which image to project that day.[29] For Williamson, unlike Barrie, the idea of masquerade is a positive one in that the woman is in control of her choices and consequently empowered rather than "trapped."[30] The artist who photographs herself in roles and images that never look alike is deconstructing the idea of femininity itself, Williamson maintains, since her work makes clear that "femininity" is not one fixed essence but either multiple or nonexistent.

> ["Femininity"] isn't any one thing at all. . . . [W]hat is crucial to the reading of Sherman's work is also the opposition between the images. "Essentially feminine" as they all are, they are all different. This not only rules out the idea that any one of them *is* the "essentially feminine," but also shows, since each *seems* to be it, that there can be no such thing. (105)

While I am not sure what Williamson means by the term "femininity," it is clear that she wants to draw attention to its status as a construct, an effect of the combination of clothing, lighting, facial expression, setting, and the narrative that is implied in each photograph. For Williamson, unlike Barrie, the one responsible for the construct is not the male, but the female (in this case, both the artist Cindy Sherman and any woman who, choosing clothing from her wardrobe, decides which image to project). Nowhere in her article does Williamson say that woman is victimized by the male gaze. Instead, she considers woman as subject, not object. While her vision seems liberating, it is important to remember that culturally induced stereotypes are *already* responsible for determining which choices the woman standing before her wardrobe will make. She chooses, but on what kind of knowledge are her choices based? She chooses based on the knowledge that her choices already

signify in specific ways (this is precisely why books like *Dress for Success* enjoy such popularity). Ironically, Williamson refers to this cultural knowledge herself, not in relation to a woman standing before her wardrobe, but in relation to the spectator of the photographs: "[T]he viewer is forced into complicity with the way these 'women' are constructed: . . . you supply the femininity simply through social and cultural knowledge" (103).

In this sense, even the female spectator of Sherman's photographs is forced into a position of complicity with the male gaze that has constructed these stereotypes in the first place. This is one reason why some feminists have sharply criticized Sherman's work as reinforcing the very stereotypes it is meant to undermine. As Vicki Goldberg puts it, "Maintaining full control over her ironies remains something of a problem."[31]

Like the "Untitled Film Stills," the horizontal series that Sherman shot in color in 1981 has generated a wide variety of critical interpretations, many of which duplicate precisely the kinds of responses they are meant to undermine. In response to an invitation from *Artforum* magazine, Sherman proposed a takeoff on a centerfold because she liked the long, horizontal cropping of the genre. She created a series of "horizontals," as they have come to be known, and although these pictures were never published in *Artforum,* Sherman showed them at Metro Pictures gallery late in 1981. Critics aware of the original purpose of these photographs have noted their resemblance to traditional centerfolds because of their relative dimensions (two feet high by four feet wide) and because the model (still Sherman) is usually represented in a supine position (see fig. 3). The expression in her eyes, however, seems to be at odds with a traditional centerfold pose, and she is never smiling. Critics have felt free to fantasize about the "mysterious" women represented in these photographs; in so doing, they reveal less about the women and more about gender-based cultural stereotypes operating in society.

One of the first critics to write about these horizontals, Andy Grundberg, describes them as follows:

> Instead of projecting allure, the expressions Sherman's personae assume are remote and ambiguous. . . . Despite the initial message of come-hither availability, the pictures ultimately close the viewer off.

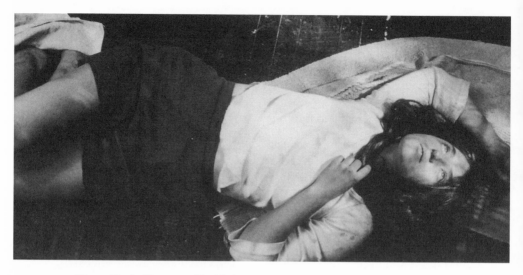

Fig. 3. Cindy Sherman, *Untitled #91*, 1981. Color photograph. 24" × 48". (Courtesy of the artist and Metro Pictures, New York.)

. . . The net effect is a nonspecific characterization that tempts one to speculate about the situation and mood of the female protagonist. . . . [S]he gives us glimpses of vulnerability, suffering, anticipation, desire.[32]

Grundberg's readings of these photographs are undoubtedly conditioned by his knowledge of Sherman's intent to parody a centerfold, for the adjectives he uses to describe them have less to do with the actual images represented than with his ideas about the kinds of images portrayed in the genre of the centerfold (Sherman does not use the word *centerfold* in her title). His association of Sherman's images with centerfold and advertising images also informs his comment about the women not "projecting allure," as if this is what we might expect such women to do. His characterization of these photographs as providing an "initial message of come-hither availability" results from the cultural conditioning of centuries of representations in which "horizontal-

ity" implies "availability." The very terms Grundberg uses to describe Sherman's women have already been determined in advance by cultural codes and stereotypes.[33]

Grundberg is aware that as spectator, the pictures are doing something to shut him out (this is an important point about which I will say more later). Much to his credit, he is simultaneously self-conscious about his desire to speculate about the female protagonist, to endow these images with his own fictions. What is significant for our purposes is that the fictions he applies are inevitably the stock ones—those of female weakness ("vulnerability") and female desire.

Like Grundberg, Marzorati is aware that as spectator, he is unable to know what the women in these pictures are feeling, yet he, too, associates the blankness of their stares with passivity and weakness:

> What "action" there is is going on behind Sherman's eyes, eyes that in nearly all the pictures are as blank as the windows of vacant tenements. These women don't seem to be enjoying themselves, though just what they *are* feeling is anything but clear. They may be lost in daydreams, lost in paranoid hallucinations, just lost. (87)

Marzorati reads these women as "lost" (although there are other possible ways to interpret the photographs, as we shall see), probably because he, like Grundberg, has been conditioned by gender-based cultural discourses. The comment that "the women don't seem to be enjoying themselves" seems oddly out of place, unless Marzorati is making the association with centerfold or advertising images and thinking that women *should* seem to be enjoying themselves in pictures destined for a male gaze.

Ken Johnson goes even further than Grundberg and Marzorati in the creation of fictions about the unknowable women. Where Marzorati saw a lack of emotion, Johnson sees "hyperemotionalism" and "a character who is entirely possessed by romantic longing . . . daydreaming . . . about her prospects for romance" (49). He notes that "[t]hese girls seem lonely but pacified and perhaps comforted by their promising fantasies," and then proceeds to fantasize about what their fantasies might be: "*Untitled #92,* for instance, in which the wet-haired, exhausted-looking girl raises herself up from the floor on her hands and looks into space with an expression of tragic apprehension as

though she's just seen her boyfriend kissing another girl . . ." (49). Not only does Johnson apply media-induced fictions to the women in Sherman's photographs, he offers us a fiction about the photographer as well when he says that "Sherman opens herself up to a certain potential that, we can safely guess, she probably lived through as a teenager and later did her best to leave behind" (51). His article is full of pop psychology and speculation, and although he is writing in 1987, he seems completely unaware of the gender issues posed by Sherman's work, particularly issues of how women have been objectified by male gazes, fantasies, and narratives such as his own.

Unlike Johnson, Peter Schjeldahl understands that his own gaze as a male is the subject of Sherman's work. He relates that after seeing the series of horizontals, he was able to go back to her previous work with fresh eyes. What he now sees is a new awareness of his own assumptions and "masculine urges":

> I am interested to note that I automatically assume, without knowing, that the photographer of the "film frames" was always male [Sherman sometimes had other people photograph her]. As a male, I also find these pictures sentimentally, charmingly, and sometimes pretty fiercely erotic: I'm in love again with every look at the insecure blonde in the nighttime city. I am responding to Sherman's knack, shared with many movie actresses, of projecting feminine vulnerability, thereby triggering (masculine) urges to ravish and/or to protect.[34]

While I am not at all sure that the blonde in the nighttime city *is* insecure, as Schjeldahl states, his self-consciousness about some of his own responses as a male and about his assumptions—that a vulnerable woman serves as a lure to masculine urges "to ravish and/or to protect"—reveals an understanding of the conceptual dynamics necessary to read Sherman's work. Many critics have already pointed out how Sherman was influenced by conceptual art in the 1970s and how her interest in the conditions of representation aligns her with artists such as Sherrie Levine, Richard Prince, and Barbara Kruger. In stimulating the spectator to think about issues such as habitual responses, the politics of gender, the conditions of representation, and cultural stereotypes, Sherman's work demands the kind of complex thinking that

Schjeldahl's article exhibits. Nevertheless, while Schjeldahl is aware of some of his own assumptions, he remains unaware of others. Although he states that "she projects" vulnerability, it is possible that "she" may be "projecting" nothing at all. The feminine vulnerability that he believes "she projects" may exist totally in the eye of the beholder, and yet his rhetoric makes the woman responsible for his "urges to ravish and/or protect."

While Marzorati's rhetoric conveys that the women in the centerfold pictures are passive ("Lost in daydreams, lost in paranoid hallucinations, just lost"), Schjeldahl's rhetoric conveys just the opposite. Elsewhere in the same article he calls these women "preoccupied," a term that, unlike Marzorati's "lost" (or "possessed," as Johnson says), implies active engagement (8). The term "preoccupied" implies that the women have thoughts and lives of their own, that they are subjects in their own right rather than just objects for the male gaze.

Sherman herself was getting at this double aspect of her photography—the fact that the women portrayed are subjects as well as objects—when she said, in an interview with Marzorati, that part of what she was doing in the film stills was "to show that these women who are playing these characters . . . maybe these actresses know what they're doing, know they are playing stereotypes . . . but what can they do?" (86). Sherman's comment, of course, applies to advertising images as well as the film stills. In other words—and I would like to stress this point—Sherman, unlike many of her critics, is thinking about these women as subjects, as actresses performing. As actresses, these women are obviously engaged in thinking about the very activity of posing in which they are involved. These are the thoughts, though, that the camera usually attempts to filter out in order to create a perfect illusion. As Sherman says, "I think I showed this part of these people you see in centerfolds. . . . The part that the photographer doesn't want to take pictures of" (87). With her statement, Sherman explicitly draws attention to the fact that the camera lies: the camera does not show the subjectivity of the actress—the woman who has a real reaction to the fact that she is posing and being photographed—but objectifies her instead for the viewer. When Sherman says that she shows "the part that the photographer doesn't want to take pictures of," she is referring to the woman as subject—the woman who is reacting, in advance, to the process of being commodified in the centerfold shot, objectified by the

camera. Since Sherman herself is the performing artist in these hori-
zontal shots, she is very much aware that an actress thinks about pos-
ing during an act of posing (unlike a spectator of the final photograph,
who is generally oblivious to the actress's preoccupation with her own
activity of posing). It is this subjectivity that Sherman's centerfolds
reveal; in other words, Sherman reveals precisely what is usually con-
cealed in this kind of photography. What is revealed is the fact that this
is an actress posing; this is an actress involved in "masquerade," in
Mary Ann Doane's sense of the term: "By destabilising the image, the
masquerade confounds this masculine structure of the look. It effects a
defamiliarisation of female iconography."[35]

Pointing to the woman's subjectivity by creating the impression that
she is "preoccupied," to use Schjeldahl's word, serves to break the illu-
sion that a photographer of traditional centerfolds or advertising
images attempts to create. This is the aspect of Sherman's horizontals
that has perplexed or annoyed so many critics, the aspect that Grund-
berg has said "close[s] the viewer off." Because her eyes indicate that
she is "elsewhere," the male spectator is being told that this woman is
not there for him.

To claim, as some feminist critics have, that Sherman's work repli-
cates the moves of patriarchal ideology is to ignore the details in her
work that simultaneously expose that ideology (e.g., the illusion-break-
ing details discussed above).[36] Similarly, to claim to "know" Lol's psy-
chology or history when reading Duras's text is to ignore one crucial
detail: the narrative gaze that mediates between Lol and the reader, cre-
ates its own fictions, and simultaneously exposes its own fiction mak-
ing. Cindy Sherman's work, like Marguerite Duras's, resists a master-
ing gaze because it explicitly undermines such a gaze by its artistic
strategies. Both artists focus attention on the way in which women have
traditionally been constructed by the male gaze that attempts to "pin
women down" into stabilizing identities. Both artists stage the gaze, or
rather, the relationship between the gaze and the object of the gaze. It is
this relationship, the many ideological variables that condition this
relationship, and the cultural implications of this relationship, that
make these works so conceptually exciting. It goes without saying that
in staging the relationship between a gaze and its object, Sherman and
Duras also implicate their own readers, who are invited to reflect on
their own assumptions and habits of thinking (their own "mediating
gazes") and consider to what extent those "gazes" function in defining

the object, or artwork, under investigation. Far from being the objects of consumption that an ideology of idealist aesthetics would have them be, these works set in motion a complex dynamics that undermines the very possibility of an idealist aesthetics, as well as the objectivist epistemology on which it is based.

TWO

The Nonreified Object:
Ponge and Magritte

Even before feminist writers, artists, and theorists introduced the category of gender into their reevaluation of epistemological models, male thinkers of the twentieth century were already at work reformulating questions about knowledge and perception. Convinced that the observer (whom I have been calling the "reader") was not as neutral, objective, or disinterested as he or she was presumed to be according to some epistemological models, many philosophers, authors, and artists set about investigating the gaze of the observing subject and the variables informing that gaze. This shift in attention to the mediating practices that govern our gaze, our attempts at knowledge ("readings"), is of central importance in the work of the French poet Francis Ponge and the Belgian artist René Magritte. As we shall see, in shifting attention to our mediating practices—our act of reading, the variables informing reading, and the way our reading creates the object under investigation—they call into question the very notion of an "object" in the reified sense. By investigating the work of poet and artist side by side, this chapter analyzes how thinkers in different media draw attention to and work with this problem. It also investigates how these thinkers have problematized the conventions of representation and reading assumptions that have conditioned and determined reading.

More than any other French poet of the twentieth century, Ponge has been called the poet of objects. He chooses the most ordinary, familiar objects—bread, an orange, a cigarette, soap—as the subjects of his poetic discourse, weaving language into text while exploring the tex-

ture of discourse and the way it organizes our perceptions of the world. I use the word *discourse* here in the Foucauldian sense to emphasize the extent to which Ponge's language produces perception and objects, instead of in the linguist's sense of language functioning as the sign of something that precedes it.

Ponge's texts are not "about" objects at all, but explore issues of representation, referentiality, and perception. Several critics have suggested that Ponge's interest lies less in objects as such than in the production of signs and the production of texts (which is not the same as the production of perception, the subject developed in this chapter).[1] The *Tel Quel* group enthusiastically embraced his work for this very reason and included his poetry in the inaugural issue of their journal in 1960.[2] Ponge's writing, the *Tel Quel* group argued, is not the transcription of some preceding idea, but an artistic fabric and a system of signs in its own right. Members of the group, however, were far more interested in Ponge's writing as *écriture* as opposed to *discourse* (in *discourse*, the emphasis is on the fact that something *beyond* discourse is produced, constituted, effected). I will be focusing on Ponge's work not as *écriture* but as *discourse*, arguing that poetic discourse is one of those countless "objects" interrogated by Ponge precisely because it serves as a medium that allows perception to come into being.

Like Ponge, Magritte has been called an artist of objects. Working with familiar objects (a pipe, a cloud, a tree), Magritte depicts them with an uncanny realism although he places them in strange contexts. Like Ponge's texts, Magritte's paintings are not "about" objects, but explore issues of representation, referentiality, and perception. In a series of paintings dating from the late 1920s and the 1930s, Magritte deliberately confuses verbal and visual signs and draws attention to the assumptions we habitually make in our responses and the conventions we follow in deciphering codes.

The strongest basis, then, for a comparison between Ponge and Magritte lies not only in their predilection for familiar, deliberately insignificant objects as motifs, but also in their shared preoccupation with signifying systems, their shared conviction about the power of signs to stimulate perception, thought, and visual conceptualization, and their common belief in the importance of the reader in completing the creative cycle of the work of art. While foregrounding issues of representation, referentiality, and perception, this chapter investigates how both Ponge's texts and Magritte's paintings "work" thanks to the

reader each of them hypothesizes; both of them rely on the reader's response as the basis of the problematics their art brings into focus.

Before analyzing the philosophical concerns informing Ponge's writing and Magritte's painting, it is useful to read Ponge in the context of the philosophical debates between Sartre and Merleau-Ponty in order to pinpoint differences inherent in their conceptions of both the subject and the object of perception. These differences are especially pertinent in the context of a poststructuralist reading of Ponge and Magritte, one in which readers, instead of mastering an object of perception, turn their attention to their own mediating practices and call into question the notion of an already constituted "object" in the reified sense. Sartre's reading of Ponge, contained in *Situations I*, provides a useful entry into the discussion.

Ponge and Phenomenology: Sartre versus Merleau-Ponty

In his 1944 essay entitled "Man and Things" ("L'Homme et les choses"), Sartre reads Ponge as a poet of petrification.[3] Focusing on what he sees as Ponge's attraction to inanimate objects, material substance, and solidified form, Sartre reads Ponge's passion for objects as a desire to petrify himself, his poems, and all of civilization:

> He has passion, vice, for inanimate material *things.* For what's solid. Everything is solid for him: from his sentence to the very foundations of his universe. If he attributes human behavior to minerals, he does so in order to mineralize men. If he himself borrows the way of being of things, he does so in order to mineralize himself. Perhaps behind his revolutionary enterprise one may glimpse a great necrological dream of burying everything living, especially man, in the shroud of matter. (287)

Behind Ponge's poetic enterprise, Sartre discerns what he calls Ponge's "necrological dream"; the desire to make things solid and be part of "an immense necropolis" seems, according to Sartre, to be the motivating force behind Ponge's work.

Sartre goes even further: he imagines that Ponge's ultimate desire lies not simply in petrifying himself, but in being perceived, along with civilization, as an object in the eyes of an *other* at some future moment.

Since Sartre imagines that Ponge already feels affected by this future *regard* and already feels himself petrified into a statue "under these Medusa-like eyes" [sous ces yeux médusants], Sartre sees Ponge's writings as prefiguring this future catastrophe (287). Ponge's poetry, then, according to Sartre, does not involve petrification for petrification's sake; instead, Sartre sees this desire for solidity as the response of a human being *in situation,* already conscious of his place in the universe, his anguish, and his lack. Sartre reads what he sees as Ponge's petrification as a desire to escape anguish: "And there I see first and foremost a certain way of annihilating with one blow everything he suffers from: abuse, injustice, the foul disorder of society into which he's been thrown" (288). Ultimately, Sartre's reading of Ponge is a conventional psychological one.

The pages that follow call into question Sartre's reading of Ponge as an escapist who desires to petrify himself and the world. Sartre has assumed that Ponge wanted, literally, to put himself on the side of things, to be an object rather than a subject and thus to enjoy the kind of existence *en-soi* that Sartre attributed to objects. But this reading ignores the extent to which Ponge's poetry seeks to unsettle our "conceptual solidification" of the very objects that Sartre claims he petrifies. Although Sartre notes, for instance, that Ponge's poems are often structured as variations on a theme, Sartre is more interested in the totalizing, unifying gesture than in paying attention to variation itself as a strategy for unstructuring petrified form. Although he notes the preponderance of words such as *but* and *nevertheless,* Sartre interprets them as transitional words whose purpose is to connect ideas *(faits pour enchaîner)* and unify the poem into a synthesis, rather than as words that indicate difference and therefore work against synthesis. Because Sartre remains convinced of Ponge's desire to petrify and pin down the object, he is unable to appreciate the extent to which Ponge's enterprise might be exploratory, experimental, and tentative.

The phenomenology of Maurice Merleau-Ponty offers a very different context for reading Ponge's work that will help bring the issues neglected by Sartre into sharper focus. Merleau-Ponty published his important work *Phenomenology of Perception* in 1945, one year after Sartre's essay on Ponge and two years after Sartre's *Being and Nothingness,* which Merleau-Ponty's work critiqued.[4] Already in the preface it is clear that Merleau-Ponty's phenomenology differs radically from

Sartre's: "The phenomenological world is not the bringing to explicit expression of a pre-existing being, but the layering down of being. Philosophy is not the reflection of a pre-existing truth, but, like art, the act of bringing truth into being" (xx). While Sartre's reading of Ponge assumes the existence of an already constituted subject who comes to the world of objects with an already constituted desire (e.g., Sartre's remark about Ponge's relationship with the mimosa: "But he already knows what he's looking for" [247]), Merleau-Ponty takes issue with that very notion of an already constituted subject. As Merleau-Ponty says in his preface, "There is no inner man, man is the world, and only in the world does he know himself" (xi). According to Merleau-Ponty, thought is always carried out in a specific context, in a temporal flux, and constitutes itself as a result of its intersections with the objects it seizes upon. The world, for Merleau-Ponty, is "already there" before reflection begins, and reflection cannot be independent of that world which is its initial situation.

In the *Phenomenology of Perception*, Merleau-Ponty criticizes the system elaborated by Sartre just two years earlier. Sartre had maintained that everything, including the "I," was exterior to consciousness and that consciousness was thus nothingness; for Merleau-Ponty, on the other hand, consciousness remains inextricably connected to the world. In place of Sartre's language of possession and reification, Merleau-Ponty proposes a more dialectical relationship. He rejects Sartre's Cartesian-like separation of subject and object and refuses the possibility of a preexisting, already fully constituted subject by denying the ontological priority and plenitude of this subject.

When we approach the poetry of Francis Ponge from the perspective of Merleau-Ponty's phenomenology, Ponge emerges as a poet who does not at all long for the ultimate self-objectification and stasis presumed by Sartre. On the contrary, Ponge's very method of reflecting on objects is a putting-into-movement that works against reification and presupposes the possibility of a nonreified authenticity. In his book *Soap (Le Savon)*, for instance, Ponge takes his subject in hand *(en mains)*, lathers it up so that it froths and bubbles, plays with it joyfully, and in the process of play watches it change form, shrink in size, and ultimately disappear. It is difficult to imagine Ponge as a poet of petrification when he chooses an object like soap, the form of which never remains constant. Instead of articulating an ideology of static form, Ponge seems to value change and the unsettling of form. Rather than

emphasizing telos, Ponge, like his predecessor Valéry, highlights process.

Sartre does not see the way Ponge underscores process, difference, and divergence because he is preoccupied with his own ideal of unity. Commenting on the variations in "The Mimosa," for example, Sartre writes: "Each of these variations is then rejected as imperfect, exceeded, buried by a new combination that starts again from scratch. . . . The last paragraph *haunts* the present paragraph and seeks to merge with it. But it cannot: the other pushes it away with all its density" (271). Sartre tells a Darwinian story in which paragraphs of organic unity compete with each other for existence because he does not consider that process itself may be important. Instead, he interprets diversity and difference as threatening, something to be done away with if his ideal of unity is to be attained. Although he notes the presence of *le discontinu* in Ponge's work and compares Ponge's sentences to the cubist paintings of Braque and Gris, he assumes that the eye attempts to organize the painting's multiplicity into one unified whole and becomes frustrated when perpetually thrown into the discontinuous.

Like Merleau-Ponty's phenomenology, Ponge's poetic enterprise grounds itself in a dialectical encounter between a not-yet-formulated subject and an object. The "I" who approaches objects such as the cigarette, the orange, or soap does not know in advance what the encounter will bring; instead, the going-forth-into-the-world itself brings the organizing "I" into being. Objects are not things to be seized, described, and accounted for by a knowing "I" but are, instead, the pretexts that allow Ponge's perceptions to come into being. The perceiving "I" in Ponge's poetry can never be the detached observer who exists outside the world interrogated or, indeed, outside the interrogation process itself. Inextricably connected with the world and in the world, Ponge's perceiving subject never seeks escape into the universe of things; on the contrary, his procedure leads him precisely to the discovery that his perception exists. Instead of pursuing petrification, Ponge's poetics reaffirms his being-in-the-world by reaffirming the fact of the intersection of his experience with things in the world.

A careful look at Ponge's work reveals the extent to which language itself plays a crucial role in this intersection, as terms like *plus que* (more than), *moins que* (less than), *comme* (like), *ainsi* (in a like manner), *quoique* (although), and *mais* (but) function to organize perception. In a similar vein, qualities such as size and color are not properties of objects but

terms used by humans to organize perception. Other phrases such as *l'on peut dire* (one can say), *si l'on veut* (if one wishes), and *on peut concevoir* (one can conceive/imagine) constantly remind us that perception is being organized in the interaction between this abstract "one" and the object interrogated. And finally, phrases like *m'apparaît* (appears to me) and *m'impressionne* (impresses/strikes me), where the "I" is grammatically the object of the verb rather than its subject, acted upon rather than acting, echo Merleau-Ponty's ideas about the "I" being constituted by its encounter with the world.

As a revolutionary, Ponge set out to disturb anything that froze thought, such as ready-made perceptions and ready-made language. Already in 1933, in his "Introduction to the Pebble" ("Introduction au galet"), he had complained about rigid habits of thinking: "All the same, it is unbearable from several points of view to think that words, the mind, and indeed man's reality have been turning around for centuries on some tiny merry-go-round."[5] Throughout his work, his aim was to disturb the status quo and discover new ways of thinking and speaking because he remained convinced that deliberate disruption of what he called the "merry-go-round" [le manège] or "the constant buzz" [le ronron] was necessary for progress to take place.

Ponge's use of poetic language to interrogate objects is the means by which he "unsettles" their apparent solidity, foreignness, and otherness. Unlike Mallarmé, whose poetics insists on "not naming" the object, Ponge names his objects continually. Ponge's strategies, in fact, seem the very opposite of Mallarmé's: where Mallarmé subtly evokes, Ponge aggressively names; where Mallarmé creates fleeting impressions, Ponge holds onto objects and interrogates them ruthlessly; where Mallarmé cultivates indeterminacy, Ponge keeps putting his objects in different contexts in order to make their various properties emerge. By showing that an object changes depending on its context ("Rain"), or by insisting on the changing aspects of an object over time ("Introduction to the Pebble"), Ponge calls into question both our habits of codification and the language that permits such codification to take place.[6]

One of the objects Ponge takes pleasure in "unsettling" is language itself; punning and playing with the materiality of language are two of his favorite pastimes. Like Ponge, Magritte calls into question our habits of reification through a similar unsettling of objects, language, and the objects of language, especially in his series of paintings from the late 1920s and 1930s that include both words and images. Before

exploring Ponge's writing more closely, we will take a look at some of these paintings.

Magritte and Verbal-Visual Signs

In Magritte's painting *The Apparition* (1928), formerly known as *Person Walking toward the Horizon,* we see the form of a man in an overcoat walking away from us toward the painted horizon (see fig. 4). We also see five dark blobs of varying shapes and sizes in the picture, each one containing a different French word: *fusil, fauteuil, cheval, horizon, nuage.* The oval-shaped blob with the word *nuage* does, in fact, appear in its expected location in the sky and is the same shape as the clouds so typical of Magritte's paintings. Similarly, the blob containing the word *horizon* does, indeed, appear on the line depicting the horizon, but its shape is not that of the horizon. The former title announces the three possibilities suggested by the painting: the man walks toward the word *horizon,* toward the shape of the blob arbitrarily labeled *horizon,* and toward the representation of what we conventionally identify as the horizon (the line that appears to separate earth from sky). The horizon, of course, is not a physical object in our world in the sense that an armchair and a horse are, but rather a phenomenon of perception—painting gives the object a material being that it does not have in the real world.

The three remaining blobs with the words *fauteuil, fusil,* and *cheval* inscribed in their shapes pose special problems. By placing these blobs on the ground and by having them cast shadows behind themselves, Magritte creates the impression of three dark "rocks" in an otherwise empty landscape (the blob containing the word *horizon* could also, for the same reasons, be a "rock"). To think of them as rocks, however, one must selectively disregard some of the visual material, that is, the words inside each form. On the other hand, one can imagine an armchair in the place of the *fauteuil* blob, a horse in the place of the *cheval* blob, and so on, but in so doing, one must make an effort to ignore the shapes and scales of the blobs, which do not correspond to the shapes of armchairs, horses, or guns. This painting invites us to recognize the way in which visual material that contradicts language interferes with our ability to conceptualize (i.e., we have difficulty seeing a horse because of the rocklike shape of the *cheval* blob). Given the contradic-

Fig. 4. René Magritte, *The Apparition* (formerly known as *Person Walking toward the Horizon*), 1928. Oil on canvas, $31\frac{7}{8}"$ × $45\frac{5}{8}"$. Staatsgalerie, Stuttgart. © 2000 Charly Herscovici, Brussels/Artists Rights Society (ARS), New York. (Photograph courtesy of the Staatsgalerie, Stuttgart.)

tion between language and a visual image, the visual image seems to dominate in this particular case, confirming, as John Berger has maintained, that "seeing comes before words."[7] This is not always the case, however; as we shall see in chapter 7, different configurations between word and image call for different conventions of reading that may produce very different results.

The Key of Dreams (1936) demonstrates again that visual images conventionally take precedence over words within a painting (see fig. 5). Here, Magritte has painted what looks like a window, and each pane contains a visual image with a label underneath (I shall return to this word *label*, which is more problematic than it may appear). The horse, clock, and pitcher are "mislabeled" with the words *the door, the wind,* and *the bird,* respectively, while the fourth image, that of a valise, is correctly called *the valise.* Magritte has presented the reader with a series of conflicts between word and image that invite us to reevaluate the

assumptions we make about the relationship between the two. Interestingly, Magritte's painting resembles a page from a child's book, drawing attention to the fact that the assumptions we hold about language stem from the way we learned to read as children, when grammar books taught us that the relationship between word and object was one of illustration. Because we have become so used to using language as a tool for communication in our daily lives, we arbitrarily assume that language will "illustrate" or "explain" something to us; in this case we assume that words will explain or at least refer to the accompanying images. A similar problem involving referentiality occurs when a spectator seeks the title of a painting on a museum wall, anticipating that the title will refer to and therefore explain the painting in some way. This example, however, contradicts Berger's statement about seeing coming before words, since the words of the title will inevitably determine what can be seen.[8] Significantly, many contemporary artists identify their paintings with numbers or with titles such as "untitled" so that words will not interfere with seeing. Other artists consider their finished work and, as spectators, assign a title suggested by the work itself or the feelings it evokes. Still others, like Paul Klee, purposely seek suggestive, poetic titles instead of descriptive ones, trying to create atmospheres with words.

When we see a clock with the words *the wind* written underneath, our conditioned response is to say that this is not wind, but a clock. Again, according to convention, the visual image tends to dominate when word and image are juxtaposed within a painting. We automatically think that the clock is somehow mislabeled, and we are less likely to say that the wind is misrepresented, although logically, either could be true. On the other hand, if the words *The Wind* were to be found on a museum wall—outside the painting—as the title of a painting containing the representation of a clock, we would be less likely to say that the clock was mislabeled and more likely to conclude that the wind was misrepresented. In painting, as discussed in more detail in chapter 7, much depends on the placement of words in relation to images. If words function as a title outside the frame, they conventionally have authority over the image and tend to determine what will be seen. If words appear juxtaposed with an image inside the frame, however, the image conventionally takes precedence.

Magritte has experimented with this distinction between visual and verbal sign in a different way in *The Apparition*. By inscribing words in rocklike forms that cast shadows of their own, he creates the impres-

Fig. 5. René Magritte, *The Key of Dreams*, 1936.
Oil on canvas, 16¼" × 10¾". Collection Jasper
Johns. © 2000 Charly Herscovici,
Brussels/Artists Rights Society (ARS), New
York. (Photograph courtesy of Eric
Pollitzer/Jim Strong.)

sion of having endowed those words with the mass and density of real
objects. The form called *fauteuil*, for instance, is the same "weight" in
the painting as the image representing the man. By providing language
with mass so that, like an object, it casts a shadow, Magritte approaches
Ponge's well-known "semantic materialism," his conception of a lan-
guage with density.[9]

In *The Key of Dreams*, however, where words do not appear inscribed

inside massive forms, we tend to assign those words a lower status by saying that they function as labels, for a label, by convention, serves to explicate and classify something that precedes it temporally and dominates it in importance. But why do we assume that the words serve as labels and refer to the image? Even though the words in *The Key of Dreams* do not appear as "solid" as those in *The Apparition,* they are no less solid than the images accompanying them; both words and images are merely signs painted on canvas. If we say that these images are mislabeled, our very response confirms the problem that Magritte has formulated here. For in order to distinguish or comprehend, we ourselves have followed conventions of labeling by calling one group of signs "language" and the other group "image." If we accept both, however, as painted entities, that is, painted on the canvas by Magritte, then there is actually an equivalence between them.

In demonstrating an equivalence between language and image, Magritte echoes ideas expressed by Freud in *The Interpretation of Dreams* (1900), particularly in the section on the dreamwork, where Freud maintains that words, like images, should be treated as "things" that undergo condensation and displacement in dreams: "The work of condensation in dreams is seen at its clearest when it handles words and names. It is true in general that words are frequently treated in dreams as though they were things, and for that reason they are apt to be combined in just the same way as are presentations of things."[10] Just as the work of condensation, for example, can result in what Freud calls a single "composite" or "collective" image in dreams, so too does condensation produce certain word-formations and verbal transformations. In dreams, then, as in Magritte's *The Key of Dreams,* neither word nor image assumes priority.

A much more complex example that questions our assumptions about the referentiality of language in painting occurs in Magritte's well-known *Treason of Images* (1928–29), also called *The Use of Speech, The Air and the Song,* and *The Faithful Image* (see fig. 6). Here, Magritte has painted what is obviously the image of a pipe, and below it he has painted a sentence in carefully rendered script: "Ceci n'est pas une pipe." In creating an apparent contradiction between language and image, Magritte silences his readers and prevents them from uttering the mechanical response: "It's a pipe." Magritte has literally made it impossible for the reader to react in a conventional way. That disrup-

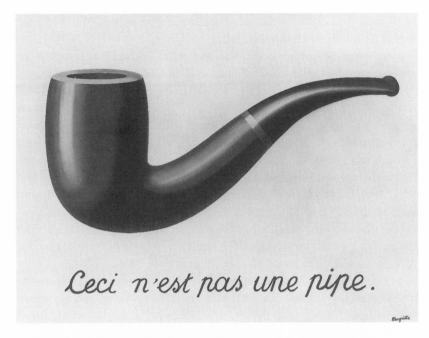

Fig. 6. René Magritte, *The Treason of Images (Ceci n'est pas une pipe)*, 1928–29. Oil on canvas, 25³/₈″ × 37″. Los Angeles County Museum of Art. Purchased with funds provided by the Mr. and Mrs. William Preston Harrison Collection. © 2000 Charly Herscovici, Brussels/Artists Rights Society (ARS), New York. (Photograph courtesy of the Los Angeles County Museum of Art.)

tion of convention and expectation now becomes the starting point for a new kind of response.

The reader's first reaction is to attempt to "make sense" of the contradiction by asserting that Magritte's sentence is absolutely true, that this is indeed not a pipe, but an image that represents a pipe. Although everyone knows that an image and an object are not equivalent, our language allows us to speak of them interchangeably as if there were an equivalence. The problem, then, lies in language itself and its tendency to call representations and objects represented by the same name.[11] Even the status of the represented object is called into question, for since this pipe is suspended in pictorial space, floating in a way that real pipes do not float, it is not clear whether this is a representation of

a real pipe that exists in our material world or a representation of the idea of a pipe that exists in our mind.

In a similar vein, the word *ceci* is less innocent than it appears. What is not a pipe? Michel Foucault has pointed out three possibilities.[12] First, if *ceci* refers to the image of a pipe, the sentence is referential and implies "this [image of a pipe] is not a pipe." Second, if *ceci* refers to the sentence painted on the canvas, then the sentence becomes self-referential and implies "this [sentence] is not a pipe," but only painted letters. Third, if *ceci* refers to Magritte's painting, that is, the one that contains both an image of a pipe and a sentence proclaiming "Ceci n'est pas une pipe," then the sentence again becomes self-referential but in a different way, implying "this [painting] is not a pipe." Shifting perspective a bit, we can also read the sentence as "this is not a pipe, but two pipes": the one painted on the canvas and the one that exists conceptually in our mind, evoked by the word *pipe.* In other words, Magritte has not only questioned the status of representations and our habitual responses to art, he has also called our attention to the imprecise and arbitrary nature of our language; in depriving us of a specific context, we cannot even judge the sentence to be true or false.

Magritte writes, "Ceci n'est pas une pipe," and Rudolf Arnheim, faulting Magritte for what he perceives as a lack of pictorial imagination, asserts: "Unfortunately, a pipe is all it is."[13] Instead of considering the truth or falsity of the assertion, however, it is perhaps more fruitful to consider the manner in which the sentence is presented as negation and the ramifications of proceeding by negation. Defining by negation is one of the hallmarks of contemporary criticism; we have become used to critics conjuring up presence by absence, speech by silence, naming by not-naming, knowing by not-knowing. Francis Ponge, too, writes of the importance of negation in approaching a grasp of an object: "To grasp a thing's properties, if they cannot be apprehended right away, one can make them emerge by comparison, by successive elimination: 'It's not this, it's not that' [*Ce n'est pas ceci, ce n'est pas cela*]."[14] Many of Ponge's own texts proceed by negation, as in the well-known opening of "Snails," where he begins his tale of snails by naming what they are not. Seeking to understand by studying systems of oppositions, relations, and distinctions is, of course, one of the principles of semiotic analysis.

As we have seen, Ponge considers his objects in various contexts, shapes, and forms in order to bring out differences (since we can only

perceive difference in terms of relation and contrast), and Magritte includes verbal and visual signs in his paintings in order to play with our assumptions about their differences. Their very emphasis on difference necessarily implies the presence of a reader to perceive the difference, a reader for whom that difference will play a crucial role in making sense of the work of art. In both cases, these artists force our attention to shift from the work of art (the "object" of our gaze) to the mediating practices that govern our attempts at knowledge, including our assumptions, habits, conventions of reading, and conventions of representation. In demonstrating that our assumptions, habits, conventions of reading, and conventions of representation actually produce the artwork (the "object") under our gaze, these two artists call into question the very notion of an "object" in the reified sense. We have seen several examples of the way in which Magritte shifts attention from the work of art to the perceiver's mediating practices; a closer look at Ponge's textual practice will reveal the extent to which Ponge's writing and Magritte's painting share similar philosophical concerns.

Ponge, Perception, and Reading Conventions

The activity of the reader plays an important role both implicitly and explicitly in Ponge's texts. Ponge often addresses his reader directly, calling attention to the reading process and the importance of the reader in bringing the work of art into existence. In *For a Malherbe* (*Pour un Malherbe*), for instance, he states: "Since you are reading me, dear reader, therefore I am; since you are reading us (my book and I), dear reader, therefore we are (You, it, and I)."[15]

The reader encountering a text like Ponge's *Soap* (*Le Savon*) for the first time will undoubtedly experience confusion, for Ponge has made it impossible for us to read this text in a conventional way.[16] The confusion disappears, however, when we realize that Ponge, like Magritte, is playing with conventions of representation and referentiality, and that this text is not about soap at all. It is neither a description of soap nor a commentary about the uses of soap. After claiming that we all share an idea about what this word *soap* represents, Ponge undermines his statement by telling us just the opposite of what we would expect: that *soap* is different for him, that it is, above all, a dossier entitled "Soap" that he has been writing for twenty-three years. Yet the success of this text

depends on the very convention that Ponge has just referred to: that of thinking referentially. In order for readers to recognize and appreciate the analogies between the activity of writing and the manifestations of soap explored in this text, they will have to bring to their reading a visualization of what they have experienced in the world: washing their hands with soap.

A second convention Ponge relies on and then subverts is the tendency to read in anticipation of a final conclusion, resolution, or discovery. Readers encountering *Soap* may initially classify it in relation to what they already know: one of Ponge's "notebook texts" documenting the various stages in the writing of a poem. And Ponge does, indeed, pretend that these are notes for the real subject that will appear later, although there is no "later." The whole text is a series of preparations for a subject that never appears, and we realize, in time, that this preparation is itself the real subject.

Anyone expecting teleological development will perceive these "preparations" as repetitive, but Ponge provides a key for reading when he says that *Soap* consists of variations on a theme, much in the manner of a musical fugue. Instead of anticipating linear development and a final conclusion, we are to pay attention to the differences within and between repetitions and to focus on the variety and the richness of language, which become apparent thanks to the structure of repetitions. The presence of a structure of repetitions and differences within and between repetitions, in fact, encourages us to make connections between and among various segments of the text. In this text, it is not the theme that counts, but the many ways in which that theme can be "played."

A third convention Ponge transgresses involves the framing of a text. The opening section of *Soap* begins one-third of the way down the page and extends for about 3 inches, following the conventional form of a preface. Traditionally, the preface is considered separate from the text proper. Since we expect to find a preface in this location, we may be surprised to discover that instead of "Preface," Ponge has entitled this section "Beginning of the Book," thereby drawing attention to the fact that this section is not to be considered as separate. Ponge draws attention to conventions of framing at the end of *Soap* as well. Traditionally, we think of appendices as separate from the main body of a text, material that supplements the work but remains subordinate in importance. Ponge includes five appendices at the end of *Soap,* but those appendices

still engage the subject matter (language) and are just as important as everything preceding them. It is for this reason that Ponge places the words "End of the Book" at the end of the appendices rather than before them: the book is not finished until the flow of language itself ceases. In framing his text between the words "Beginning of the Book" and "End of the Book," Ponge has shown that the frames we normally take for granted (preface and appendix) are themselves integral parts of the work of art.

After reading several sections entitled "Soap," we may be surprised to reach a section called "Prelude to Soap." According to convention, preludes, like prefaces, usually appear at the beginning, but Ponge transgresses convention and shows that just as the introduction to the book was already the book, now the fugue already in progress is still a repetition of beginning.[17] Significantly, Ponge uses the musical term *prélude* instead of the more common *préface*, again suggesting an analogy between textual activity and fugue (variations on a theme) and drawing attention to the ludic nature of the text, where the playing with, and the generating of, language (the making of "soap bubbles") is the subject under study. Readers familiar with Ponge's work may also associate the prefix *pré-* with the variations of the same sound appearing throughout his poem called "Le Pré," so that *prélude* evokes not only a period of time that precedes play (*pré-*) but also the state of being ready *(prêt)* for play as well as the field *(le pré)* on which that play takes place: the page.[18]

As late as page 69, Ponge is still talking about beginning: "We shall take in hand [*en mains*] a laughable subject. Because it froths interminably. No, not interminably." By negating his own statement, Ponge deliberately entices his reader to stop and consider the reasons he might have for such a contradiction, much in the same manner as Magritte challenges his spectator with his statement, "Ceci n'est pas une pipe." The most logical way to make sense of Ponge's contradiction is to accept both affirmation and negation as true by assuming that Ponge changes from a figurative to a literal use of language. In juxtaposing figurative and literal expression, he reminds us that his text functions simultaneously at several levels. At one level his subject is language, which has a capacity to generate itself indefinitely; at another level, however, the subject is the reading of this particular text, in which language does not "froth interminably" because once the reader ceases reading, the book is finished. Soap froths and bubbles *en mains*, in the

hands of the person doing the washing (an activity taking place in the mind of the reader) for as long as the language of the text remains in play (literally, *en mains,* in the hands of the reader holding the book). Just as soap diminishes in size from being handled over a period of time, so does the book (physically, the number of pages yet to be read) diminish in thickness with each page turned.

Ponge's *Soap* provides an excellent example of a multilayered text in which the reader's cognitive ability to perceive the relations between the layers is the crucial first step in making sense of the slippages from one level to another. As the reader progresses through Ponge's text, it becomes increasingly clear that Ponge has established soap as a metaphor not only for the activity of the text, but also for our activity of reading. Most importantly, though, "soap" is also a metaphor for the conceptual activity taking place in the reader's imagination during reading, the very activity that allows identification of the analogies between soap bubbling, language frothing, and the reader reading and imagining. When Ponge speaks of a "sudden catastrophe of fresh water," for instance, the reader must be able to perceive that he is talking about three things at once: running tap water that quickly rinses away all trace of soap bubbles (whether on hands or on the bar of soap itself); the white spaces appearing in the text after each paragraph (cat-a*strophes*) that serve to "rinse away" the preceding words (words, like soap bubbles when soap is lathered, are "traces"); and the "cleansing" of our mind as we partake of the pleasure of the textual webs (he calls our reading a *toilette intellectuelle*). Similarly, when Ponge talks about "unfettering soap's dry tongue/language" [délier la langue sèche du savon], he evokes simultaneously the dry bar of soap before use, the "dry" or inert language of the text, and the activity of reading that serves to *délier* and set the text into motion.[19]

Many of Ponge's texts function simultaneously at several levels and rely on the reader's ability to perceive connections among the various levels. Like *Soap,* Ponge's prose poem "Blackberries" ("Les Mûres") comments on the reading process itself. The poem begins with a strange allusion to "typographical thickets": "In the typographical thickets that go into the making of a poem, along a road that leads neither beyond things nor to the mind, certain fruits are formed by an agglomeration of spheres, each filled with a drop of ink."[20] "Typographical thickets" immediately calls attention to itself because of its strangeness, unless, of course, we are so used to expecting this sort of

thing from Ponge that we no longer notice it. The word "typographi-cal" has something to do with the printed page we are reading, and the thickets are obviously related somehow to the blackberries promised in the title, but so far the relationship between thickets of blackberries and things typographical remains enigmatic. Reading a few more words, we find "poem," which belongs to the same code as "typographical," and we read "road," which may bear a metonymic relation to "thick-ets," if we consider that thickets are found on the sides of roads in the French countryside that grounds much of Ponge's lyric poetry. But again, the two different codes seem unrelated semantically. The seman-tic ambiguity is reinforced by the syntax, since meaning is promised but withheld as we pass through prepositional phrases, subordinate clauses, and a negation before we reach the subject of the sentence: the fruits. Although we expect that this sort of syntax will deliver meaning after we locate the subject, verb, and object, no such meaning is appar-ent. We find, instead, a continuation of the double code, with one group of words relating to fruit and the other relating to writing. "Thickets," "along a road," and "fruits" seem to cluster together in one way, while "typographical," "poem," and "ink" form another cluster. What we encounter, then, is two parallel sets of relations, clusters, or *aggloméra-tions,* the word Ponge himself uses. This word, agglomeration, is the first word in the poem to transcend the specificity of both the botanical code and the poem code; it is linked to the botanical code because blackberries are visual agglomerations of black spheres, and it relates to the poem code because words are agglomerations of letters. "Agglomeration" functions at yet a third level as well: the level of our reading. For in order to make sense of this poem, we have to proceed by agglomeration in the way I have just described: we gather together bits of evidence that seem to relate to one another in specific ways. To pro-ceed by agglomeration, readers must first be able to perceive that cer-tain words relate to each other and form clusters, and then they must be able to perceive that the clusters themselves relate to each other in some way. Since our own activity of decoding proceeds by agglomeration, then we can say that the word "agglomeration" in this poem no longer refers to two things, but three.

This discovery and/or creation of multiple layers of meaning is pos-sible thanks to the prose poem's density. Ponge has condensed a great deal of information into a few images, and this condensation, or econ-omy, is one of the crucial factors that distinguishes poetic discourse

from other types of language. Poetic discourse is semantically satu-
rated. But this saturation must be perceived by a reader who defines it
as such, and not all readers will perceive the same language as being
saturated. In reading Ponge's poem, for instance, only a reader familiar
with what blackberries actually look like will be able to perceive the
play of the text and the multiple layers on which Ponge is simultane-
ously working. In other words, as Jauss reminded us, readers exist in
historical and cultural contexts that will determine their "horizon of
expectations" and thus the ways in which they can read.

Once readers become aware that blackberries and texts are receiving
parallel development, they will inevitably become more sensitive to
even the slightest hint that would sustain or develop the parallel. In the
second section of the poem, to take a specific example, the word "spec-
tacle" might encourage readers to think visually about agglomeration,
and if they continue thinking along these lines they may then notice
that even the visual form of the poem on the page is one of agglomera-
tion. Ponge has divided his prose poem into three sections, "agglomer-
ations" that are separated by asterisks "each filled with a drop of ink."
Just as blackberries of different colors, hence different ripeness, coexist
on a single bush, so do the poem's sections of unequal lengths and
forms coexist on the page. Or another visual example of the "agglom-
eration of spheres": the word "agglomeration" itself, especially the two
typographical *g*s whose round parts combine visually in the way that
the spheres in blackberries combine. This interpretation is not as far-
fetched as it may seem, especially for readers familiar with other exam-
ples in which Ponge deliberately chooses words for their visual value
(for instance, his visual play with the circumflex accents in "The Oys-
ter" ["L'Huître"] that duplicate the form of the oyster's shell).[21] The
more familiar readers become with Ponge's textual universe, the more
they are able to perceive ways in which the poem might be multiply
motivated.

Ponge's texts "work" thanks to the reader he hypothesizes. Because
he disrupts not only reading conventions but also conventional episte-
mological models that propose a separation between a knower and an
object of knowledge,[22] and because he simultaneously organizes lan-
guage to stimulate new kinds of perception and interpretation, Ponge's
texts focus attention on the presence of mediating human practices.
Magritte's paintings, too, depend initially on the reader's awareness of
the deliberate disruption of conventions, which then becomes the basis

of a fresh inquiry. As readers engage in a consideration of these works of art, their attention inevitably shifts from a concern with art as an "end product" to be grasped or comprehended toward an awareness of their own responses and the strategies they consciously or unconsciously rely on in attempting to decipher the works. Both Ponge and Magritte have created works of art that provoke and anticipate this sort of shift of emphasis from the object under scrutiny to the frame of reference. In this sense, their artistic praxis anticipates poststructuralism, with its project of making visible and demystifying the moves by which discourses and ideological frames of reference shape perception.

Part 2

Reading Relationally

The Reader, the Open Work, and Relational Logic: Mallarmé, Duchamp, Calvino

It was Octavio Paz who first suggested the resemblance between Marcel Duchamp's artwork *The Bride Stripped Bare by Her Bachelors, Even (La Mariée mise à nu par ses célibitaires, même)* (1915–23), also called the *Large Glass,* and Stéphane Mallarmé's poem *A Throw of the Dice (Un Coup de dés)* (1897), although Paz made his comparison only in passing without exploring in depth the reasons for or the ramifications of such a comparison.[1] Interestingly enough, Mallarmé's poem, like Duchamp's artwork, has been a favorite subject of study among critics interested in exegesis.[2] The wealth of commentary undoubtedly results from the particular nature of the works themselves: both are what Umberto Eco has called "open works" that, precisely because of their difficulty of access, require the reader to play an organizing role and therefore encourage a plurality of readings.[3] More recently, Italo Calvino has humorously evoked and explored the inevitability of differing perceptions and readings in his 1979 novel, *If on a Winter's Night a Traveler (Se una notte d'inverno un viaggiatore),* in which two of his protagonists, Reader and Other Reader, read differently. The present chapter explores some of the reasons these works have commanded so much attention, with particular emphasis on the ways in which they challenge the reader with their shared insistence on networks of relations and their endorsement of relational reading.

The concern with relationality that Mallarmé, Duchamp, and

Calvino have inscribed in their works has important ramifications for the reading process. For in creating complex "open works" that ostensibly require the participation of a reader, these figures undermine epistemological models that rely on a separation between subject and object of knowledge, between reader and text. In valuing looking at relations between things rather than things-in-themselves, and in promoting this kind of reading of their own works, these artists provoke a reevaluation of conventional ways of seeing, thinking, and organizing knowledge by unsettling some of the habitual and/or codified methods of analysis that had previously governed the mind and the eye.

This emphasis on considering things-in-relation instead of things-in-themselves has perhaps nowhere been as cogently argued and promoted as in "Theatrum Philosophicum," Foucault's essay on the *event;* as such, Foucault's essay provides a valuable introduction to the philosophical concerns staged in the work of Mallarmé, Duchamp, and Calvino.[4] The *event,* as Foucault writes, "is always an effect produced entirely of bodies colliding, mingling, separating. . . ."[5] The event is neither a state of things nor a concept; it is "devoid of any grounding in an original, outside all forms of imitation, freed from constraints of similitude," in particular the model (177). Foucault's essay is a concisely articulated critique of the model as well as the philosophy of representation. He proposes a different kind of philosophical thought that would embrace divergence instead of remaining caught in the rigid system of oppositional or bipolar thinking inherited from Plato with its grounding in the original, the model, and resemblance. He proposes replacing the philosophy of representation with a philosophy of phantasms, where phantasms arise between "surfaces" and acquire meaning there, "freed from the dilemmas of truth and falsehood and of being and non-being" (170). Instead of conceiving of the phantasm as something already shaped, we should conceive of it "in its play of surfaces without the aid of models . . ." (171). Foucault argues the necessity of freeing thought from the model, or the concept (for which he substitutes the event), representation, oppositional thinking, and categories.[6] As will become clear, Mallarmé and Duchamp inscribe this kind of thought in their works with their emphasis on events and relations instead of concepts and representations. The praxis of both the poet and the artist grows out of similar philosophical conceptions of the universe as a place of energy exchanges (events, in Foucault's sense) rather

than a harmonious, relatively static place of synthesis (a conception that an idealist philosophy, or a philosophy of representation, would support).

In *A Throw of the Dice*, Mallarmé strategically manipulates syntax and arranges words and phrases typographically on the page so that what inevitably emerges in importance is a sense of the dynamic relationships among the parts that form the whole. Syntactical construction, differing typefaces, typographical arrangement, appositions, sustained metaphors, multiple resonances, analogies, and blank spaces all function to draw attention to the relationships between words and to maintain constant mobility, suggestive plurality, and suspense. Similarly, Duchamp's *Large Glass* contains a multiplicity of ambiguous parts designed to relate to and interact with each other in very mysterious ways. Duchamp's work, like Mallarmé's, favors complex networks in which the significance of any one part can be determined only in the context of its relationships. To remove a part from its context or to focus attention on any signifier instead of on the complete system is precisely to miss the point of these artists' works. Both artists propose a philosophical logic of relations in their works; as we shall see, both set in motion a process that necessitates relational reading.

Mallarmé and Things-in-Relation

Like poststructuralist thinkers, Mallarmé undermined in his own way the belief that language could be used as a tool for direct, nonproblematic communication, as well as the belief that words enjoyed a one-to-one fit with reality. Instead, Mallarmé envisioned writing as a process that, rather than representing the objects of the world, would instead elucidate the relations between objects or, analogically, between words: "[T]hings exist, we do not have to create them; we have only to seize the relationships between them; and it is the threads of these relationships that form verses and orchestras."[7] The writer's function, according to Mallarmé, was to express, through the use of words, the relationships between things instead of things themselves. As Judy Kravis has put it in her discussion of Mallarmé's "The Mystery in Letters": "Words express as the pieces in a kaleidoscope express, by a succession of mental mirrors that meet in a 'centre de suspens vibratoire' that they seem to have created."[8]

In the networks built by Mallarmé and Duchamp, blank spaces of white page and transparent glass are themselves integral parts of the total system, just as important as the words or paint inscribed on them. Of course, this perception is not new, and much has already been made of the white page in Mallarmé criticism. Jean-Pierre Richard, for instance, treats whiteness as a thematic category in his *L'Univers imaginaire de Mallarmé* and interprets it as a place of fullness and polyvalence. Jacques Derrida, on the other hand, says that Richard is wrong to thematize whiteness since this is precisely the place where no theme manifests itself.[9] However, instead of categorizing these blank spaces as "full" or not, it is possible to focus on their difference from the printed material and to analyze the relationships between words and spaces, thereby shifting the field of inquiry toward an analysis of relational systems.

As an example of such a relational reading, we can consider page 6 of *A Throw of the Dice* (see fig. 7).[10] One of the functions of the blank spaces in Mallarmé is to disrupt radically our habitual ways of reading. Since we tend to look for units of meaning in subject-verb-object sequences, our tendency has been to value nouns more highly than, for example, adjectives as carriers of meaning and as key words in sense-gathering. But a writer can disrupt that tendency and force us to change focus; he or she can emphasize adjectives instead of nouns, for instance, simply by manipulating typographical layout and using the white of the page strategically, as Mallarmé has done here. On this page he divides the fragment "dans quelque proche tourbillon d'hilarité et d'horreur" so that the first three words appear on the left side of the book's spine and the rest appear on the right side. The effect of the division and the resulting gap of white page between the adjective *proche* (near) and the noun *tourbillon* (whirlwind) is to draw attention to the adjective, which would have seemed less prominent had it been coupled visually with the noun. By separating adjective and noun with a blank space, Mallarmé forces us to consider *proche* as an important word in its own right rather than as "just" a modifier of its supposedly more important companion, the noun. In addition, *proche* draws attention thanks to its placement at the end of the line (on the left-hand page), as is the case in more traditional poetry.

The use of the white page in this way is one of the factors contributing to "overdetermination" in Mallarmé's poetry, the phenomenon whereby something is repeated in a variety of different ways (in this

Fig. 7. Stéphane Mallarmé, *A Throw of the Dice* (page 6). *Un Coup de dés* was originally published in 1897. (Photograph of the 1914 Gallimard edition.)

case, the theme of approximation). The strategic placement of the blank space after *proche* and the resulting focus on *proche* has the effect of emphasizing and repeating a theme that Mallarmé sustains through the whole poem: that an event (or "meaning," or "something") is (perhaps) *near* (promised, desired, about to take place), but never immediately graspable or knowable at the present time. The word *insinuation* (also on page 6) repeats yet again this preoccupation with approximation. Even the opening and closing words of this page, *COMME SI*, emphasize the theme of approximation as they function to withhold absolute certainty: nothing ever *is;* it is only *as if* (as is the case with the *if* in Calvino's title, *If on a Winter's Night a Traveler*). The use of the white page to emphasize the word *proche*, then, is one of the devices by which Mallarmé fulfills the promise made in the preface to *A Throw of the Dice:* "Everything happens, in abridgement, hypothetically; one avoids narrative" [Tout se passe, par raccourci, en hypothèse; on évite le récit].[11] For if one avoids narrative, or direct "telling," one proceeds "hypothetically" by suggestion, insinuation, and approximation.

Large gaps on the page in Mallarmé divide the poem into segments and challenge readers' sense-making desires by depriving them of the linearity they are used to and upon which they habitually rely. As numerous critics remind us, we become aware of our dependence on linearity when it is absent. Even though the reader can always jump over the gaps and reconstitute a continuity, the gaps nevertheless function to disrupt that desired continuity and to maintain polyvalence. In other words, the gaps help to combat and subvert the linearity of the sentence, or "the individual, enthusiastic trajectory of the sentence" [la direction personnelle enthousiaste de la phrase] that Mallarmé decried in *Crise de vers*. They provoke, instead, an awareness of the relations not only between words but also between what we habitually refer to as "full" and "empty" places. This is undoubtedly the reason why Malcolm Bowie has called *A Throw of the Dice* "a world of alternative logics." As he puts it, the poem's structures "suggest an alternative, synchronic mode of meaning which calls the very idea of a *developing* poem into question."[12] Calvino will disrupt the linearity of narrative in a similar way eighty-two years later when he subverts the idea of plot development in *If on a Winter's Night a Traveler*.

Like a painter, Mallarmé treats the white page as a surface to be inscribed; like a musician, he draws attention to duration when he leaves large gaps of empty space between units of the system.[13] Indeed, another effect of the gaps in Mallarmé, especially in the absence of any perceptible meaning, is to slow down our reading and make us even more aware of the duration of reading and the activities taking place within that time span. The empty spaces provide places for readers to halt, meditate on what they have just read, and create connections in their own minds. That emptiness, that absence of text (or "other") is precisely the trigger that engages and animates the reader's creativity. What I am suggesting is a dialectic between the reader's attention to the text and the reader's own musings, a dual activity whose component parts play equally important roles (this is precisely the dialectic that Calvino has thematized in *If on a Winter's Night a Traveler*). Barthes has maintained that a text capable of producing this kind of dialectic is a source of great pleasure: "[The text] produces, in me, the best pleasure if it manages to make itself heard indirectly; if, reading it, I am led to look up often, to listen to something else."[14] Much of the pleasure we feel in reading Mallarmé results from our own activity of creating connections in the duration of reading. One of Mallarmé's most often

quoted statements tells of the poet's relinquishing control, getting out of the way of words to allow them to reflect and refract of their own accord: "The pure Work implies the elocutionary disappearance of the poet, who yields the initiative to words, mobilized by the colliding of their disparate natures. . . ."[15] Words may be mobilized thanks to the "colliding of their disparate natures," but printed words cannot reflect each other without a reader to perceive those reflections. The time for perceiving and reflecting on the reflections between words is guaranteed by the poem's spatial configuration.

Duchamp and Verbal-Visual Relations

With his *Large Glass,* Duchamp has created a work of art just as "open" as Mallarmé's, just as full of enigmatic parts, suggestive detail, and gaps for the reader/spectator to consider (see fig. 8). Duchamp's art, like Mallarmé's, requires the reader to play an organizing role; Duchamp himself often said that the viewer completes the creative cycle of the work of art.[16] The title does not help much in the attempt to interpret: *The Bride Stripped Bare by Her Bachelors, Even.* In fact, the title may even complicate the situation since the word *even* seems enigmatic and neither the bride nor her bachelors is immediately discernible. What the title does, however, is promise some erotic subject matter, engage the reader's curiosity, and get the connection-making juices going.[17]

The erotically suggestive title inevitably acts as a stimulus to the reader's imagination, enticing us to read the artwork in very specific ways. Further clues for reading the *Large Glass* were provided by Duchamp himself, who left behind a green cardboard box of randomly ordered notes relating ambiguously to the work. That box of notes, now assembled and printed, is called the *Green Box.*[18] In the notes, Duchamp suggested that his artwork was not really a "picture on glass" or a "painting on glass," but a "delay in glass." As with most of the notes in the *Green Box,* this concept invites speculation. Although Duchamp did, indeed, paint his work on glass, it is not clear exactly what is delayed. The verbal clues provided in the title suggest that we are witnessing the ongoing process of the stripping and all that goes with it, a dynamic situation that has been "caught in the act," temporarily frozen in glass and *delayed* (delay, of course, promises comple-

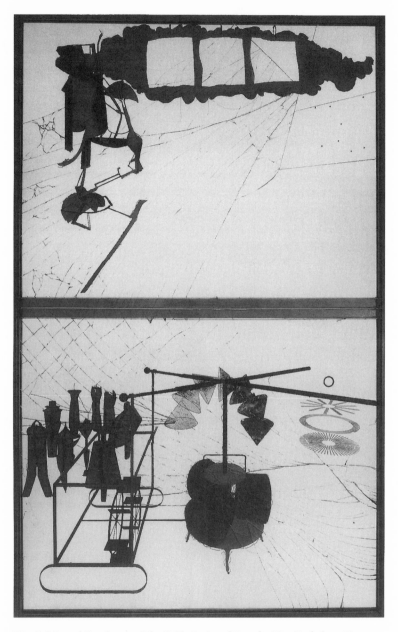

Fig. 8. Marcel Duchamp, *The Bride Stripped Bare by Her Bachelors, Even (Large Glass)*, 1915–23. Oil and lead wire on glass, 109¼″ × 69⅛″. Philadelphia Museum of Art: Bequest of Katherine S. Dreier. © 2000 Artists Rights Society (ARS), New York/ADAGP, Paris/Estate of Marcel Duchamp. (Photograph courtesy of the Philadelphia Museum of Art.)

tion at some later time).[19] The parallels with Mallarmé are evident here: one need only think of the ways in which he delays our desire for meaning with his tortured syntax, typographical arrangement, and other techniques, or the numerous thematic examples of delayed desire appearing in his poetry.

Yet there is another important way in which Duchamp's art, like Mallarmé's poetry, "delays." Like Mallarmé, Duchamp employs techniques that function to delay the spectator's response, and this very delay (and the subsequent heightening of the spectator's desire to comprehend, solve, figure out, read) produces pleasure in the sense in which Barthes has used the term.[20] In fact, the very act of publishing the *Green Box* acts as a supreme delay: rather than provide the solution to the enigma of the *Large Glass*, the notes complicate the matter significantly. Many of the problems of interpretation result not from a lack of information but from an overabundance. Because the notes obviously refer to the artwork, one is easily tempted to believe that the keys to the mystery of the work lie in the notes, if only we knew how to decipher them. We look for correspondences between words and images, we stretch our imaginations to understand the strange laws of physics that Duchamp outlines in the *Green Box* and try to apply them to the artwork, and in this whole process of searching, stretching, and interpreting, what is "delayed" is precisely our own response. The notes slow us down, make us look more carefully, entice us into believing that they hold the solution to the puzzle. We read in the notes, for instance, that a reservoir of "love gasoline" sits at the bride's base and that this love gasoline is distributed to the motor with "quite feeble cylinders." When we look at the artwork, however, we have no way of knowing whether the reservoir and the motor are represented or not. We see something that may correspond, but we have no way of knowing with any certainty if the words written correspond to the images we see. In fact, some of the notes of the *Green Box* provide detailed explanations of elements that Duchamp never painted onto the glass, such as the waterfall that is supposed to turn the watermill. (Ironically, the spectator who stands in front of the *Large Glass* at the Philadelphia Museum of Art can insert a waterfall into the work: the window located just behind the *Large Glass* permits a view of the fountain in the museum courtyard, and by lining up the view properly, the real fountain can be made to take the place of the absent waterfall.)

Throughout the whole process of searching the *Green Box* for clues,

the ultimate mystery that readers have seemed to want to solve is "how does the machine function?" But in this case, where the combination of verbal and visual elements introduces more complex problems, it becomes equally interesting and fruitful to explore the question of how *we* function in deciphering how *it* functions.[21] Although many readers have been operating under unquestioned assumptions such as a belief in the ontological status of a solution or a belief in the power of words (in this case, the notes of the *Green Box*) to reveal some truth beyond themselves, such assumptions are already frustrated by the works in question. For instance, Duchamp (following Mallarmé) playfully suggests that this one-to-one fit between language and reality is illusory when he includes a great deal of nonsensical language in the notes, such as "oscillating density" and "subsidized symmetry." Too often, however, in their desire to figure out what is represented in the artwork, readers have tended to ignore such verbal material from the notes that does not seem to make sense and have focused instead on those words that appear to have representational value. Ironically, though, one of the notes in the *Green Box* calls the bride—*bride* being a word that would appear to have representational value—"an example without representational value." Here, language does not "refer" to reality; it is its own fabric of reality, as Mallarmé's *Throw of the Dice* makes abundantly clear.

A preoccupation with interpretation will, of course, limit one's perception of Mallarmé and Duchamp to certain aspects of their work, but once desires for solutions are abandoned, other elements concerning their work and the reading process come into sharper focus, allowing for an appreciation of their accomplishments in radically different ways. Barthes has gone so far as to call Mallarmé the murderer of Literature, referring to the violence he performs on traditional syntax, form, and especially language.[22] By depriving readers of the habitual supports they rely on for interpretation, by scrambling language and dispersing meaning, Mallarmé leaves his readers with constellations of signifiers arranged enigmatically on the page whose meaning becomes impossible to decipher. If Mallarmé can be called the murderer of Literature, then Duchamp is the murderer of Art. The component parts of Duchamp's *Large Glass* are just as enigmatic as Mallarmé's signifiers in a poem like *A Throw of the Dice*. In both works, readers travel from one signifier to another, searching for the one that might clarify all the others, yet always aware that something eludes their grasp. Readers accu-

mulate information, suspending judgment until meaning can be located, but all the while meaning seems "elsewhere" and the desire for completion remains unsatisfied.

The Artwork as Field of Relations and Exchanges

Jean-François Lyotard is one critic who has commented at length on Duchamp's skill in frustrating totalizing or unifying understandings of his work. In *Les Transformateurs Duchamp*, he focuses on the relations between elements in the *Large Glass* rather than on the elements themselves. For example, he points out that in both the lower and upper halves, the spatial figuration works against the narrative, although it does so in opposite ways in each of the sections.[23] The bottom half, according to Lyotard, contains several interlocking intricate mini-narratives, or mechanical apparatuses: the transformation of the gas, the working of the chocolate grinder, and the glider. Although the overall narrative in this lower half, the bachelors' domain, is thus quite complex, the spatial figuration is nevertheless homogeneous and regulated by the laws of classical perspective. Spatially, then, the lower half is characterized by optical simplicity and narrative complexity. The opposite is true for the upper half, which is characterized by narrative simplicity and optical complexity. Here in the domain of the bride, Lyotard describes space as heterogeneous because the forms on the left are organized according to a flat, fragmented cubist style, while the forms on the right are studies in depth. Yet despite the complex heterogeneous space of the upper section, the narrative remains simple.

In concentrating on the ways in which the spatial figuration of each half of the *Large Glass* relates to and works against its respective narrative, Lyotard has substantially complicated the reading of this work of art. The *Large Glass*, he maintains, disorganizes all attempts at totalizing or unifying interpretation: "The *mèchanè* aims at disorganizing and, if possible, baffling any totalizing and unifying machine, whether in areas of technics (in the contemporary sense of the word), language, or politics" (50). Because the *Large Glass* is conceived of as a "technological functioning," as he says, rather than as a static representation, its dominant mode is one of transformation, not unification: "There are only transformations, redistributions of energy. The world is a multiplicity of apparatuses that transform units of energy into one another" (39–40).

Lyotard astutely foregrounds not only relations but also transformations of energy in this work. Interestingly enough, Octavio Paz conceives of a very similar field of relations and energies informing *A Throw of the Dice* when he describes Mallarméan space as "a field of forces, a knot of energies and relations—something very different from the more or less stable expanse or area of the former cosmologies and philosophies."[24] The artistic focus on energy and dynamism that is common to both works is grounded, as I have already suggested, in a philosophical conception of the universe as a place of energy exchanges (Foucault's notion of the event) rather than as a harmonious, relatively static place of synthesis.

There are even two different technologies opposing each other in the *Large Glass,* as Lyotard points out: the lower portion is conceived to function in a more traditional mechanical way, while the upper portion functions in a modern, electrical manner. But rather than simply concentrating on the representation of these technologies and being content to identify them, Lyotard insists on their relation, as he does with all the other elements he studies (e.g., the relation between the narrative and spatial aspects of the *Large Glass*). In other words, in order to understand the *Large Glass* as a place of transformations constantly working against a static or unified synthesis, it is necessary to read and think relationally.[25]

In pointing out Duchamp's move away from conventional representation, Lyotard makes an interesting distinction between the *Large Glass* and Duchamp's earlier work of 1911–12, such as *Nude Descending a Staircase* (see fig. 17). In the earlier work, which is essentially a static representation of movement, the viewer can conceptually synthesize the various forms into one overall continuous movement. In the *Large Glass,* however, movement is no longer represented in the same way. Now conceptual synthesis is no longer possible. Like Mallarmé, Duchamp transforms intelligibility by forcing us to maintain a mobility and multiplicity of thought while considering these works; in this sense, thought becomes a relational rather than a synthetic operation.

In certain respects, one can say that where Mallarmé's writing approaches painting, Duchamp's painting approaches writing. By disrupting both traditional typographical linearity and syntactical continuity, Mallarmé creates a complex spatial matrix and subverts the temporal directional flow that we normally associate with the act of reading. In addition to reading the forward thrust of the syntactical

logic, which is sometimes made legible thanks to the typeface (as in, for example, the statement that appears intermittently on pages 1, 2, 5, 9: "Un Coup de dés / Jamais / n'abolira / le hasard"), we are forced to wander into tangential qualifications, contradictions, elaborations, analogies, related sound patterns, and so forth. An example of this appears on page 6 (see fig. 7), where the subject-verb-object sequence *(Une insinuation voltige et berce l'indice)* appears interspersed with other material that interrupts and yet relates to that syntactical clause in various ways. And at the same time that the clause is interrupted by subclauses, it functions as a subset of something larger. In short, Mallarmé has created a complex system in which various parts group together to form subsystems, and any single part participates in several systems simultaneously.

The same is true for Duchamp, who develops a temporality within the space of painting by incorporating a directionality into his *Large Glass.* The increasingly saturated colors of the sieves from left to right, for example, guide our eyes in that direction. This directionality is reinforced by the conelike shapes of the sieves. But like Mallarmé, Duchamp creates a linear continuity only to interrupt it. Although we can read the work directionally, we must, at the same time, halt our reading to incorporate other elements that seem tangential to the forward thrust but that are, nevertheless, integral parts of the machine's functioning.[26] For instance, if the gas's travel through the machine (and its simultaneous transformation into first a solid and then a liquid substance) can be thought of as the primary narrative thrust, we must halt the narrative when the solidified gas gets cut by the scissors so that we can consider all the machinery that permits the scissors to move.

Even though Mallarmé and Duchamp subvert linearity, their works still contain that push forward, that linear progression we associate with the development of the story or plot in narrative. Yet at the same time, Mallarmé was very careful to flesh out his narrative armature by including a variety of qualifiers and modifiers, all of which complicate the forward movement, just as Duchamp consciously created detailed machinery that would allow each element in the whole to function. It seems, then, that Duchamp created in his own way with his own figures and materials the same schema that Mallarmé suggests in *A Throw of the Dice.* In both works, the component parts participate in their own complex dramas while they simultaneously relate to the drama of the whole.

Just as we cannot pin down meaning in *A Throw of the Dice,* we remain ignorant of what happens in the *Large Glass.* Has anything at all taken place in the poem, or is it, as Bowie has suggested, a "work which means less as we read it more?" (115). Bowie's assessment that we proceed from guess to ineffectual guess in reading Mallarmé's poem is undoubtedly the most accurate that can be made:

> There has been a disaster and mighty human energies have failed to forestall it. Or rather, a disaster is occurring now, and the human powers which until recently had seemed able and ready to prevent it are proving to be worthless. Or rather, a disaster might occur at any moment and will be prevented, if at all, by a small but decisively human intervention in the course of events . . . by a prudent calculation perhaps, or a blind gamble. Or at least some crisis is in question and the human capacity to respond to crisis is somehow also involved. Or at the very least something is wrong somewhere. Or, keeping our prior assumptions to that barest minimum without which thought cannot proceed, something is somewhere the case. Or is it. . . ? (115)

Similarly, we might ask, has anything taken place in Duchamp's artwork, or is it perpetually about to take place? In both cases we encounter a difficult, hermetic art; any effort to make sense and interpret by reducing tensions and contradictions necessarily entails doing violence to the artwork. In this respect, the spectator seeking an interpretation ironically resembles the bachelors attempting to strip bare the complexity of the bride (see fig. 9).[27] Laurence D. Steefel paved the way for this reading by stressing that the *Large Glass* as a whole was the bride, not the female image alone.[28] By abandoning interpretation and focusing instead on the types of responses made by readers when they encounter these works of art, we can undoubtedly discover more provocative artworks than we might have encountered with more conventional approaches that seek to master, or "strip," the artwork as *other.*[29] Neither Duchamp nor Mallarmé creates works that allow readers to remain the independent observers they may believe (or desire) themselves to be. On the contrary, readers quickly become aware that this art, this mysterious *other,* demands their active participation as a condition of its very existence.

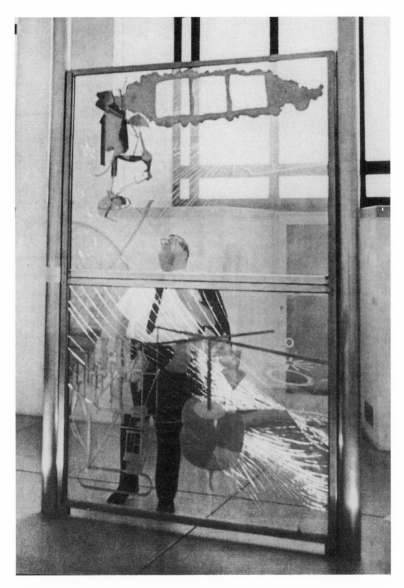

Fig. 9. Spectator and Marcel Duchamp's *Large Glass*. (Photograph courtesy of the Philadelphia Museum of Art.)

Calvino, Readers, and Relational Reading

What was developed by Mallarmé and Duchamp became, in the twenti-eth century and certainly in postmodern times, a dominant mode. Much contemporary art and literature has tended to focus on the medium as productive rather than reproductive; instead of reproducing or repre-senting reality, art tends to be structured in order to produce certain effects. Meanings are not recovered, they are produced. Much contem-porary art and literature is very consciously geared toward a manipula-tion of the reader's expectations and plays with our desire for compre-hension. Italo Calvino is one writer who has successfully thematized these issues in his novel *If on a Winter's Night a Traveler.*[30]

Calvino from the beginning consciously includes the reader's reac-tions in the very fabric of his text. His novel is made of multiple plot segments, and yet a thread of continuity runs through the whole. The central character, called "you," is a reader about to begin Calvino's novel. After a while, though, "you" realizes that because of an error in printing, Calvino's novel does not advance beyond the initial thirty-two–page signature. When "you" goes to the bookstore to complain, he is told that the book he is reading is not the one he thinks it is because the signatures of two different books were mixed up. He learns that he was not reading the book by Calvino, as he thought, but a book by a Polish author. He takes that other book instead, only to discover that it is an altogether different text. But he does not really mind, since this new book is better than the first anyway. As "you" reads this new book, we, the readers, read it along with him for the next fifteen pages or so. But again the book ends abruptly, again he seeks the continuation, again he manages to find what he thinks he seeks, and again he realizes that this new book is not a continuation, but yet another different book. Once again "you" proceeds to read with joy, and we read along with him for the next fifteen pages or so, and so on.

I have just described the basic structure of Calvino's novel: a recur-ring alternation between, on the one hand, a focus on the character "you" and, on the other, a focus on the various stories that "you" reads. The plot (or one of the plots) thickens, however, when the reader in the book ("you") meets a woman called the "Other Reader." Together the two readers discuss their different readings until, as the publisher's blurb on the back cover of the novel advertises, the "two readers end

up in a great double bed to engage in parallel readings. They are the true heroes of the novel: for what would writing be without readers?" If the two readers are the heroes of the novel, as the back cover suggests, then we would expect their developing love affair to be the dominant, central story. The remaining chapters, that is, the chapters containing the material those readers read, would, in this case, be somehow of secondary interest, or would function as the mere pretext for their discussions, that which preceded their exchanges and allowed their discourse to take place.

But it makes just as much sense to turn things around and, instead of calling the story of the two central protagonists the dominant text, consider their story as only the "pretext," the excuse for gathering a bunch of exciting fragmented narratives together in the same physical book— in short, the excuse for "writing" in the Derridean sense. Viewed from this perspective, the multiple fragmented plots would be primary and the plot about the two readers coming together would be secondary. The publisher's blurb, in this case, would then be read as a marketing attempt to situate this novel within a traditional genre to make it more salable. Indeed, describing Calvino's novel by focusing on the two central protagonists does it a great injustice, especially since the intervening chapters contain a multiplicity of engaging, provocative, and superbly written story fragments. But even the word "intervening" is decidedly inappropriate in this context with its implication that these chapters have interrupted and are secondary or subservient to the main thrust, which is perceived to exist elsewhere. Although *difference* is easily distinguishable (in the guise of two different orders of narrative— the story of the readers as opposed to the stories the readers read), it is impossible to determine which of the orders is pretext and which is text, since text and pretext coexist, share equal status, and function in relation to each other. Derrida's writings about the logic of the supplement are obviously very much to the point in Calvino's novel. Can either order be said to supplement the other if neither can stand without the other? Calvino questions such oppositions as primary/secondary, original/supplement, and text/pretext both by thematizing the problems they cause and by incorporating these problems into the very structure of his novel.

Another related binary opposition ingeniously deconstructed by Calvino is the relationship between reading and writing. In his eighth

chapter, one of the most engaging of the book, he starts from the traditional assumption that considers writing and reading as two distinct independent activities and then proceeds to demonstrate various ways in which they are inextricably interrelated. This eighth chapter is supposedly extracted from the diary of a writer named Silas Flannery who, every day before writing, gazes through his spyglass to watch a female reader in a deck chair totally engaged in her reading. His desire, of course, is that someone will read his book as eagerly, completely, pleasurably, and voraciously as she is reading the book she holds in her hands. As he becomes the daily voyeur of her pleasure, he desires to be both the object of her pleasure and that which provides her with pleasure (his desire originates in seeing an "other"—a book—in the space he imagines himself occupying). He wants to write for her: "At times I am gripped by an absurd desire: that the sentence I am about to write be the one the woman is reading at the same moment" (170). A few pages later the writer reaffirms his dependence on the reader: "Looking at the woman in the deck chair, I felt the need to write 'from life,' that is, to write not her but her reading, to write anything at all, but thinking that it must pass through her reading" (172). The other's reading becomes, for the writer, an all-important activity in which he might be able to see himself mirrored, to learn something about himself that he does not already know, to be able to see himself (his hypothetical true self) as others see him. Strangely enough, the writer feels that he has not yet written his true book, the one that she is *perhaps* reading, the one that he, because of all the variables that make him who he is, will never succeed in writing:

> How well I would write if I were not here! . . . Style, taste, individual philosophy, subjectivity, cultural background, real experience, psychology, talent, tricks of the trade: all the elements that make what I write recognizable as mine seem to me a cage that restricts my possibilities. (171)

In essence, the writer is here lamenting the fact that he is already a reader: he has already "read" (that is, he has been influenced by) the culture and history in which he lives, so much so that he feels that nothing he writes is original, that everything has been acquired. If the writer is already a reader (already a locus of intertextuality, as Barthes would

say), and if the writer writes for an (imagined) reader (and in imagining the reader, he is "writing" her), then it can no longer be stated in a simple, nonproblematic way that writing precedes reading. Writing and reading, like text and pretext, are inextricably related; their interdependence serves as the fabric from which and upon which Calvino weaves his dramas.

But what about the reader of Calvino's novel, not the reader in the text, but the reader of the text? Does Calvino really expect our thoughts and reactions to be identical to those of the reader in the text? And who, precisely, is Calvino's implied reader? Is there one or many? Must this reader be male to identify with "you" (the reader in the text)? Will all readers read in the same ways? Clearly no two readers are alike, but Calvino has written his book so that an implied reader can, on occasion (leaving aside, for the moment, the issue of gender), identify with the experiences of "you." Toward the end of the novel, for instance, "you" is captured and taken prisoner (or liberated—he is not sure which) and given the book whose continuation he was seeking when the narrator asks:

> Reader, you have found again the book you were seeking; now you can pick up the broken thread; the smile returns to your lips. But do you imagine it can go on in this way, this story? No, not that of the novel! Yours! How long are you going to let yourself be dragged passively by the plot? (217–18)

Statements such as this ring strangely true to Calvino's readers, who find that they, too, have been and continue to be "dragged passively" by the plot, and the tendency is to stop reading and reflect on what it means to be dragged passively or to participate actively. Statements like this trigger the dialectic Barthes has spoken about, between an awareness on the part of readers of the material they are reading and a simultaneous awareness of their own musings. The pronoun "you," of course, serves to facilitate any identification that might take place; indeed, it is meant to encourage identification. The fact that the novel is written in the present tense also functions to facilitate identification; the story unravels in the present that is also the present of the reading. No event involving "you" occurs before the reader's reading. In some cases, it even seems as though Calvino were on the scene of our read-

ing, watching us and commenting on our (unconscious) reactions. Toward the beginning of the book, for instance, the narrator warns the reader about reading:

> Watch out: it is surely a method of involving you gradually, capturing you in the story before you realize it—a trap. Or perhaps the author still has not made up his mind, just as you, reader, for that matter, are not sure what you would like most to read. . . . (12)

The "you" of this sentence, as we learn, refers to the character "you" in the book, not to us, but the effect produced is one of conspicuous ambiguity, an effect that Calvino is careful to repeat regularly throughout his entire novel: "You fight with the dreams as with formless and meaningless life, seeking a pattern, a route that must surely be there, as when you begin to read a book and you don't yet know in which direction it will carry you" (27). Again, this statement is spoken to the reader in the text, although it obviously refers to us, the readers of the text, as well. Different theorists have given various names to the varieties of readers that may exist in relation to a given text (implied reader, superreader, etc.); without going into descriptions of the categories here, it can be said that Calvino plays with these categories and attempts to blur their boundaries by his narrative strategies.

In the eleventh chapter, "you" and seven other readers in a library unveil myths of reading as they discuss the various ways they like to read.[31] One of them finds pleasure in moving away from the book by mentally pursuing tangents suggested by images, feelings, or questions raised in books. Another, on the contrary, does not like to be distracted because he believes that clues to the "truth" of a book are contained in "minimal segments, juxtapositions of words, metaphors, syntactic nexuses, logical passages, lexical peculiarities that prove to possess an extremely concentrated density of meaning" (254). The third reader admits that every rereading of a book seems like reading an entirely new book because awareness and expectations have changed: "The conclusion I have reached is that reading is an operation without object; or that its true object is itself. The book is an accessory aid, or even a pretext" (255). The fourth reader agrees with the subjectivity of reading but proposes that every new book is incorporated into the single book that is the sum of his readings, so that he does nothing but continue reading a single book. The fifth agrees that all readings are part of a sin-

gle book, but that this single book is only a faint memory from child-hood, and that all readings aim at seeking that lost, single book. The sixth reader states that the title or the first few sentences are enough to produce desire and trigger imagination, while the seventh says that it is not the beginning but the end that counts.

Against these seven readers and their stories of reading (in which one can identify bits of phenomenological, structuralist, semiotic, Marxist, and Freudian theories of reading), the words of "you" seem strangely simplistic: "I like to read only what is written, and to connect details with the whole, and to consider certain readings as definitive; and I like to keep one book distinct from the other, each for what it has that is different and new; and I especially like books to be read from beginning to end" (256–57). This statement is full of problematic articu-lations that break down upon closer scrutiny. To want to "read only what is written" seems an innocent enough enterprise, but how does one determine what is "really" in the text as opposed to what one brings to it? Do texts make us read in certain ways because of objective structures, or do we make texts conform to our expectations? Reader-response theorists have reminded us of the dialectics at work and the importance of the reader's experience in any act of interpretation, pointing out that what the text does to us depends on what we do to it. "You"'s statement, for instance, that he likes to connect details to the whole seems like a sound enterprise—indeed, one of the procedures that guides hermeneutical reading. But it is simultaneously true that given a wealth of details, the ones that readers will notice in the first place and take to be pertinent are already influenced by their own expe-riences, cultural contexts, and habits of reading.

Calvino's book explicitly plays with and undermines several expec-tations and assumptions readers commonly make about literature. Probably the most common expectation is that of unity: that the work of art will form a coherent whole. But Calvino's text gains coherency only because the readers exist (literally, Reader and Other Reader) to read the ten different stories. In this respect, then, instead of saying that a work of art is a unified whole in and of itself, we need to shift per-spective and say that readers give coherence to texts by and during the act of reading.

In another respect, however, Calvino's novel is quite traditional in its desire to situate everything around a stable, reliable, unproblematic center: the male character "you" whose desires, frustrations, and per-

spectives we are meant to accept as our own. "You" guides our approach to the strange world of Calvino's text while gradually confirming himself as our trusted center of orientation. The fact that the Other Reader is characterized by the adjective *other* only serves to reinforce the traditional nature of the narrative: *other* is always foreign, distant, not-I, and yet, as Lacan has shown, the necessary ingredient against which one differentiates, distinguishes, and affirms the self even more strongly. The self to be affirmed, in this case, is the male character called "you." As Teresa de Lauretis notes in her feminist reading of this text, the other is female, and her representation as "passive capacity, receptivity, readiness to receive . . . is a notorious cliché of Western literary writing."[32] In this sense too, then, Calvino's novel is quite traditional.

A second commonly held belief that Calvino plays with while simultaneously undermining it is a belief in teleology: the idea that a story has a beginning, a middle, and an end, that it goes somewhere. Viewed from one perspective, of course, Calvino's novel is a classic male love story: boy meets girl, boy gets girl, boy ends up with girl in bed. But viewed from another perspective, this is a detective novel full of clues that do not necessarily lead anywhere, traces that do not necessarily mean anything, characters that appear and disappear without discernible significance, and plots that accumulate and remain unresolved. Indeed, this is a book that could go on indefinitely, arbitrarily. In an article entitled "Calvino's Combinatorics," Warren F. Motte draws attention to Calvino's interest in patterns of combination and points to Calvino's growing association with the group Oulipo (Ouvroir de Littérature Potentielle, or Workshop for Potential Literature), whose members experiment with formal constraints.[33] He also draws attention to the fact that the book Calvino published with Oulipo, *Comment j'ai écrit un de mes livres* (Paris: Bibliothèque Oulipienne, 1983) is essentially a gloss on *If on a Winter's Night a Traveler* and was published to call attention to the novel's experimental formal structures. Instead of elucidating its teleological development, Motte emphasizes the way in which the novel's narrative structures are patterned according to highly codified systems of formal constraint.

Even the opening and closing words of Calvino's novel set up a teleological structure that Calvino's textual practice undermines. The first words of Calvino's book caution, "You are about to begin reading Italo Calvino's new novel, *If On a Winter's Night a Traveler*," and the last

words are the character "you" saying, "I've almost finished *If On a Winter's Night a Traveler* by Italo Calvino"—certainly the most literal description of the reality that we as readers are experiencing. While forming a teleological, coherent whole from one point of view, Calvino's multiple plots, repeatedly suspended, paradoxically serve to undermine any notion of teleology and function instead as a reminder of the arbitrary nature of all beginnings and endings. Everything in this novel starts and stops *in medias res;* beginnings and endings are nothing but constructs of the human mind and evidence of our insatiable need to order phenomena for purposes of comprehension.

Probably the most explicit example of the undermining of teleology occurs when Calvino probes the similarities and differences between lovemaking and reading in his seventh chapter. Calvino's male character has discovered that his desire to find out more about the Other Reader is strangely equivalent to his desire to find the continuation of the book he is reading. Reading people and reading texts are taken to be very similar enterprises:

> the clouding of your eyes, your laughing, the words you speak, your way of gathering and spreading your hair, your initiatives and your reticences . . . all codes, all the poor alphabets by which one human being believes at certain moments he is reading another human being. (155)

Once Calvino sets up the parallel, he moves in closer to reveal the ways in which reading texts and reading bodies (lovemaking) actually undermine teleology:

> Lovers' reading of each other's bodies (of that concentrate of mind and body which lovers use to go to bed together) differs from the reading of written pages in that it is not linear. It starts at any point, skips, repeats itself, goes backward, insists, ramifies in simultaneous and divergent messages, converges again, has moments of irritation, turns the page, finds its place, gets lost. A direction can be recognized in it, a route to an end, since it tends toward a climax, and with this end in view it arranges rhythmic phrases, metrical scansions, recurrence of motives. But is the climax really the end? Or is the race toward that end opposed by another drive which works in the opposite direction, swimming against the moments, recovering time?

If one wanted to depict the whole thing graphically, every episode, with its climax, would require a three-dimensional model, perhaps four-dimensional, or, rather, no model: every experience is unrepeatable. What makes lovemaking and reading resemble each other most is that within both of them times and spaces open, different from measurable time and space. (156)

Calvino's description, in fact, sets forth the process he has been trying to create in his novel, a process of reading that, although necessarily accumulating and developing in linear time because of its form (successive pages with linear writing), nevertheless undermines the very idea of development in the traditional sense.

What is particularly interesting here is Calvino's thought about depicting this nonteleological process graphically in a multidimensional model, or, as he says, with no model at all. Calvino's call for a graphical depiction via a multidimensional model or no model at all is an attempt to undermine the very idea of model and relates to Foucault's critique of both the model and the philosophy of representation, which I discussed at the beginning of this chapter. Instead of reducing things to forms, concepts, or models, Calvino, like Foucault, seeks to open up space and time by emphasizing the relations between things, rather than things themselves. Like Foucault, Calvino conceives of the universe as a place of *events,* or exchanges, rather than the static place of synthesis that an idealist philosophy, or a philosophy of representation, would support.

Indeed, what might the multidimensional, nonteleological process described by Calvino look like graphically? Is it not possible to see Mallarmé's *Throw of the Dice* and Duchamp's *Large Glass* as two plausible depictions of what Calvino is hinting at here: an unrepeatable, nonteleological, dynamic process? Mallarmé's poem certainly hints at some nonrecoverable or potential dynamic event without providing a clear, linear representation of anything in particular. The *Large Glass,* too, spatializes and thematizes some potential or nonrecoverable process while opening time and space by its very form. It need hardly be pointed out that glass both reflects what is in front of it and permits a view of whatever is behind it, so that the work of art expands to include at least three spaces at the same time: the plane of the glass, the space behind the glass, and the space in front of it. In addition, none of these spaces remains stable for very long, since any movement on the

viewer's part will alter what is seen, as will any movement occurring behind the glass. Calvino's novel, like Mallarmé's poem and Duchamp's delay in glass, works to open space in various ways; all seek to engage the reader in a dialectical process that, by its very nature, expands the time and space of our perception.

Calvino's entire book demonstrates narrative seduction at its best while thematizing the power of storytelling, the pleasures of reading, and the dynamic relationship between readers and texts. As Barthes has demonstrated in *The Pleasure of the Text,* it is precisely narrative seduction—recurring delay and promise of completion—that functions as a source of pleasure. Although continually promised, completion is endlessly deferred while deferral functions to sustain desire. Calvino's text is so thoroughly and so transparently "disseminated" that the pleasures gained from reading far outweigh any sense of frustration. Although Reader and Other Reader become frustrated when they cannot discover what happens in the various unfinished stories (that is, their desire is delayed, as in Mallarmé's *Throw of the Dice* and Duchamp's *Large Glass*), they (and we) quickly forget the frustration as soon as they (and we) become immersed in another story.

With Calvino's novel, as with Mallarmé's poem and Duchamp's painting, the reader is caught in a web of mystery, a labyrinth of uncertainties and possibilities in which it is more exciting to be lost than it is to escape. The fragmented, interrupted, "delayed" stories in Calvino's novel accumulate experiences of disorientation and mystification in plots involving false translations, confused editions, banned books, pseudonyms, subversive and countersubversive politics, and the overthrow of various myths of authority. In all three cases, the artist relies on our fascination with mysteries as the ingredient that allows him to speak enigmatically. All three artists deliberately create complex networks of relations and then put the reader somewhere on a continuum between tantalizing mystery and insoluble enigma.

Reading and the Restructuring of Reality: Apollinaire and Picasso

In 1907, when Pablo Picasso first showed his revolutionary painting called *Les Demoiselles d'Avignon* to Guillaume Apollinaire and a few others, Picasso and Apollinaire had been close friends for about three years.[1] Two dynamic and colorful personalities who met nearly every day and spent a great deal of time in each other's company, Picasso and Apollinaire certainly exchanged ideas about the subjects in the air during the first decade of the twentieth century. One a painter and the other a poet, both were very conscious of the spirit of freedom and innovation of the new century. Living in a time of experimentation, rapid change, and reevaluation, both were consciously engaged in quests for new directions and preoccupied by questions of perception and expression.

As has been widely documented, the first decade of the twentieth century was marked by extraordinary energy, creativity, and rapid change in a wide range of intellectual and cultural activities. The artistic innovations of Apollinaire and Picasso during the highly experimental years of 1907–8 must therefore be read in the context of the profound shifts in consciousness brought about by innovations in the sciences and technology during the late 1890s and the early 1900s.[2] Radical changes taking place in the sciences, particularly in physics, greatly affected the way people thought about the physical universe.[3] Previously thought to be solid and stable, the old positivistic systems, models, and truths on which knowledge had been based had crumbled,

and the remaining fragmented concepts of knowledge were now being reorganized, restructured, and rerelated. The whole process of restructuring fragmented bits of reality finds a parallel in the work of poets and artists beginning in the first decade, particularly the work of Apollinaire and Picasso.

In addition to the intellectual and cultural climate at the turn of the century, the political climate and especially the influence of anarchism contributed significantly to the radical experimentation and innovation taking place in the arts. Anarchism was particularly strong in Spain, and Picasso had moved in anarchist circles during his time in Barcelona from 1895 to 1904.[4] When he moved to Paris in 1904, he continued his ties with the political Spanish community and quickly made connections with the Parisian bohemian group who called for nothing less than a complete revolution in art and the overthrow of bourgeois values, traditions, and forms. Many of the utopian ideas that permeate Apollinaire's writings and art criticism are borrowed from political rhetoric and social theory, including his recurring emphasis on individualism and freedom, as well as his ideas about the social role of poets and artists in expressing the new spirit of the age through their art.

It is clear, from a cultural perspective, that the preoccupations of painters, poets, scientists, and thinkers converged at the turn of the century. As scientists and thinkers questioned the old rationalist models and reformulated ideas about the nature of reality, painters and poets were moving in the same direction, away from representational art and the depiction of objective reality. Increasingly aware of the ways in which what had been called objective reality depended on the perceiver's conceptual knowledge and capacity to "see," painters and poets were choosing instead to focus their attention on the viewer, perception, and conceptual reality.

Picasso, of course, had the example of Cézanne, whose paintings were first shown at the Salon d'Automne in Paris in 1904.[5] Liberated from single-point perspective and the desire to represent objects as they existed visually in reality, Cézanne had already begun to work on expressing reality in a revolutionary way. By working with volumes and the two-dimensionality of the picture plane, Cézanne combined form and color with a purely conceptual and intellectual view of the universe and opened art to new areas of exploration. Apollinaire had the example of Mallarmé, the poet who revolutionized poetry by

declaring that the poet had to "get out of the way of words" and allow the universe of words, with its multiple resonances and suggestive ambiguities, to dominate. In both cases, art and poetry had turned an important corner: instead of a painting or a poem being used as a tool to represent or duplicate some preexisting reality, paintings and poems were now to become realities in their own right.

It is precisely this experimental period of 1907 (before Picasso's "analytical" portraits of 1910, before the near-abstract paintings of musical instruments of 1911, and before the invention of *papier collé* and collage of 1912) that deserves special consideration because of shifting aesthetics in both poetry and painting. During this experimental period, Picasso was beginning to transgress accepted Western aesthetic ideals of harmony and beauty; Apollinaire undertook a similar sort of experimentation in his poetry of 1907–8.[6] Interestingly enough, most critics who discuss Apollinaire's poetry of this period have chosen to analyze "Le Brasier" instead of "Les Fiançailles," perhaps because it is less problematic; the few critical discussions of "Les Fiançailles" that do exist leave too many questions unresolved. As we shall see, however, reading "Les Fiançailles" through the lens of Picasso's *Les Demoiselles d'Avignon* allows for an understanding of some of the more difficult aspects of the poem that have not yet been adequately discussed. "Seeing" the poem through the painting opens the poem in new ways and allows us to appreciate just how similar Apollinaire's preoccupations were to Picasso's radical experimentation of 1907. Significantly, Apollinaire dedicated this poem to Picasso when it appeared in *Alcools*.[7]

"Les Fiançailles" and *Les Demoiselles d'Avignon*

Apollinaire was one of the first to see Picasso's strange painting, and he certainly experienced the frustration of not knowing how to read it (Gombrich's point that we can only see what we've been taught to see is particularly relevant here). Gazing at *Les Demoiselles d'Avignon* produces a sense of discomfort (see fig. 10). It is definitely not a harmonious picture meant to please the eye, but a violent collusion of sharp edges, distorted planes, and heavy angular volumes. Five female figures and some fruit form the subject of the painting in the traditional sense, but what emerges in importance is the multitude of unharmonious tensions held in suspension.[8]

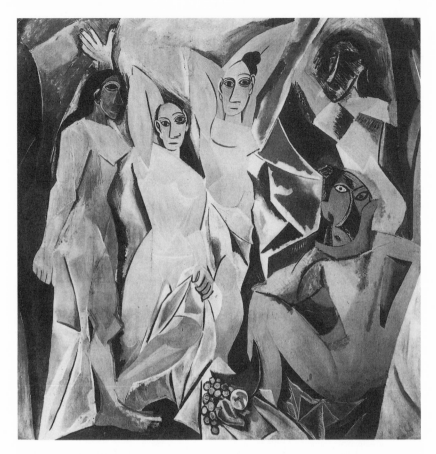

Fig. 10. Pablo Picasso, *Les Demoiselles d'Avignon*. Paris (June–July 1907). Oil on canvas, 8' × 7' 8". Museum of Modern Art, New York. Acquired through the Lillie P. Bliss Bequest. © 2000 Estate of Pablo Picasso/ Artists Rights Society (ARS), New York. (Photograph ©1999 Museum of Modern Art, New York.)

These tensions are by no means limited to the surface of the picture plane; they also occur between the spectator and the work of art. Probably the most disquieting features of the painting are those huge, bulging eyes that stare impassively at the spectator. The defiant, blank stares of the two figures in the middle keep us "out," although by lifting a skirt and by raising their elbows high over their heads to expose their breasts, the women simultaneously assume a stance that is tradi-

tionally interpreted as beckoning a sexual partner "in." We look at the painting; the eyes look back at us and make us conscious of our looking. We feel discomfort because we have been caught in our own voyeurism, perplexity, fascination, and anxiety. This is the view of Robert Hughes, who identifies the subject of this painting as the sexual anxiety that results from the interaction between the viewer (the "voyeur") and the painting.[9] It is also the view of Leo Steinberg, who uses the word "contagion" in discussing a similar dynamic between the work and the spectator.[10]

The three other figures in the painting contrast sharply with the two central figures staring at us. They seem much less threatening because they face the two central nudes instead of facing forward and because Picasso has sculpted their faces in varying degrees to resemble masks, thus distancing them from the realm of the human.[11] The face of the standing figure on the right is further deformed by cross-hatching, and her body seems chopped into planes. The sitting figure is totally deformed, her back and her eyes facing us simultaneously. In addition to painting contrasts among the figures, Picasso has created contrasts between what is seen and what is (supposedly) hidden. Angular bodies are visible beneath transparent layers: the figure on the left seems partially draped in a diaphanous rose dress, and one of the central figures lifts a skirt to reveal a leg that would have been visible beneath the material anyway. The standing figure on the right parts a blue curtain and peers through the opening. Thus everything is "seen" equally: the concealed and the revealed, the front and the back, the human and the inhuman, the figures and their surroundings. Even the curtains and other surfaces "behind" the figures have been brought forward on the picture plane to fill the space and create an airless density that increases the force of the tensions.

Picasso has made no attempt to represent a realistic scene as it presents itself to our eyes; he has abolished single-point perspective, the realistic treatment of subject matter, and the realistic play of light.[12] Instead, he paints a new conceptual reality and substitutes what he knows to be true for what he sees. As he has said, "I paint objects as I think them, not as I see them."[13] Rather than perpetuating the illusion of reality through realist representation, Picasso draws attention to the nature of the work of art itself, one that substitutes its own reality for the reality of the world. In including the still life of fruit and nude bodies, he takes traditional subjects of art and deforms them. Knowing how

conscious Picasso was at this time of destroying old forms and tradition, it is not unreasonable to read the rose and blue of the painting as a remembrance of his past rose and blue periods, especially since the standing figure on the right, the most sculpted and artlike, emerges through a hole in the blue material as if to indicate an emergence of art as the subject of painting. To reinforce our impression of the painting as art and not life, Picasso holds all the tensions in a static immobility, freezing the moment and calling attention to the volumes on the flat canvas.

Like Picasso, Apollinaire has created a transparently fragmented art object with "Les Fiançailles" ("Betrothal"). The very first line of the poem already hints at the philosophical and aesthetic concerns to be developed both thematically and structurally, which have to do with an insistence on multiplicity rather than harmony, unity, or coherence. This first line reveals that the unity normally associated with the idea of betrothal—the promise of joining together separate entities into marriage—is illusory: those entities will remain separate because they are, in this first line, "perjured fiancés" [les fiancés parjures], having violated their oath of unity. Similarly, the nine fragments comprising this poem do not form a unified whole but clearly and intentionally exist as separate entities, disassociated from each other in subject matter, style, and tone.

A comparison of the first two sections of "Les Fiançailles" reveals striking disjunctions. The first tells of an outdoor scene (or scenes) in the country, a Madonna gathering flowers, and "lovers of love" in a lemon grove, their hearts "suspended [eternally] among the lemons," while the second shifts abruptly to a modern cityscape steeped in everyday reality. Here, the Madonna is replaced by women who have just given birth, and the lovers of love become the less idealized "detachable collars thrown recklessly on top of unkempt skirts."[14] The more realist second part stands in sharp contrast to the pastoral harmony and beauty suggested in the first part, a contradiction crystallized by the line, "The gas lamps pissed their flame in/by the light of the moon" [les becs de gaz pissaient leur flamme au clair de lune]. Instead of moonlight, a common nineteenth-century image of something eternal and ideal (*clair de lune* even evokes the Symbolist aesthetic), we now have gas lamps—man-made, modern, and plural. The gas lamps "piss" their flame in the moonlight and create a visual image (flames rise in a yellow stream), an auditory suggestion (the "s" sound

in the verb *pisser* resembles the sound made by both a lit gas lamp and liquid hitting a surface), and an affective reality (the pissing gas lamps indicate a defiant rejection of everything associated with the nineteenth-century *clair de lune*). While the first section ends with the word "suspended," emphasizing the idea of an ideal, suspended, eternal (and therefore static) time, the second section is completely modern in its cluttered details, everyday, antipoetic vocabulary, movement, and attention to real people of the city rather than to idealized fictions. In this second section Apollinaire follows the Baudelaire of *Les Tableaux parisiens* in vehemently rejecting conventional ideas about the proper subjects for poetry, including allusions to beggars, drunks, prostitutes, and those who inhabit the seamy side of night: "the shadowy figures circulating in the streets were never pretty" [Les ombres qui passaient n'étaient jamais jolies]. Poetry's social mission, now, was to reveal the realities and new forces of modernism. The abrupt shift from the conventional poetic form of the first section to the innovative form of the rest of the poem occurred practically overnight, as Apollinaire says: "While I was sleeping an angel exterminated the lambs, shepherds of sad pastorals" [Un ange a exterminé pendant que je dormais / Les agneaux les pasteurs des tristes bergeries]. It is tempting to compare this poetic "overnight" shift to an abrupt shift in painting—Picasso's *Demoiselles* of 1907 was certainly a far cry from fauvist Mediterranean pastorals of 1904–6.

It is well known that Apollinaire combined parts of different manuscripts in composing "Les Fiançailles."[15] The first section comes from a poem dated 1902 by the editors of *Le Guetteur mélancolique* called "Le Printemps"; the second, third, and fourth are from an earlier manuscript entitled "Les Paroles étoiles," although the order is rearranged, and fragments of the next to the last section come from "Le Pyrée." This poem was never conceived of as a coherent aesthetic object, but progressively became a fragmented object composed of prior (and present) creations. In combining different styles, vocabulary, and aesthetics in the same poem and in letting the various segments conflict and contrast with each other, Apollinaire created a poem as transparently fragmented as Picasso's *Demoiselles d'Avignon*. Picasso, too, reworked parts of his painting during the period 1906–7 and allowed different styles from different time periods to coexist with each other in the final product.[16]

It has been suggested that Picasso replaced personalized faces with

masks to detach himself emotionally from the figures as human beings in order to avoid considerations of beauty and ugliness. "Les Fiançailles" reveals a similar emotional detachment and a flatness of tone as the poet calmly displays for us various fragments of his past and present. The third section of the poem, for instance, begins with his dispassionate admission of having passed through the stage of self-pity and now being unable to express his torment of silence because his words have turned themselves into "stars" ("Tous les mots que j'avais à dire se sont changés en étoiles"). That is, the words that the poet once used as tools to express some preexisting reality (his emotional state) have crystallized; words have now become stars, separate entities with realities of their own. Like stars, they form their own constellations of meaning that have their own powers of evocation. Apollinaire's debt to Mallarmé is evident here.

The fourth section of "Les Fiançailles" reveals the same emotional detachment as the poet looks back on his past and sees nothing but corpses serving as landmarks for his days ("Les cadavres de mes jours / Marquent ma route . . ."). However, language no longer conveys Romantic or Symbolist emotion here but creates its own reality instead, as Apollinaire demonstrates by playing with the word *citronniers* in the midst of his evocation of wasted days in Italian churches and lemon groves. Here the word *citronniers* leads him away from the subject of self-pity into playful elaboration: "[Lemon trees] that flower and bear fruit at the same time and in all seasons" [Qui fleurissent et fructifient / En même temps et en toute saison]. He asks us to pardon him for no longer knowing "l'ancien jeu de vers," the old rhetoric of poetry in which language is meant to express or create emotion. The poet now puts words on the page and maintains that they come alive and interact with each other of their own accord (this is a technique he will elaborate later in his calligrams): "And I smile at the beings I have not created" [Et je souris des êtres que je n'ai pas créés]. Here, Apollinaire has projected himself as reader of his own work, the God who passively and dispassionately meditates upon his creation: "Je médite divinement."

The fifth section of the poem differs radically from the fourth, although Apollinaire's first line echoes an idea from the previous section when he introduces a wordplay and puns with the idea of being a spectator: "I observe Sunday's rest" [J'observe le repos du dimanche]. Now, instead of reflecting on his past, he focuses on the senses. The

poet wonders how to break down what he calls the "science" that his senses impose on him ("Comment comment réduire / L'infiniment petite science / Que m'imposent mes sens"). Although it is difficult to know exactly what Apollinaire is referring to with his use of the word "science," the context suggests that he is interested in breaking down some monolithic (albeit infinitely small) entity into its component parts to see what kind of stuff it is made of. Although this monolithic entity is something *imposed* on him through his senses, he remains active because, as he implies, his intellect is capable of investigating the information further. Apollinaire thus draws attention to the difference between the idea that our senses furnish us data and the idea that we conceptually order data. Although we may believe we are passive recipients of reality ("I praise idleness" [Je loue la paresse]), we are instead continually involved in an active ordering of data for purposes of comprehension. To demonstrate his point, Apollinaire bombards us with disordered fragments, each of them involving one of our senses. "Mountains," "the sky" and the highly charged visual image evoked by "his head is the sun and the moon's his sliced neck" all involve the sense of sight (later he explicitly refers to eyes); "your claws" and "the monstrous touch" involve the sense of touch; "roar," "thunder," and "song" are all associated with what he calls the "monster of my sense of hearing" [Monstre de mon ouïe]; "poison" and "flavor" involve the sense of taste; "smoke" and "the smell of the laurel tree" involve, in part, smell. The lines in this section of the poem are dense, and it is impossible to read any sense into them because of their fragmentation. Apollinaire's lines just "are," like the stars in the third section of the poem, but they don't "mean." Yet toward the end of this section he includes a line that echoes an earlier part of the poem and furnishes a clue about how we are to read: "And the stars, intact, are my masters. . . ." The presence of stars as models reminds us to consider the interplay of words ("constellations," as Mallarmé would say) instead of looking "behind" them for meaning.

There is no meaning "behind" the words, just as there is nothing "behind" Picasso's canvas. Picasso abandoned single-point perspective in order to do away with the illusion of a "deeper" (three-dimensional) reality. Apollinaire destroys our illusions and frustrates our desire for referentiality in passages of "Les Fiançailles" in a similar way. Instead of considering the poem as a "three-dimensional reality" (i.e., the two dimensions of the poem on the page plus what is supposedly "behind"

it), we would do well to take a lesson from painting and see the poem as a flat surface upon which the poet inscribes words that interrelate with each other to produce certain effects. Just as a canvas is nothing other than a coexistence of lines, colors, and forms relating in specific ways, so is the poem a surface of words, shapes, and lines that interpenetrate in various combinations (Apollinaire will develop this idea, too, in his calligrams). If one can speak of a fuller, three-dimensional reality in the metaphorical sense, then that third dimension must be the one that reaches out in space from the flat page or canvas to the reader. This is what the eyes staring out of *Les Demoiselles d'Avignon* seem to be saying.

In the sixth section of "Les Fiançailles," Apollinaire provides a humorous example of the contradiction between what our senses tell us and what we know conceptually to be true, one of the key problems facing Picasso at the time. The moon against the sky appears flat to us because we have no way to gauge depth, although we know that the moon is round. When Apollinaire writes "It's the moon that cooks like a fried egg" [C'est la lune qui cuit comme un oeuf sur le plat], he plays with the various meanings of *plat* (fried/flat) and draws attention to the way our sense of sight lies to us by making the moon appear as a flat egg against the sky. Picasso, too, was well aware that a single perspective of any given object revealed only one facet and therefore could not reveal the "true" object that the mind could conceive (Plato had banished artists from the Republic for perpetuating such falsehoods). He sought to paint an object not as it appears to our eyes, but as it relates to our conceptual knowledge about that object, that is, a coexistence of multiple perspectives at a single point in time. Henri Bergson had already pointed out the importance of accumulated visual experience in obtaining conceptual knowledge of an object and had emphasized the passage of time in this process (*Introduction à la métaphysique*, 1903, and *L'Evolution créatrice*, 1907). In *Les Demoiselles d'Avignon*, Picasso began experimentation with accumulated visual material, seeking ways to express this conceptual multiplicity on the canvas while respecting the flatness of the picture plane. After 1910, however, his work was guided by more formal considerations of structure.

Apollinaire, too, worked on expressing conceptual multiplicity in "Les Fiançailles," and a prime example can be seen in the transition from the sixth to the seventh section of the poem. At the end of section 6, the poet is the object of someone else's gaze: "A woman leaning out

of her window watched for a long time as I moved away singing." At the beginning of section 7, a complete change in perspective occurs, and now it is the poet who gazes ("I saw sailors"). This shift in perspective from poet as object to poet as subject is to be read not as a passage of time but as a simultaneity; conceptually, Apollinaire is simultaneously both object for someone else and subject for himself. Apollinaire calls attention to the coexistence of different perspectives by noting that this action takes place "at a street corner," a site of intersection.

This example of the coexistence of different perspectives is different from the kind of simultaneous multiplicity that critics have noticed in Apollinaire's later poems such as "Zone" and "Lundi Rue Christine," and the difference corresponds to changes in painting. For instance, when the poet of "Zone" says, "You no longer dare to look at your hands and at every moment I would like to sob," the "you" and the "I" refer to the same person; that is, multiplicity exists within a single individual. This technique corresponds more to Picasso's portraits of single individuals, as his *Portrait of Daniel-Henry Kahnweiler* (1910), his *Portrait of Ambroise Vollard* (1909–10), and his *Portrait of Wilhelm Uhde* (1910), in which a single subject is analyzed by faceting. In 1907, however, with *Les Demoiselles d'Avignon*, Picasso had only begun to experiment with the problem of accumulated vision and of expressing conceptual reality by faceting. Another way in which "Les Fiançailles" differs radically from "Zone" is in the relationship between the subject and his surroundings. In "Zone" the subject is very much linked to place (i.e., "Now you walk in Paris"; "Now you are at the edge of the Mediterranean"; "You stand before the zinc of a filthy bar"), just as in Picasso's portraits of 1910 the facets of the subject and of the background overlap ambiguously so that it is difficult to say where one stops and the other begins. In "Les Fiançailles," however, subject and surroundings are kept relatively separate (e.g., the distinct separation between the background scene in section 1 and the entrance of the subject in section 2), just as in *Les Demoiselles d'Avignon* the five figures remain clearly distinct from their surroundings.

Apollinaire ends his poem by concentrating on the theme of fire in the last two sections, although earlier allusions have already prepared its emergence as a central concern here. Critics consistently link the fire imagery of this poem with that of "Le Brasier" and interpret it in terms of symbolic generalities such as purity, unity, or truth. But in interpret-

ing fire referentially as a symbol for some absolute throughout Apollinaire's poetry, critics have neglected a much more important aspect: the process of burning and a fire's function of transforming matter. For instance, when Apollinaire writes "Bonds unbound by a free flame" [Liens déliés par une libre flamme], he alludes to fire's ability to break apart unified structures or entities (recalling the "perjured fiancés" of the first line) and transform their appearances. Critics have also overlooked the political implications of these lines about fire, probably because Apollinaire's name had been linked with cubism from the beginning and because cubism has largely been treated as an apolitical movement. But the relation between Apollinaire's aesthetics and his politics cannot be ignored. Apollinaire himself drew attention to the creative artist's social role of bringing about change by transforming appearances and enabling the public to see differently: "It is the social function of great poets and artists to renew appearances continually—appearances that nature reclothes for the eyes of men."[17] In this poem, he calls himself "The desirable fire that sacrifices itself for you" [Le désirable feu qui pour vous se dévoue], playing with the similarity of sounds in *dévoue* and its phonetic equivalent, *dé-vous,* and establishing an interesting parallel between *liens déliés* and *vous dé-vous-(é)* that again suggests a breaking down of matter. Ironically, although this line seems to indicate that the poet is the fire that sacrifices itself/himself, it is phonetically the *other (vous)* who is to be broken apart, *dé-vous-(é).* Taking into consideration the fact that the verb is reflexive, however, provides another interesting twist. Now the combination of semantic and phonetic material suggests that the poet *is* the other, the *vous (qui) se dé-vous.* Although it is tempting to compare the transformation process brought about by fire and the poet with the purification process proposed by Mallarmé ("Donner un sens plus pur aux mots de la tribu"), they are not at all similar. While Mallarmé replaces the object with language and thus transposes reality to another level, Apollinaire, like the fire, transfigures reality by changing its visual appearance, as Picasso does in his paintings.[18]

Radiograms taken for the Museum of Modern Art have confirmed that Picasso reworked his canvas over a period of several months, painting over figures, deforming features, and darkening three of the five faces.[19] As in Apollinaire's poem, old and new exist simultaneously and create a strong impression of dislocation. Instead of observing a unified whole, we cannot help but notice the fragmented parts.

The human mind is such that it attempts to make order out of apparent chaos, sifting through fragmented details to try to establish patterns, revising those patterns with the accumulation of new material. Gombrich's words about perception being "primarily the modification of an anticipation" are particularly relevant here:

> It is always an active process, conditioned by our expectations and adapted to situations. . . . We notice only when we look *for* something, and we look when our attention is aroused by some disequilibrium, a difference between our expectation and the incoming message.[20]

What we "see" depends both on the given reality and on the idea we have in our mind about what that reality will be (our expectations about reality and how it will be represented). In creating poems and paintings in which fragmentation challenges our ability to make sense of them, Apollinaire and Picasso draw our attention to our own searching and the act of perception itself. As we study Picasso's canvas, the eyes look back at us in mockery and defiance as they resist our effort to understand and to master the unknown and the unusual. Those eyes watch us as we go through the process of searching for order or meaning, and they mock us for being so naive as to presume that order or meaning exists "out there," whether in the canvas, the poem, or the world. By creating works of art with a great number of details and fragments that have no necessary logic in themselves, Apollinaire and Picasso challenge the nineteenth-century Romantic vision of the underlying unity of all things—a harmony in which, as Baudelaire so mysteriously puts it, "Perfumes, colors, and sounds converse with each other" [les parfums, les couleurs et les sons se répondent]. On the contrary, the painting and the poem remain immobile as we create order and imbue them with significance.

An Erotics of Excess: Lautréamont and Dalí

Reading Lautréamont through the lens of Dalí seems less odd when we remember that Dalí admired Lautréamont's work to such an extent that he agreed to include forty-two of his illustrations in the 1934 Skira edition of *Les Chants de Maldoror*. As Renée Riese Hubert has noted in her analysis of surrealist illustration in *Surrealism and the Book*, although Dalí's illustrations do not seem to refer to Lautréamont's text, the painter nevertheless felt a deep affinity for the poet, and "certain not always easily perceptible analogies exist between the poem and the illustrations."[1] This chapter will pursue Hubert's provocative suggestion about analogies existing between Lautréamont's verbal material and Dalí's visual material. Instead of discussing Dalí's illustrations, however, I propose rereading Lautréamont's *Les Chants de Maldoror* through the lens of some of Dalí's post-1934 paintings in order to highlight the analogous textual dynamics at work in the verbal and visual material. In particular, I will be looking at syntactical, stylistic, and formal features characterizing the work of these two men: meandering formal qualities; an excess of activity and minute detail; boldness, precision, and intensity of expression; and continual fluctuation and transgression.

This focus on the dynamics of Lautréamont's text differs substantially from the many classic critical studies that have highlighted thematic and psychological aspects of the text or that have studied sources.[2] The thematic similarities between Lautréamont and Dalí cannot be ignored: both create images of terrifying fantasy and violent impulse, transposing elements from the dark, repressed unconscious

onto page and canvas with shocking precision and an intensity of expression. It is for this reason, of course, that the surrealists claimed Lautréamont as a precursor and that Dalí rose to such prominence in the surrealist movement. Beyond the thematic similarities, though, rereading Lautréamont through the lens of Dalí's painting allows the often neglected dynamic features of Lautréamont's text to come into sharper focus.

Dalí thematizes sex and violence in his 1936 painting *Autumnal Cannibalism*, as two characters attempt to devour each other, literally, with knives, forks, and spoons (see fig. 11). Passion is translated into appetite, with the culinary metaphor sustained by all the food products strewn around: an apple, bread, and soft pieces of meat hanging over objects like melting camembert. The sharp knives, forks, and spoons are rendered all the more frightening because Dalí has positioned them strategically so that they shine in the brilliant light coming from some mysterious source. Dalí's paintings often contain such instruments of mutilation and create uncomfortable tensions of nightmarish intensity.

In this painting, each blob of the couple sucks, chews, cuts, eats, and squeezes the other. Partners in crime and passion, who is doing what to whom? The dialectics of victim and aggressor that critics have celebrated in Lautréamont is perhaps nowhere more graphically represented than here. If the figure on the left can be said to be female, we follow her arm as it encircles her lover's neck in what initially appears as an embrace, until we notice the knife in her hand that cuts into his flesh . . . or, at least, we suppose that this is his flesh because of its location in the area under his neck . . . until we realize that no, it is the prolongation of her own breast, which has meandered over to his side of the picture and extends even further to hang over what looks like his left shoulder. What at first appears sadistic turns out to be masochistic—a familiar dialectic highlighted in *Les Chants de Maldoror* as well; instead of slicing a juicy morsel of her lover, this woman is about to consume herself. In order to see all of that, though, we have to read the painting by following the meandering forms.[3]

The meandering that characterizes Dalí's style here and in many of his paintings pervades Lautréamont's prose. As a point of entry, I quote from the second canto of *Les Chants de Maldoror*, the scene during which a stranger approaches an innocent child sitting on a bench in the Tuileries and sits down beside him. In a theatrical aside, Lautréamont ironically reveals to the reader what the reader already knows: that this

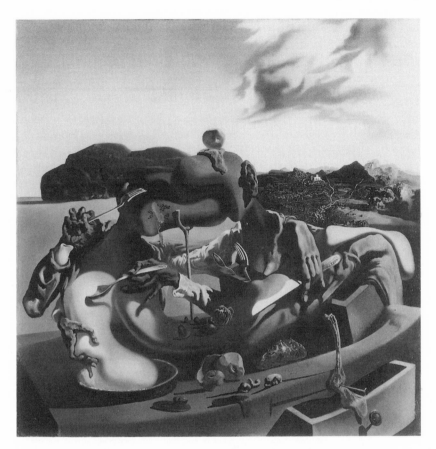

Fig. 11. Salvador Dalí, *Autumnal Cannibalism*, 1936. Oil on canvas. Tate Gallery, London. © 2000 Artists Rights Society (ARS), New York. (Photograph courtesy of Tate Gallery, London/Art Resource, New York.)

shady figure is none other than Maldoror, about to assault innocence once again: "How sweet is that child sitting on a bench in the Tuileries Garden! A man, moved by a secret design, sits down beside him on the same bench with a questionable air. Who is he? I need not tell you, for you will recognize him by his tortuous conversation."[4] By his use of the word "tortuous," Lautréamont refers ironically to the content of *Les Chants de Maldoror*, that is, all the torture, violent aggression, and sado-masochism that fills its pages. More importantly for our purposes, however, he draws attention to the way his language has been operat-

ing "tortuously," in a meandering way. Indeed, this "tortuous conver-sation" is the very mark that characterizes not only Maldoror's lan-guage, but also Lautréamont's.

The word "tortuous" has a certain perspective already built into it, for we say that something is tortuous if we wish to speak pejoratively of it. A tortuous discourse, then, is one that is painfully meandering or convoluted; the implied norm here would be nonmeandering, direct speech, or saying what is meant without artful intricacies and elabora-tion. By his ironic reference to his own "tortuous discourse," Lautréa-mont consciously rejects direct language with its claims for a one-to-one fit between language and reality, and offers instead a deliberately provocative, complex, opaque discourse that calls attention to its own fabric.

This meandering quality manifests itself in various ways in *Les Chants*. Probably the most obvious example is found in those very long sentences in which Lautréamont inserts subclauses, modifiers, preposi-tional phrases, qualifiers, and other grammatical structures within sub-ject-verb-object sequences. Obviously, the reader cannot hope to assim-ilate such an excess of accumulated information, but what we do notice and remember is the very fact that this language could meander indef-initely. A relatively simple sentence from the beginning of the first canto serves as an example. Here, it is the accumulation of preposi-tional phrases beginning with the word "at" that propels the sentence forward (I quote only one-third of it):

> The dogs howl at the northern stars, at the eastern stars, at the south-ern stars, at the western stars; at the moon; at the mountains which at a distance resemble giant rocks reclining in the shadows; at the keen air they breathe in deep lungfuls, burning and reddening their nostrils; at the silence of the night; at an owl, whose slanting flight brushes the dogs' muzzles as it wings swiftly on its way carrying a rat or a frog in its beak, living food, sweet morsel for the fledglings. . . . (13)

By saturating his text with long, winding sentences in which subject-verb-object sequences are bombarded with constant accumulations of clauses, Lautréamont plays with our desire to arrive at the end of sen-tences and find closure. This technique intensifies considerably in the fourth canto, where abstract expression replaces concrete examples of

Maldoror's exploits as the dominant mode. In the fourth canto, Lautréamont's sentences become even more complex as he elongates them with parenthetical clauses and other meandering strategies. After locating the subject, we unconsciously read more rapidly in an effort to locate the verb, and then speed through the sentence to find the object, as if we expect to find meaning in the subject-verb-object sequence. Lautréamont occasionally includes some reference to our own frenzied activity of reading within his meandering discourse, as he does in the following example when he encourages us to relax and drink a glass of water after we have plowed through an unusually long, tortuous sentence whose "message" is no more than "it is good . . . to return . . . to the . . . subject":

> To close this little incident, which itself is deprived of its matrix by a flippancy as irremediably deplorable as it is inevitably full of interest (which no one will have failed to verify, on condition he has sounded his most recent memories), *it is good*, if one has one's faculties in perfect equilibrium, or better still, if the balance of idiocy does not outweigh too much the scale in which repose the noble and magnificent qualities of reason, that is to say, in order to make things clearer (for until now I have been nothing if not concise, a fact that many will not admit because of my prolixity which is only imaginary since it achieves its goal of hunting down with the scalpel of analysis the fugitive appearances of truth to their ultimate entrenchments), if the intelligence predominates sufficiently over deficiencies under the weight of which it has been partially smothered by habit, nature and education, it is good, I repeat for the second and last time, for, by dint of repetition we shall finish, and this is true more often than not, by misunderstanding one another, *to return* with my tail between my legs (if it be even true that I have a tail) *to the* dramatic *subject* embedded in this stanza.
>
> It is useful to drink a glass of water before undertaking the continuation of my work. (177–78; emphasis added)

The short, succinct sentence following the exceedingly long one draws attention precisely because of its difference in length. Here, Lautréamont explicitly acknowledges the possibility that readers might want to pause and drink some water before continuing the harried activity of trying to follow his sentences. But Lautréamont's irony, if that is what

it can be called, does not end there. He immediately compares the drinking of water (i.e., the temporary "pause" in the frenzy that his short sentence has allowed us) to a halt in the pursuit of a runaway slave, noting that the halt lasts only a few seconds before "the pursuit is taken up again with fury . . ." (178). The image of a runaway slave seems to refer to Lautréamont's own language that has found freedom from conventional constraints of representation. Paradoxically, it is the reader pursuing meaning who seems much more of a "slave." After this brief comparison Lautréamont is off and running once again with the reader, having been given a "resting period" in the space of a few short sentences, in hot pursuit of the subject-verb-object units of meaning. Even in the most seemingly chaotic and meandering of Lautréamont's sentences, one can, indeed, always locate the subject, verb, and object; within the apparent confusion there is always an order and a logical structure.

A related type of meandering occurs whenever Lautréamont uses the word *like (comme)*, the very word that opens up unlimited possibilities. Again, our attention focuses not so much on what is being said, but on Lautréamont's ability to write whatever he pleases, since he is obviously not limited by semantic constraints or the necessity of unity or coherence. Thus, the dogs howl "like a child crying from hunger, or like a cat wounded in the stomach up on the roof, or like a woman about to be delivered of a child, or like a plague victim dying in the hospital, or like a young girl singing a divine melody" (13). Nothing could be simpler than accumulating similes as a strategy for dispersing meaning. Marcelin Pleynet has singled out the importance of the adverb *comme* in *Les Chants* because it focuses on the arbitrary nature of all fiction;[5] Lautréamont himself notes metaphor's ability to transcend specificity when he calls metaphor "this rhetorical figure [that] renders much more service to human aspirations towards the infinite . . ." (198–99).

The bewildering proliferation of minute details characterizing both Dalí's painting and Lautréamont's text might be called an aesthetic, if not an erotics, of excess. In Dalí's work the beads in the silver handle of the knife, the reflection on the back of the spoon's smooth surface, the folds and shadows in the cloth of his shirt—all portrayed in the sort of hyperrealism for which Dalí is famous—are among the many exact, little details that make the painting appear busy and excessive. The more

we look, the more we see; and the more we see, the more we look for more in our desire to consume this painting. Lautréamont's prose, too, with its constant obsession for minute description and its careful attention to seemingly insignificant details, appears just as baroque and excessive. The sheer quantity of adjectives, metaphors, accumulated modifiers, and other syntactic devices makes Lautréamont's descriptive segments seem cluttered with an abundance of words, as if his language had become intoxicated or were taking pleasure in its own proliferation. In the prose as in the painting, lots of things are being done in lots of ways simultaneously.

In her study on Lautréamont, Ora Avni has examined the ways in which such excess and proliferation actually neutralizes rather than contributes to our understanding by causing the reader to forget the "message": "Under the pretext of saying *everything,* [Lautréamont's rhetorical techniques] overtax the monologic, coherent, and linear assertions, obliterating them in the end because of their sheer excess."[6] We have already seen, in chapter 3, how the excess of information contained in Duchamp's *Green Box* serves to complicate any understanding or interpretation of the *Large Glass;* the situation is much the same here. Although Lautréamont claims to want to instruct his readers, the effect he creates through his erotics of excess is to overwhelm them. Already in the opening section of the first canto, Lautréamont warns the reader to turn away from the approaching storm, that is, to avoid the onslaught of language that threatens to "imbibe his soul as sugar absorbs water" unless he is prepared to become as "ferocious as what he reads" [féroce comme ce qu'il lit]. If readers insist on penetrating the text and do not want to be transformed by it, they must, according to Lautréamont, bring to their reading "a rigorous logic and a spiritual tension":

So, timid soul, before penetrating further into such uncharted lands, set your feet the other way. Listen well to what I tell you: set your feet the other way like the eyes of a son who lowers his gaze respectfully before the august countenance of his mother; or rather, like a wedge of flying, cold-trembling cranes which in the winter time, with much meditation, fly powerfully through the silence, full sail, towards a predetermined point in the horizon from which of a sudden springs a strange, strong wind. . . . (1–2)

It is impossible for readers to "listen well to what I tell you" when the telling is so overburdened with excessive detail.[7]

A preoccupation with continual transformation of substance is yet another characteristic informing the work of both Lautréamont and Dalí. In Dalí, such transformation is most visible in the context of the dialectics of hard and soft that runs through his works. We are all familiar with his recurring "soft" motifs such as the famous melting watches, the limp body parts and objects held up on crutches, even runny eggs and cheeses. These "soft" motifs usually suggest an overriding of the boundaries between forms, as one substance melts to merge into another. In keeping with Dalí's obsession with primitive impulses and libidinal flows, such a lack of boundaries recalls what Freud has described as the infant's "oceanic self," or what Lacan calls *l'hommelette,* a human omelette that spreads out in all directions. In *Autumnal Cannibalism,* for instance, the two "soft" desiring figures who ravage each other spread out and melt into one another, recalling what Deleuze and Guattari have termed "desiring-machines" propelled by "schizzes-flows," or limitless exchanges and "nomadic conjunctions,"

> machines in the strict sense, because they proceed by breaks and flows, associated waves and particles, associative flows and partial objects, inducing—always at a distance—transverse connections, inclusive disjunctions, and polyvocal conjunctions, thereby producing selections, detachments, and remainders, with a transference of individuality, in a generalized schizogenesis whose elements are the schizzes-flows.[8]

Dalí's "soft" motifs can thus be located within a schizophrenic, libidinal economy that works against form and regulation, beyond what Deleuze and Guattari call "the anthropomorphic representation that society imposes on [the] subject" (296).

At the other extreme from schizophrenia is paranoia, which translates in Dalí's work as ossification: bones protruding through human flesh, bones of meat sticking into the air, and sets of drawers that, in certain paintings, suggest the ossification of knowledge into strict and rigid compartmentalization. In the world of irrationality, thought Dalí, no such ossification exists: structures dictated by time and space melt and transform even before they have time to be settled. Dalí's ambition was to take images from what he called "concrete irrationality" and

render them just as solid, just as persuasively thick and communicable as those images of the exterior world:

> My entire ambition in the pictorial domain consists in materializing the images of concrete irrationality with the most imperialistic rage of precision. The imaginative world of concrete irrationality must be of the same objective evidence, the same consistency, the same hardness, the same persuasive thickness, knowable and communicable, as that of the external world of phenomenal reality.[9]

Dalí defined images from "concrete irrationality" as "images that provisionally are neither able to be explained nor reduced by systems of intuitive logic or by rational mechanisms" (17). Of course, it is possible to understand Dalí's obsession with painting these images from "concrete irrationality," many of which are often sexual or scatological in content, as a desire to master them through representation in order to render them unthreatening. Visual representation serves as a mediation, a buffer zone that would keep Dalí safe from the anxiety that an immediate, unmediated encounter would produce. By representing sexuality in painting, Dalí keeps it under control, mastered and contained on canvas.

On the pictorial level, Dalí not only renders these irrational images "solid," he also stages the opposite and represents "hard" forms from external reality liquefying and deforming themselves, a continual transformation and transmutation of substance according to the dictates of his inventive imagination. Sometimes even the image we believe to be "hard" and stable tricks us and changes into a different image before our eyes, as in the well-known double image of *Slave Market with the Disappearing Bust of Voltaire* (1940), where, depending on how we look, we see either a pair of figures or Voltaire's head occupying the same space (see fig. 12).[10]

The continual transformation of substance that informs Dalí's paintings also manifests itself in Lautréamont's text on several levels. Thematically, we find examples like the lamp that changes into an angel against which Maldoror struggles, or Maldoror transforming himself into an immense eagle to fight a dragon, or even transformations taking place as aggressor and victim change places. Syntactically, too, there are numerous examples of transformations and metamorphoses made possible through the use of metaphor. Transformation occurs on a nar-

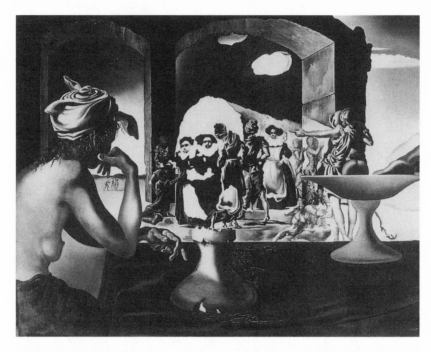

Fig. 12. Salvador Dalí, *Slave Market with the Disappearing Bust of Voltaire,* 1940. Oil on canvas, 18¼″ × 25¾″. Salvador Dali Museum, St. Petersburg, Florida. © 2000 Artists Rights Society (ARS), New York. (Photograph courtesy of the Salvador Dali Museum. © 1999 Salvador Dalí Museum, Inc.)

rative level as well, as Maldoror and the narrator seem to exchange identities, and on an intertextual level whenever Lautréamont parodies the *roman noir,* the *roman populaire,* romanticism, or any of his predecessors, since parody always involves absorbing and changing the original in some way.[11] Finally, as we have already seen, Lautréamont believed that his text would be capable of transforming unsuspecting readers and converting them to evil: "[T]he deadly emanations of this book will imbibe [the reader's] soul as sugar absorbs water," unless the reader brings a certain "hardness" to reading, what Lautréamont called a "rigorous logic and a spiritual tension . . ." (1).

As part of his poetics valorizing transformation, Lautréamont creates many examples in which people in the text are "changed" as a

result of their own encounter with language. The person who discovers the madwoman's manuscript in the third canto, for instance, is so affected by the horrendous content of that manuscript and the sheer power of the language that he faints. The reader of the inscription on the bridge, also in the third canto, finds himself seduced by the inscription warning against venturing further and yields to temptation. The many representations of readers *in* the text undergoing change are meant to implicate the readers *of* the text as well. Echoing Baudelaire's call to a "[h]ypocrite lecteur,—mon semblable,—mon frère!" Lautréamont would like his readers to recognize their own murderous impulses and not cling hypocritically to a belief in their own purity.

It is not only the readers within Lautréamont's text who undergo transformation, but the innocent characters as well. Virtue is transformed into vice as Maldoror poisons naive, unsuspecting minds and corrupts youth for his own ends:

> From the dawn of time [man] had modestly believed that he was filled with goodness mingled with only a minute quantity of evil. By dragging out his heart and his life-thread into the light of day I taught him the rude lesson that, on the contrary, he is made up of evil mingled with only a minute quantity of good. . . . (49–50)

Thus we watch as Maldoror easily seduces Mervyn in the sixth canto, despite the efforts of the boy's parents to protect him.

If all these kinds of transformations in Lautréamont can be considered analogous to Dalí's soft, malleable substances that readily change form, then the opposite would be some constant, unchanging form equivalent to Dalí's bones. For Lautréamont, that unchanging, "hard" form is represented by mathematics. In his well-known invocation to mathematics in the second canto, he hails mathematics with its "tenacious propositions," "iron-bound laws," and "eternal axioms," and celebrates its capacity to endure long after things of the world disappear:

> But you are unchanging. No change, no envenomed wind, touches the steep rocks and wide valleys of your identity. Your modest pyramids will endure longer than the pyramids of Egypt, those ant-hills erected by stupidity and slavery. The end of all the centuries will yet see, standing upon the ruins of time, your cabalistic ciphers, your terse equations, and your sculptural lines. . . . (89)

One finds in Lautréamont's writing an uncanny combination of mathematical rigor on the one hand and frenzied thematic and stylistic activity on the other, especially in the final episode in which Mervyn's body is flung through the air, tracing various geometric forms according to very precisely elaborated laws of physics. This same uncanny combination of scientific precision and outrageous content characterizes Dalí's work as well.

The Subversion of Form

The meandering, excessive, intense, and fluctuating features characterizing the work of Lautréamont and Dalí participate in a larger paradigm of subversion and function to unsettle codified form as well as conventional reading. Lautréamont's text participates in the counterhegemonic discourse of nineteenth-century France that Richard Terdiman has analyzed in his *Discourse/Counter-Discourse;* Dalí's paintings put the same counterhegemonic tendencies into play in the 1930s.[12] Considering *Les Chants* in its social and political context, Aimé Césaire sees in Lautréamont's text "an implacable denunciation of a very precise form of society," referring to the rigid control practiced under the Second Empire (1852–70).[13]

The structures of conflict and the subversion that operate within Lautréamont's language have already been closely analyzed by Julia Kristeva in *Révolution du langage poétique.* Her well-known descriptions of the dialectic between what she has termed the *semiotic* and the *symbolic,* two inseparable components of the signifying process, are very much to the point here.[14] The semiotic, for Kristeva, refers to the pulsational energy contained in language as well as its destructuring and explosive qualities, while the symbolic refers to codified discourse and the mechanisms of language that serve to constrain, regulate, and normalize, such as grammar and semantics. Both the semiotic and the symbolic occur simultaneously in language, with the result that the normalizing, regulating functions of grammar are constantly being undermined by the pulsations of the semiotic in various degrees, depending on the type of language under consideration. The semiotic can be thought of in terms of drives or quantities of energy like "charges and stases" that are essentially mobile, kinetically rhythmic, and that undergo constant assimilation and destruction. Kristeva is

attracted to Lautréamont precisely because of his use of a language that disrupts, explodes, and destructures as it articulates. Like Lautréamont, Dalí's paintings work to unsettle the symbolic order and to destroy reified form, either by rendering "hard" objects from the world soft or by rendering delusional images solid and thereby calling into question the fixed boundaries separating delusion and reality. Both Lautréamont and Dalí produce works in which excess spills over and cannot be contained; both produce works that stage the transgression and subversion of logical and social codes. The ideology informing their work, then, is one in which dominant value systems are opposed.

The excessive exuberance and the resulting subversion of form enacted in Lautréamont's and Dalí's works can be thought of in terms of what Georges Bataille theorized as an inevitable expenditure of energy operating in the world. The excess of energy represented here in terms of eating (consumption), sexual appetite, or killing relates closely to Bataille's theories of expenditure *(la dépense)*, the idea that as excess accumulates and develops into superabundance, it must be spent "gloriously or catastrophically" as waste:

> I insist on the fact that there is generally no growth but only a luxurious squandering of energy in every form! The history of life on earth is mainly the effect of a wild exuberance; the dominant event is the development of luxury. . . .[15]

Luxury, for Bataille, refers to the lavish expenditure (without return) of wealth or energy. Surely Lautréamont and Dalí, with all their attention to violence, eating, and sexual activity, provide vivid examples of the excesses of energy that preoccupied Bataille.

While the semiotic as Kristeva theorizes it is not, strictly speaking, equivalent to the unconscious, her positing of the semiotic is inseparable from a theory of the subject that takes into account the unconscious. In *Desire in Language* she associates the logic of poetic language with dream logic. This logic proceeds by analogy instead of causality and is diametrically opposed to the "monologism" of the realist novel and realist description:

> Literary semiotics can accept the word "dialogism"; the logic of *distance* and *relationship* between the different units of a sentence or narrative structure, indicating a *becoming*—in opposition to the level of

continuity and substance, both of which obey the logic of being and are thus monological. Secondly, it is a logic of *analogy* and *nonexclusive opposition*, opposed to monological levels of causality and identifying determination.[16]

The work of Lautréamont and Dalí exhibits the kind of transrational dream logic that Kristeva evokes here, with its obsessive exploration of the internal world of unconscious desires and repressed instincts. Disturbing, irrational images fill the pages of *Les Chants de Maldoror*, where they accumulate in rapid succession as if by impulse and free association. Similarly, the frightening dreamlike visions and deformed parts of human anatomy that appear in Dalí's paintings are juxtaposed on canvas with no regard for conventional logic. That absence of conventional logic has even lead Robert Hughes to describe Dalí's canvas as "the flat, desert-like plane, Lautréamont's operating table, on which strange objects meet. . . ."[17] Eroticism and death are thematized in expansive, atmospheric landscapes with De Chirico–like deep perspectives and antinaturalistic lighting, creating a frightening combination of realistic figures on hallucinatory ground. Like Dalí's paintings, Lautréamont's text probes the inner workings of the mind. Like Dalí, Lautréamont's obsessive attention to minute detail serves to highlight and keep attention focused on the uncanny activities of that mind, with all its unimaginable, repressed content.

Performative Acts: Rimbaud and Matisse

Considering the young, mercurial Symbolist poet together with the more mature and "civilized" Matisse may initially seem odd, especially since Matisse, unlike Rimbaud, has come to be widely known for his decorative harmony, equilibrium, and French *mesure*.[1] However, a new biography of Matisse's early years from 1869 to 1908 presents quite a different view. In *The Unknown Matisse*, Hilary Spurling traces what she sees as "Matisse's intimate acquaintance with violence and destruction, a sense of human misery sharpened by years of humiliation, rejection and exposure—which could be neutralized only by the serene power and stable weight of art."[2] She interprets his cautiousness and disarming rationality as a cover for the destructive aspects of his work that frightened him; indeed, in the space of eighteen months, his work scandalized the public on three separate occasions.[3] As we shall see, Matisse's famous panel *Dance (II)* (1909–10) provides a provocative lens through which to view Rimbaud's *Season in Hell* (1873) and serves to focus attention on the "artful" aspects of Rimbaud's text, especially the sheer energy and activity of Rimbaud's language as well as the dynamic process of role-playing and storytelling enacted by the text: a series of "poses" and a multiplicity of voices in perpetual movement and constant yet changing tensions. This reading, however, necessitates a shift in focus away from two conventions of reading that have guided interpretations of Rimbaud's text: reading with the expectation of referentiality and reading with the expectation of teleological development. Since Rimbaud's text establishes and sustains the illusions of both referentiality and teleological development,

such reading conventions may seem especially difficult to break in this case.

The following discussion first demonstrates how these two reading conventions are reinforced by the text and how they have guided much of the criticism of Rimbaud, preventing us from appreciating the more "artful" aspects of the text. Then, by yoking together Rimbaud's verbal text and Matisse's visual text, this chapter brings a different dimension of Rimbaud's work into sharper focus and suggests, as a consequence, a different, postmodern way of reading *A Season in Hell*. It should be clear that I am not attempting a close reading in the traditional sense, but rather demonstrating how changing the frame of reference dramatically changes the possibilities for interpretation. We might even say that this technique of viewing the verbal text through the lens of the visual text serves as a catalyst for what Rimbaud, in one of his best-known slogans from *A Season in Hell*, called "changing life" [changer la vie]: changing habitual ways of thinking about literature and art.[4]

The Illusion of Referentiality: "Long ago, if I remember correctly . . ."

From its opening line, *A Season in Hell* creates the illusion of an "I" about to recount its past. The confessional mode has led many critics to take for granted the presence of a self-conscious, unified narrative voice and to consider the text as referential, as if some real experience preceded its language. Some commentators have read the work as the expression of a spiritual or psychological nightmare and awakening; others have looked for references to Rimbaud's life, most notably by reading "Delirium I" as an account of the relationship between Rimbaud and Verlaine or by reading "Adieu" as Rimbaud's renunciation of poetry. Still others have read sections as narratives of the poet's struggles with writing poetry, or his inability to express his visions in language. Other commentators have tried to locate meaning in the text by proposing biblical or literary sources or by interpreting passages in the light of biographical, historical, or psychological details.[5] In general, the overriding preoccupation with meaning prevalent in Rimbaud criticism of the 1950s, 1960s, and, to a lesser extent, the 1970s, has meant that other kinds of challenges posed by the text have been neglected. In subsuming textual difficulties into a relatively simplifying narrative of

meaning, this type of criticism cannot deal with the reasons why we still enjoy reading Rimbaud and continue to welcome the challenges posed by his poetry.

An alternative approach to reading *A Season in Hell* is to focus on language's activity as language and to *dé-lire,* as Shoshana Felman once suggested, "un-chain the code; un-hinge and un-do a classical, linear reading oriented in one direction, in order to un-read it, to disseminate it, 'literally and in all directions.' *Un-learn* to read classically. . . ."[6] To help achieve this, I turn to a consideration of Matisse's painting precisely because it is constructed according to different codes and read according to different conventions.

Perhaps the first aspect of *Dance (II)* to draw our attention is the force of the colors, for Matisse has juxtaposed three saturated colors that in 1910 had not yet ordinarily appeared together (see fig. 13). The exaggerated earth and sky colors are not mere backgrounds but active protagonists, primary blocks in Matisse's visual language that stimulate the mind and the senses as intensely as Rimbaud's new poetic language with "the color of vowels." Matisse frees colors from the way they had been used before him by the divisionists and fauves; instead of applying colors in the form of dots or strokes in order to create an illusion, Matisse allows the colors to draw attention to themselves by applying them boldly over the huge canvas (about 8½ × 13 feet). In a similar self-referential gesture, as we shall see, Rimbaud liberates language from traditional referential usage by performing his "alchemy of the word."

The figures in Matisse's painting dance on an uneven hill instead of a flat surface to reinforce the impression of disequilibrium, announcing the syncopated rhythm of Stravinsky and Satie. The effort of the five figures themselves is expressed by their twisted poses and the display of muscles rather than by facial expression. This energy has led one commentator to read the figures as "curving, rocking, jumping—gesture itself."[7] Even the surface of the panel seems vibrant and alive because the colors, although saturated, vary in intensity. All these elements combine to create a total effect of dynamic energy and force, the same kind of aggressive mobility apparent in Rimbaud's text. The energy seems even more concentrated and intensified because it is confined within the limits of the panel: the circle of dancers seems locked inside the rectangle of the panel as if they were destined to repeat themselves eternally. The figures of Matisse's *Dance* cannot step outside the edges of the painting, just as the language of Rimbaud's text does not

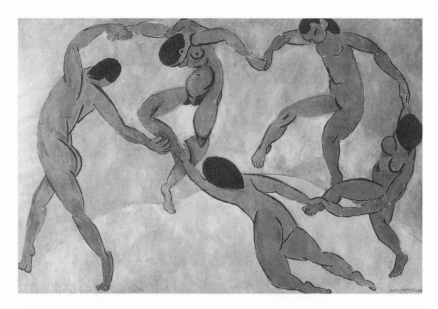

Fig. 13. Henri Matisse, *Dance (II)*, 1909–10. Oil on canvas, 8' 5⅝" × 12' 9½". Hermitage Museum, St. Petersburg. © 2000 Succession H. Matisse, Paris/Artists Rights Society (ARS), New York. (Photograph courtesy of Art Resource, New York.)

really "go" anywhere and, as we shall see, does not escape its own performative nature.

Comparing *Dance (II)* with Matisse's earlier treatments of the same subject reveals just how conscious the artist was of making changes to intensify the energy.[8] The dance motif first appears in the central background of *Joy of Life* in 1905–6, although the overall effect of this painting with its lounging figures is sensual, flowing, and dreamlike. Then, in 1909 Matisse isolated and painted just the dance (see fig. 14), replacing two of the figures in the upper left of the circle with one, thereby reducing the number from six to five. In the substitution, Matisse deliberately removed the figures with the least energy, the ones that seemed to threaten to halt the movement of the dance with their relatively tempered gestures. This composition, now housed at the Museum of Modern Art, is the one that S. I. Shchukin, the important Russian collector of French paintings, saw in March 1909 when he commissioned *Dance (II)* and *Music* for his home in Moscow.[9]

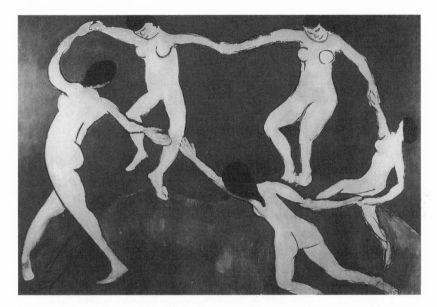

Fig. 14. Henri Matisse, *Dance* (first version). Paris (March 1909). Oil on canvas, 8' 6½" × 12' 9½". Museum of Modern Art, New York. Gift of Nelson A. Rockefeller in honor of Alfred H. Barr Jr. © 2000 Succession H. Matisse, Paris/Artists Rights Society (ARS), New York. (Photograph © 1999 Museum of Modern Art, New York.)

This early version of *Dance* can also be seen as part of the subject matter in another of Matisse's paintings of 1909, *Still Life with Panel of the "Dance,"* the first example of Matisse's using one of his own works as a motif (see fig. 15). Rimbaud, too, included altered versions of earlier poems in *A Season in Hell,* and critics have interpreted their presence as Rimbaud's renunciation of his old work. I would like to suggest, instead, that the embedding of earlier artworks within new artworks indicates that Rimbaud, like Matisse, was interested in proposing art as a proper subject for art—hence Matisse's interest in arabesque and decoration. Like Rimbaud, Matisse distorts his earlier composition (he includes only the lower half of the dancers), reinforcing the idea that art never achieves a "truthful" representation of something outside its own existence but creates its own reality instead. By alluding to and contextualizing his *Dance* within a new painting, *Still Life with Panel of the "Dance,"* he has rendered it new, different, and *other.* The fruits, flowers, and panel have now assumed the role of the

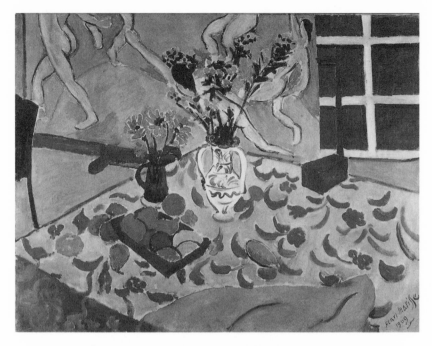

Fig. 15. Henri Matisse, *Still Life with Panel of the "Dance,"* 1909. Oil on canvas, 35¼" × 46¼". Hermitage Museum, St. Petersburg. © 2000 Succession H. Matisse, Paris/Artists Rights Society (ARS), New York. (Photograph courtesy of Scala/Art Resource, New York.)

dancing figures, although, paradoxically, fruits and flowers are the traditional subject matter of still-life painting. Here, however, they are no longer still as they interact spatially on Matisse's canvas and perform their own dance.

A comparison of the 1909 version of *Dance* with the 1910 version housed in the Hermitage Museum in St. Petersburg again reveals Matisse's preoccupation with intensification. The pink figures are now rendered in a terra cotta red that suggests much greater concentrated force.[10] Thanks to the saturated colors, the movement of the dancers becomes even more powerful. Matisse creates the impression of Dionysian frenzy by highlighting leg, arm, and stomach muscles with black lines and by distorting the fifth figure, whose head bends to the ground in effort.[11] When *Dance (II)* was first exhibited at the Salon d'Automne of 1910 with its mate, *Music*, the two panels provoked reactions

from shocked critics that could just as conceivably refer to Rimbaud's *Season in Hell*. One critic spoke of "conscientious plumbing of the prehistoric depths" and a "bacchanalian dance"; another wrote in a review article:

> [T]here are constant bursts of indignation, rage, mockery. Admittedly, the loud, poisonous colours give the idea of a diabolical cacophony, the draughtsmanship is simplified almost to vanishing point, and the shockingly hideous forms express the artist's intention with insolence and arrogance. The world created by Matisse, in these naive, cannibalistic panels is, I think, a most unpleasant world.[12]

Yet another reason for the hostile critical reaction was that Matisse's panels challenged the distinction between decorative mural painting and easel painting.[13] Because he combined the large scale and simplified flatness of the decorative arts with the use of color then associated with the fine arts (although not this specific combination of saturated colors), Matisse eliminated the boundaries between the two categories that had been kept strictly separate until then. Although much of the abstract art of our time includes both large-scale dimensions and a bold use of color, Matisse was creating a new form in 1910.

Rimbaud, too, created a new form in his own time, a prose that was much more poetic and energetic than Baudelaire's prose poems and that included, as Suzanne Bernard has pointed out, a certain use of forceful and frenzied language (170). A comparison between fragments of earlier manuscripts and the definitive text enables her to conclude that Rimbaud consciously worked at condensing his text to make it more intense without worrying about making himself understood ("I held back the translation"). She offers examples to show how Rimbaud cut his text, kept only the significant words, multiplied his exclamation points, and rendered his prose more disjointed, choppy, powerful. Although Rimbaud's text and Matisse's *Dance (II)* are separated by thirty-seven years, both artists were consciously engaged in an activity of intensification, and it is precisely this intensification that helps distinguish and liberate their works from the traditional formal categories.

Even readers who initially attempt to read Rimbaud's text as a narrative of experience cannot fail to notice the energy of his language. From the very first page, Rimbaud's nouns are so vague and abstract

that it is difficult to glean any specific meaning from them; the first page abounds in nouns like "beauty," "justice," "hope," and "joy," and for each of these abstractions a verb of destruction operates—the poet "abuses" beauty, "takes up arms" against justice, makes hope "disappear," and "strangles" joy. Within a very short space of time, then, the reader's attention is drawn to the language itself. As verbs "annihilate" nouns, we begin to concentrate our attention on the activity of the language rather than on its meaning. Rimbaud's paragraphs and sentences resemble short, choppy, staccato outbursts, analogous to the frenzied energy of the dancers on the uneven hill in Matisse's painting, as if some wild beast were pouncing on each sentence to strangle any meaning that might manifest itself if the sentence were allowed to continue: "Like a ferocious beast, I pounced voicelessly on every joy to strangle it."

This focus on the activity of Rimbaud's language has been pursued by Atle Kittang, who concentrates on what he calls the *plurivocité* of the text instead of seeing language as a tool to be used for expression or representation; that is, he sees Rimbaud's poetic activity as dynamic play, hence his title, *Discours et jeu*.[14] Kittang draws attention to the absence of referents in Rimbaud's work (e.g., "I wrote down silences, nights, I noted the inexpressible") and maintains that Rimbaud creates these absences and silences specifically to direct the reader's attention toward the signifier rather than the signified. Like Kittang, J. Marc Blanchard has considered Rimbaud's text as an exchange between signifiers, a text that "makes itself" as it unfolds, or a scene of production in which the subject disappears and the activity of the language is of prime interest.[15]

Rimbaud playfully reinforces the idea that we are to consider the "playing" or the "spectacle" of the text instead of reducing it to descriptive information or moral conclusions when he notes in the opening section of *A Season in Hell* that he writes for "you who like the absence of descriptive or instructive faculties in a writer" (his own statement, paradoxically, can be considered descriptive information). Rimbaud's originality lies precisely in the way he uses language. His text is characterized by dislocation, fragmentation, multiplicity, experimentation, and, above all, a powerful language that moves forward, doubles back on itself, watches itself, wanders off, and continually seeks its own threads. *A Season in Hell* is truly a "scene of production" staged by a poet conscious of his unlimited power to generate language. As in the

work of Lautréamont, Beckett, or certain texts of Michaux, Rimbaud's prose contains a multiplicity of voices and interactions in perpetual movement and constant yet changing tensions;[16] for this reason the text resembles a dynamic theatrical performance much more than a linear narrative discourse. What is of paramount importance in this text is the dynamic process of role-playing and storytelling staged by the text.

The Process of Role-Playing: "Continual farce!"

Both Jean-Pierre Richard and Jacques Plessen have recognized the importance of movement throughout Rimbaud's work: Richard calls it "a poetry of becoming," and Plessen sees an equivalence between poetry and walking.[17] But "walking" and "becoming" are not energetic enough terms to characterize what happens in *A Season in Hell*—the uneven tempo and aggressive outbursts are more like what Rimbaud calls the "pouncing" of the "ferocious beast" than a calm moving forward. An additional problem with terms like "walking" and "becoming" is their implication of some endpoint, or telos, toward which everything tends, some progression forward toward a conclusion. Indeed, many Rimbaud scholars have identified a linear development in *A Season in Hell* beginning with a descent into despair, continuing with the experience of hell, and ending either negatively (failure, renunciation of poetry) or positively (acceptance of life, work). Even though scholars have interpreted the final section of *A Season in Hell* in these different ways, the varying interpretations still rest on the assumption that one is dealing with linear discourse.

Several critics have, indeed, commented on Rimbaud's theatricality and identified various masks he assumes, but they have not considered the ramifications of theatricality and role-playing for a reading of the whole text.[18] Commentators often point to Rimbaud's predilection for theatricality but then willingly believe that the poet of "Adieu" who admits to his past inventions and role-playing is no longer inventing or role-playing. Because their working assumption is that they are presented with an "authentic" voice at the end as well as linear development throughout, they must locate (however arbitrarily) a point at which the poet ceases assuming masks and becomes sincere.

However, when seen from a different perspective, there is no reason to believe that Rimbaud's change of tone in "Adieu" and statements

such as "today, I believe I have terminated the relating of my hell" from "Morning" are anything other than yet another role he plays in his perpetual theatricalizing. As he says, "I invented all the celebrations, all the triumphs, all the dramas." From this new perspective, it is hard to understand why readers have assumed that Rimbaud has ceased fabulating in the last sections of the text, especially since he still refers to himself as a "storyteller." Here, as well as throughout the whole of *A Season in Hell*, Rimbaud's text hints at the pleasures of storytelling and refers to its own dynamic nature with phrases such as "Let's go!" The language of the text is perpetually mobile, although it cannot foresee the directions in which it will travel, as it cautions with phrases like "where are we heading?" [où va-t-on?] and "You don't know where you're going or why you're going, enter everywhere, respond to everything." The sections that critics have designated as the ending, then, are just one more instance of Rimbaud's theatrical talents ("Listen! . . . I have all talents"), talents he already warns us about in "Night of Hell" when he exclaims, "Bah! let's make all the faces imaginable," and again in "The Lightening Flash" with "Come on! let's pretend. . . . And we shall exist by amusing ourselves. . . ." Rimbaud even stages a little theatrical scene between two different voices in "Delirium I" and takes his place in the audience next to the reader to watch, playing the role of spectator.[19] The activity of role-playing does not change, although the roles themselves do. If the so-called redemption of "Adieu" is as imaginable a staging as the other roles that he has assumed, then there is no reason to grant this last section special status and exempt it from Rimbaud's perpetual theatricality.

There is a further reason for considering the final section of Rimbaud's text as yet another manifestation of a constant activity of role-playing rather than a definitive ending. The poet who writes in the opening section, "I am tearing these few hideous sheets from my damned-man's notebook for you" implies that he is giving us merely a sampling from a larger notebook. These are just some of his pages, a part from a greater whole that, presumably, bears more of the same. If Rimbaud's pages continue on beyond what we as readers perceive as the "end" of his text, as he implies, then that ending is a false ending. This is perhaps the place to add that there are several false endings in the text, especially the two that appear in italics: "No more words" and "I no longer know how to speak!" In both instances, the text continues.

The Nonteleological Nature of the Text: "Science, the new nobility! Progress. The world moves on! Why shouldn't it rotate?"

Viewing the text as a constant theatrical activity allows us to appreciate its nonteleological nature. When Rimbaud says, "The world moves on! Why shouldn't it rotate?" his tongue-in-cheek play of words points to the very text that he is in the act of writing and rewriting. The word for "moves on" is *marcher*, which implies progressing forward. The word for rotate is *tourner*, which designates a turning around, a revolving. The tensions arising from these two diametrically opposed movements describe Rimbaud's language and style. For throughout *A Season in Hell* Rimbaud fabricates a complex web that wanders, turns, and repeats itself instead of proceeding forward through beginning, middle, and end, all the while creating the very labyrinth it pretends to want to escape. "It's the vision of numbers," exclaims Rimbaud, suggesting the notion of progress in terms of an Aristotelian teleology that moves perpetually forward in an orderly fashion. Instead of linear progression, however, Rimbaud's text is built around the notion of turning.

At the beginning of every subsection of "Bad Blood," for instance, Rimbaud repeats a reference to origin, a repetition that itself subverts the notion of origin. "From my Gallic ancestors I inherited whitish-blue eyes" is a turning backward in time from the present ("I") toward an origin ("my ancestors"), a turning that is then repeated in the opening sentence of the next subsection: "If only I had antecedents at any point in France's history!" The third subsection begins with the words, "Pagan blood returns," again a pointing backward in time; the verb "returns" underlines the fact that a sameness is manifesting itself (that is, the fact that all these subsections are beginning in the same way). The often-quoted opening from the fourth subsection is just another articulation of the same idea that one (the text) never actually goes anywhere but keeps rewriting and perpetually begins to go: "One does not leave.—Let's move on from here . . ." [Reprenons les chemins d'ici]. "Let's move on from here" implies: let's start again from this point, but let's not go backward to find the proper beginning (this very sentence is, of course, the only "beginning" there has ever been). "Let's move on from here," however, is a beginning, or rather, a re-beginning that indicates that something has come before (like the fact of having ancestors)

and that a subsequent moving forward is taking place. Contrary to common usage in French, Rimbaud puts *chemins* in the plural to suggest that his text is not following one teleological path but many overlapping paths that have been repeating themselves.

"Let's move on from here, burdened with my vice, the vice that has sprouted its roots of suffering at my side since the age of reason, that rises skyward, beats me, knocks me over, drags me along." This vice that has plagued the poet since his own age of reason is language, the very mark of a "reasonable" human being; Rimbaud's own preoccupation with words and writing, as well as his obsession with creating, are all implicated here.[20] "Let's move on from here, burdened with my vice" is the expression of the poet's will to go forward and his hope that he will move on despite the burden of language. The verb "burdened" underscores the double nature of language as both help and hindrance. Language is a burden precisely because it goes its own way and "leads" the writer instead of vice versa: language "rises skyward, beats me, knocks me over, drags me along." All of the poet's effort has been to get away from this perpetual turning around in circles, an effort that paradoxically imprisons him all the more: "One does not leave." This imprisonment within the world of language is one of the real hells of *A Season in Hell*. As Jean-Louis Baudry puts it, "Hell is the recognition of the system's closure and saturation, and, at the same time, the impossibility of getting out of it."[21]

The poet's battle with language helps to explain the choppy nature of the text, its continual starting and stopping, its short sentences and paragraphs, its recurrent spaces of silence as the white page aggressively intervenes between sections and subsections of text. As the poet sees that he is getting nowhere, his only recourse is to stop and attempt to start afresh. For instance, at the end of the second subsection of "Bad Blood" he states: "Not knowing how to express myself without pagan words, I would like to be silent." He immediately ceases writing, a halt represented visually by the blank space on the page. At the end of the third subsection he seeks "a well-intoxicated sleep on the beach," and again his text falls into the temporary silence of sleep (the blank page). At the end of the fourth part, after again watching himself trying to "go somewhere" ("Let's go!"), he finally exclaims with self-disdain: "How stupid I am!" Once again he breaks off writing, only to begin the next section with his habitual return to beginning: "While still a child . . ." At

the end of this fifth part he remarks: "I can't even see the time when, with the whites landing, I'll fall into nothingness," and again there appears a white space in the text during which the "I" (the text) falls into nothingness because the "whites" (white people? white spaces?) have aggressively taken over. In the opening line of the next section he exclaims, "The whites have landed. . . . I hadn't foreseen it!" This is a repetition of his previous denial of foreknowledge ("I can't even see the time when . . .") that draws the reader's attention to the way in which Rimbaud's language plays games with itself.

One cannot read a linear progression into *A Season in Hell* and identify a definitive silence at the end because that silence into which the text inevitably falls is, as we have seen, a repetition of the many manifestations of silence that have occurred throughout, a repetition that, because of its very nature as repetition, continues the work of the text. The ending is not an ending in the Aristotelian sense, just as the opening "formula" does not really constitute a beginning.

Matisse and Rimbaud: Energetic Performances

Rimbaud's verbal text, like Matisse's visual text, is a self-referential, non-teleological, energetic performance. Both Rimbaud and Matisse emphasize gesture, intensity, and interaction, or what I have been calling theatricality. The poet who writes "No more words. . . . Cries, drum, dance, dance, dance, dance!" opts for a primitive display of energy in the continual "voiceless pouncing of the ferocious beast" that constitutes his language (his dance). Certainly the theatricality of Rimbaud's prose style and his continual role-playing are just as antinaturalistic and "artlike" as Matisse's painting. A few critics have compared the dynamic quality of Rimbaud's work to a sort of dance, but none has thought to look to the realm of visual art for a possible analogue, probably because none of them has thought of visual art as performative in nature.

In the introduction to the catalog of the Matisse exhibition at the Grand Palais in 1970, Pierre Schneider drew attention to the space between the hands of the two dancers in the foreground of *Dance*. Instead of closing the circle of dancers by joining all the hands, Matisse leaves a gap to invite the spectator to participate in the activity, thereby pointing to the importance of the spectator in completing the work of

art. Whenever we read a verbal or visual text, we are constantly involved in an active ordering of a multiplicity of details that permits us to read; the referentiality and teleology that readers have tended to see in *A Season in Hell* are products of their own ordering of the text to make it comprehensible within the limits of habitual modes of reading literature. Reading Rimbaud in the context of other art forms such as painting and theater, however, allows us to apply other kinds of codes and to appreciate Rimbaud's text in radically different ways.

Reading Images with Words: Duchamp, Miró, Apollinaire, Lichtenstein

Very often artists include a combination of words and images in their artworks to provoke certain reactions that make us aware of our interpretive strategies. In these instances, especially when an artist deliberately subverts reading conventions, one can easily recognize the creative activity required by readers as they seek to resolve special problems of reading. While the previous three chapters demonstrated how reading a verbal text through the lens of a visual text enriches our reading of literature by enabling us to see and think differently, this chapter investigates examples in which an artist combines words and visual images within an individual artwork in order to unsettle habitual methods of analysis. In so doing, an artist depends, in advance, on the reader's capacity to read words and images relationally in order for the artwork to "work." In the series of image-text relations that follow, the real question to ask, as W. J. T. Mitchell has put it, is not "what is the difference (or similarity) between words and images?" but rather "what difference do the differences (and similarities) make?" In other words, "what does it matter how words and images are juxtaposed, blended, or separated?"[1]

In the first group of examples I consider, artists create titles that are meant to challenge readers rather than aid them in identifying images or events represented in paintings; in this way they anticipate and play with the reader's tendency to rely on titles for a key to understanding an artwork. In the second group of examples, taken from Apollinaire's

Calligrams, words themselves are arranged to form images and the reading process becomes even more intricate. The third group of examples investigates the problematics of reading in a series of verbal-visual "comic book" paintings by Roy Lichtenstein.

The Functions of Titles in Duchamp and Miró

To understand how easily titles can challenge readers, one need only think of Marcel Duchamp's love for punning in such works as *LHOOQ* or *Why Not Sneeze Rrose Sélavy?* or his deliberate "mislabeling" of readymades with such titles as *Fountain* or *In Advance of a Broken Arm.* Duchamp's *Fresh Widow* (see fig. 16) is an exemplary artwork that deliberately plays with the spectator's tendency to try to understand visual material through recourse to the title. This work appears innocent enough at first glance—we recognize a tightly closed French window, as opposed to the open windows and doors so characteristic of later surrealist paintings. The power of suggestion created by the image might even lead us to believe that we are reading the title as *French Window* instead of *Fresh Widow,* a humorous pun in itself because we do not usually call recently widowed women "fresh"—the positive associations of *fresh* are at odds with the ideological nuances of *widow.* When title and conflicting image appear together (and in this respect, it is all the more significant that Duchamp inscribed his title on the window frame), one is strongly tempted to look for comparisons between French windows and fresh widows. In true surrealist manner, the juxtaposition of two unrelated entities inevitably provokes new perceptions, and once spectators begin looking for analogies, they are relatively easy to find: the windowpanes are covered with black leather, the widow wears black; the closed window separates inside from outside, the fresh (newly widowed) widow closes herself off from the world to mourn. The windowpanes may even bring to mind the widow's pain. And, like the window, the widow is undoubtedly blue.

Duchamp has often said that the spectator completes the creative cycle of the work of art, and his statement is wholly convincing in this example; in the act of looking for analogies between French windows and fresh widows, the reader creates them based on personal experiences of the world. The fact that widows conventionally wear black, for instance, is nowhere in the artwork, but rather in the mind of the reader

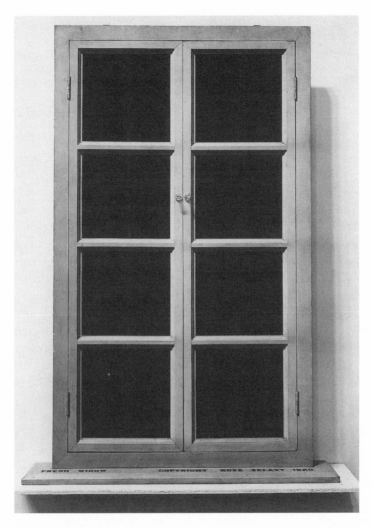

Fig. 16. Marcel Duchamp, *Fresh Widow*, 1920. Miniature French window, painted wood frame, and eight panes of glass covered with black leather, 30½″ × 17⅝″, on wood sill ¾″ × 21″ × 4″. Museum of Modern Art: Katherine S. Dreier Bequest. © 2000 Artists Rights Society (ARS), New York/ADAGP, Paris/Estate of Marcel Duchamp. (Photograph © 1999 Museum of Modern Art, New York.)

who must bring this knowledge about the world to the work of art. Quite literally, then, this artwork depends on the reader's response and active participation. *Fresh Widow* is a good example of what Octavio Paz meant when he called the artwork a machine for producing meanings: "The value of a picture, poem, or any other artistic creation is in proportion to the number of signs or meanings that we can see in it and the possibilities it contains for combining them."[2] The provocative analogies between image and title that readers imagine as they contemplate *Fresh Widow* necessarily reactivate the artwork and open it toward the world. Instead of an aesthetics of consumption, this is an aesthetics of production.

The impact of title on interpretation can be seen in the case of many of Duchamp's works, especially the one that caused such a scandal at the Armory Show in New York in February 1913: *Nude Descending a Staircase* (see fig. 17). One Chicago newspaper told people to "eat three Welsh Rarebits and sniff cocaine" in order to understand the painting.[3] Several theories have been proposed to explain the hostile reception, for example, that the painting deviated from the brand of cubism fashionable at the time, or that Duchamp seemed to be painting in the futurist manner. Duchamp himself, however, has suggested that the scandal was caused not so much by the painting as by its title.

As in *Fresh Widow*, the title is inscribed clearly in the lower-left-hand corner of the work, so it is difficult to miss. Here, Duchamp has taken the nude, one of the sacrosanct, traditional motifs of Western art, and completely deformed it, substituting for traditional flesh tones harsh metallic machinelike shapes devoid of anything human. The word *nude* undoubtedly made readers think of the idealized, sensuous women depicted in more traditional paintings of the genre—nudes presented, for instance, as objects of desire for the male gaze. To see a painting that suggested the ideal only in order to negate it was probably too much of an affront to the uninitiated American audience. To make matters worse, this "nude" was not reclining or sitting or standing gracefully, as was the custom, but descending and moving—coming down off the immobilizing pedestal that woman, along with everything that she had come to represent, had occupied for centuries. The nude had been linked to eternal and unchanging ideals of truth and beauty throughout the history of Western art; on the contrary, this nude moves quite rapidly in what appears as jerky motion and confused clutter. The movement downward explicit in the word *descending* may have

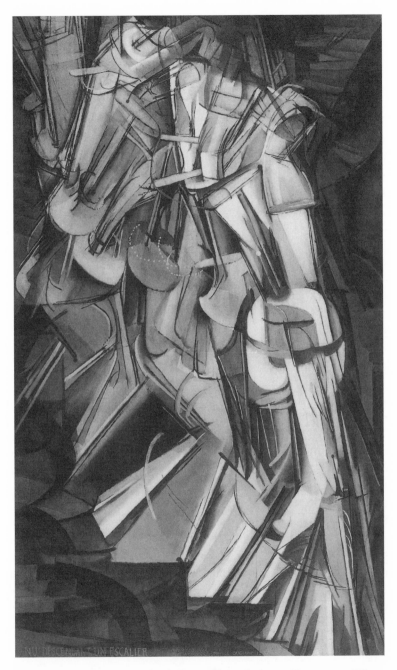

Fig. 17. Marcel Duchamp, *Nude Descending a Staircase*, No. 2, 1912. Oil on canvas, 57⅞″ × 35⅛″. Philadelphia Museum of Art: The Louise and Walter Arensberg Collection. © 2000 Artists Rights Society (ARS), New York/ADAGP, Paris/Estate of Marcel Duchamp. (Photograph courtesy of the Philadelphia Museum of Art.)

warned spectators that they were witnessing the end of beauty as an aesthetic value to be cultivated in art. Only a few years earlier, the futurists had denounced the nude as a subject for painting in their 1910 manifesto, calling it "nauseous and tedious." Even the cubists had shunned the nude as a subject, so that in 1912, Apollinaire was able to write that Duchamp was the only one still interested in the nude. Duchamp, however, represents the nude nowhere except in his title. Indeed, the nude for Duchamp is nothing more than a perceptual category that activates a discursive field; his work points to his skeptical, analytical approach to the very concept of the nude as an unchanging, static essence.

Duchamp's intentional provocation is a crucial factor that cannot be ignored here, and it is precisely this desire to provoke on the part of the artist that, in many instances, separates dadaist from surrealist art.[4] One need only recall André Breton's dictates about the abandonment of conscious control as a standard in surrealism to gauge how far Duchamp's artistic enterprise, with its desire to undermine and play with readers' expectations, differs from surrealism's. At the opposite end of the spectrum from Duchamp's deliberate choice of title would be something like Max Ernst's *frottage* technique of watching shapes emerge and then entitling his artwork accordingly.

In the examples discussed so far, I have shown how the verbal element—the title—radically restructures the visual. When I refer to the verbal component as "title" (even though it, too, is visual), I am provisionally assuming that the visual material is primary in importance, and that the verbal is in the service of the visual. But in the case of Duchamp, who was just as happy to play with words as with images, it is logically possible to understand the visual as being in the service of the verbal "text" (what I have been calling "title"). How can we speak of the dominance of the visual over the verbal when Duchamp problematizes their relationship? Since Duchamp conventionally belongs within the disciplinary boundary of visual art, the assumption has always been that his visual material was of primary importance, but this is not necessarily the case. We have already seen, in chapter 2, how René Magritte pursues the project of unsettling the boundary between the verbal and the visual.

Some painters refuse to give titles to their paintings and designate them by numbers or by the medium used so that the title remains as neutral as possible. Other painters go to the opposite extreme and

choose poetic titles to evoke elements not represented visually. Regardless of whether the artist does or does not intend to increase the possibilities for interpretation in this manner, the combination of verbal and visual necessarily enriches interpretation. A good example of such an instance is Joan Miró's *The Beautiful Bird Revealing the Unknown to a Pair of Lovers* (see fig. 18). The French title has a slightly different nuance: *Le Bel Oiseau déchiffrant l'inconnu au couple d'amoureux*. After locating the title on a museum wall, typical spectators would probably respond to the verbal clues and examine the painting in an attempt to locate the beautiful bird and the pair of lovers they assumed would be represented somewhere. After noticing the busyness of the painting and the quantity of mysterious signs, shapes, symbols, and forms, they would see light lines connecting some of the signs and would discover that these lines themselves formed other nonidentifiable forms. These lines, in fact, are an essential factor in what Sidra Stich has called Miró's sign language: "The potency of a basic vocabulary of dot and line markings is declared as Miró shows how these primal elements can be ordered into various patterns, expanded into divergent shapes, and formed into ideographic letters, numbers, and figure images."[5] The lines serve to relate the dots and forms to each other in ways that allow additional shapes to come into being.

Instead of attempting to identify shapes and forms, however, I would like to propose an alternative way of going about reading this painting by considering the title in relation to the title of the whole series of gouaches, "Constellations." This painting is the twenty-first in a series of twenty-three "Constellations" painted between January 1940 and September 1941.[6] Unlike stars, which exist physically in the sky, constellations exist only conceptually. Although the component parts of constellations exist against the sky, we are the ones creating an image by our act of looking; we are the ones who conceptualize invisible lines between stars to connect them to each other. Miró's "Constellations" draw attention to this same activity of connecting things to each other to form clusters of sense or meaning. His paintings are full of enigmatic signs placed arbitrarily on the canvas, yet no sign has intrinsic value or importance over the others until they are brought together by the light lines.

In a painting such as *The Beautiful Bird Revealing the Unknown to a Pair of Lovers*, we may or may not recognize the beautiful bird and the pair of lovers, but we do see something being revealed in the mass. The

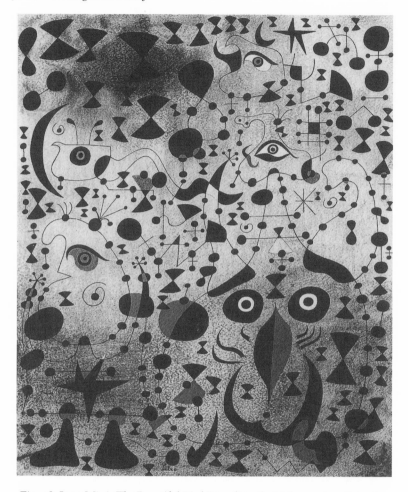

Fig. 18. Joan Miró, *The Beautiful Bird Revealing the Unknown to a Pair of Lovers*, 1941. Gouache and oil wash on paper, 18" × 15". Museum of Modern Art, New York. Acquired through the Lillie P. Bliss Bequest. © 2000 Artists Rights Society (ARS), New York/ADAGP, Paris. (Photograph © 1999 Museum of Modern Art, New York.)

operative word in the English title, then, is *revealing*. The poetic title, in this case, does relate to the painting, not because it tells us what is represented, or because it identifies the shapes for us, but because this word *revealing* draws attention to the function of constellations: they reveal a shape that is a pure construct.

The forms depicted in Miró's painting are of less interest than the

fact that forms can always be constructed by connecting dots in certain ways. To put it differently, disparate variables can always be given shape through the operation of an organizing gesture; it is always the connections made between things, and not the things themselves, that produce meaning. In her study of Miró, Margit Rowell has suggested that this art be called "existential painting" because of its parallels with existential philosophy: "One could call this existential painting insofar as the philosophy of existentialism, born of World War II, can be understood as asserting that nothing (or no person) exists except as a term in a relationship with something (or someone) else, that man is not an individual in the traditional idealist sense but part of a total scheme, in which his identity depends on its recognition by other existing beings."[7] The parallel with existentialist philosophy holds up in the French title of Miró's painting as well, where the operative word would be *déchiffrant*, which points to our own activity of decoding (and simultaneously encoding and creating) the connections between things.

Miró sometimes includes his titles visually in his paintings and calls them "picture-poems," as in *Un Oiseau poursuit une abeille et la baisse* (see fig. 19). Although less problematic than the other painting, this one also contains a group of signs that calls for decoding/encoding. At the top of the painting, a white patch of paint suggests a cloud in the sky through which the words *un oiseau* pass as if representing not the bird, but the movement of the bird from left to right through the cloud. The bird then emerges from the end of the final letter, *u*, represented as a clump of feathers pasted to the canvas in the form of a bird. Next, in the center of the painting is a yellow lasso-shaped form of oil paint applied directly from the tube, perhaps representing the flight of the bee. The word *poursuit* is written in a vague, meandering script over and under the lasso-shape and suggests the movement of the bird's flight as it follows the bee's path in hot pursuit. There is also a hint of another bird just above the place where the *u* in *poursuit* should be—in fact, this mark looks more like a *u* than it does a bird, but we have come to expect this particular sign to represent a bird. By positioning the *u* above the word, Miró reminds us that it is merely a *u*-shaped sign to which we give value by calling it a bird. Moving downward, we find a splotch of blue paint with the words *une abeille* written through it, as if the splotch were to represent the collision of bird and bee. This collision is an example of the dada idea of shock that Miró believed was central to the work of art. According to Miró, dada was what initiated him into the avant-garde, not surrealism.

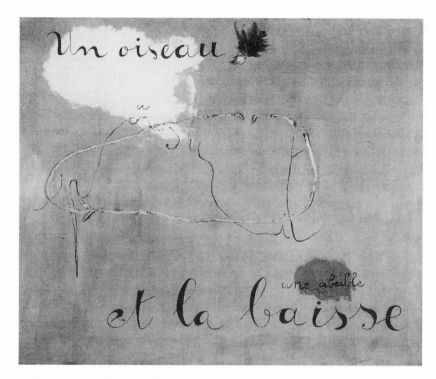

Fig. 19. Joan Miró, *Un Oiseau poursuit une abeille et la baisse,* 1926 (picture-poem). Oil and collage on canvas, 31⅞″ × 39⅜″. Private Collection, U.S.A. © 2000 Artists Rights Society (ARS), New York/ADAGP, Paris. (Photograph courtesy of the Acquavella Galleries, New York.)

Barbara Rose describes Miró's affinity with dada in terms of the type of shock it sought, much different from the type of shock desired in surrealist art:

> The splatter, the spot, the anti-art look, the ugly, and the brutal were acceptable [to Miró] first within the Dada context. In contrast with Dada, Surrealism was a reactionary movement that sought to define "shock" in terms of erotic or sado-masochistic subject matter, which had nothing in common with Miró's sensibility.[8]

Rose may be accurate in her assessment that Miró's use of shock differs substantially from surrealism's penchant for shock value obtained

through erotic or sadomasochistic subject matter, but the very next verb painted on Miró's canvas has erotic overtones that cannot be ignored. Although the words *la baisse* are used incorrectly in this sentence, they simultaneously suggest *l'abaisse* (takes her down) and *la baise* (kisses her/copulates with her), either of which would be grammatically correct. In this painting, the phonetic ambiguity as well as the shape and the movement of the writing through the space of the painting tell a whimsical story of their own. It was precisely this whimsy, in fact, that led André Breton to complain about "a certain arrest of [Miró's] personality at the infantile level."[9]

The four paintings discussed above differ substantially from each other, but all are variations on a theme: that no matter what the relationship between word and image, and regardless of whether the word appears within the artwork or outside the frame as title, the reader will always "make sense" of even the most contradictory or seemingly arbitrary details in an attempt to understand the work. A title may not correspond to the visual image the reader initially perceives, but the combination of word and image will certainly elicit a response and an interpretation.

Apollinaire and *Calligrams*

Guillaume Apollinaire's collection of picture-poems entitled *Calligrams* provides a different type of example of the word-image interaction, one that brings into even sharper focus, because of its antitraditional arrangement of lettering, the activity required of readers and the ways in which that activity depends on conventions and habits of reading.[10] As in the artworks discussed above, we read the images that comprise the calligrams through their titles and/or the words contained within. Apollinaire follows the artists of cubist collage in his use of explicit, rather than poetic, titles that tell readers exactly what they are seeing. Apollinaire's title, "The Neck-Tie and the Watch," for example, is as explicitly descriptive as the title of Picasso's collage, *Newspaper and Violin.*

In his 1917 lecture entitled "The New Spirit and the Poets" ("L'Esprit nouveau et les poètes"), Apollinaire spoke about the innovations of cinema and encouraged visual experimentation in the field of poetry: "In an epoch when the popular art *par excellence,* the cinema, is in essence a

picture-book, it would be strange if poets did not try to create pictures for meditative, more sophisticated persons who find the productions of the film makers too crude."[11] Apollinaire himself had, in fact, already begun experimenting with the visual arrangement of words on the page as early as 1913, when he first started composing the *Calligrams* he would publish in 1918. Of course, Apollinaire was not the first to play with the typographical arrangement of words on a page—Mallarmé had already published *A Throw of the Dice*. Indeed, as early as the sixteenth century, Rabelais had already formed the shape of the Holy Bottle by manipulating words.

The typographical manipulation in Apollinaire's *Calligrams* is very different from that appearing in Mallarmé's *Throw of the Dice*—much less ambiguous, much less suggestive, and certainly much less difficult to decode. Apollinaire's picture-poems are meant to exist visually on the page; when read aloud they seem quite banal. As in Mallarmé, the activity of reading and making connections, thanks to the poet's typographical manipulation, becomes a challenge and a source of pleasure for the reader. Apollinaire's attitude, however, is significantly more lighthearted and colloquial than Mallarmé's. As he writes in the calligram entitled "The Neck-Tie and the Watch," "This is so much fun" [Comme l'on s'amuse bien].

Apollinaire has gone further than Mallarmé in terms of typographical arrangement, abandoning the traditional horizontality of words on the page and instead forming images with his words. While Mallarmé seeks to use words in such a way as to avoid evoking any stable, concrete reality, Apollinaire's goal is exactly the opposite: to create visual images with words in the same way that a painter renders images concrete on canvas. While Mallarmé seeks to approach the abstract and the art of music, Apollinaire aims for the concrete, as in the art of painting. At one point he even thought of publishing his ideograms under the title, *And I, Too, Am a Painter (Et moi aussi je suis peintre)*.

While Apollinaire's painter friends Braque and Picasso were experimenting with new ways to treat the problem of space and represent a three-dimensional reality on a two-dimensional canvas, Apollinaire was attempting to innovate poetry by playing with space. Apollinaire's experimentation with the calligrams, however, is quite different from the cubist aesthetic. Where Braque and Picasso sought to represent an object from many perspectives simultaneously (since they believed that simultaneous multiple perspectives would offer a "truer" representa-

tion of an object in its three-dimensional reality), such simultaneity is nowhere present in Apollinaire's picture-poems. Although Apollinaire praised simultaneity and wrote that a painter must be a kind of God who could "take in, with one glance, past, present, and future" [embrasser d'un coup d'oeil: le passé, le présent et l'avenir], he himself did not attempt to achieve this in the calligrams.

Instead of comparing these *Calligrams* to the cubist's experiments with simultaneity, it is more productive to compare them with collage. The cubist experimentation with collage is well documented. In a first stage, disparate objects were painted together on a canvas: bits of newspaper, parts of musical instruments, cigarette packs, objects from a café. Soon, instead of painting objects, the cubists began to paste other materials onto the canvas: cloth printed with chair-caning, wallpaper resembling wood, even bits of newspaper. Art was no longer just a painted representation of reality, it incorporated material reality. Both Braque and Picasso relished the paradoxical new relationship between "true" and "false" that this technique enabled them to create.

Apollinaire's calligram entitled "Heart crown and mirror" ("Coeur couronne et miroir") (see fig. 20) resembles the first stage of cubist collage in that Apollinaire, like the cubist painters, juxtaposed representations of three disparate objects together on the page without attempting to suggest unity or coherence. The three nouns of the title indicate to us the identification of the three visual images formed by the words of the poem. Starting in the upper-left-hand corner, according to convention, we read the heart figure first. We start with the capitalized words, *Mon Coeur,* and proceed clockwise: "Mon Coeur pareil à une flamme renversée" [My heart like an upside-down flame]. "Heart" and "flame," of course, are both words suggestive of passion and warmth, but in this example Apollinaire exploits their visual as well as their semantic similarities: the heart actually resembles an upside-down flame. Moreover, the word *renversée* refers to our own activity of reading, for in order to read the words *une flamme,* we must reverse our normal patterns of reading both from left to right and from top to bottom.

The second image, the title tells us, is a crown. If we start reading from the top down, as is customary, we discover the word *qui,* which seems to be a continuation from the previous image: "Mon coeur pareil à une flamme renversée qui . . ." But we reach an impasse when we try to continue. The fact that Apollinaire teases us with this possibility that dead ends again draws attention to the reader's activity, to the choices

CŒUR COURONNE ET MIROIR

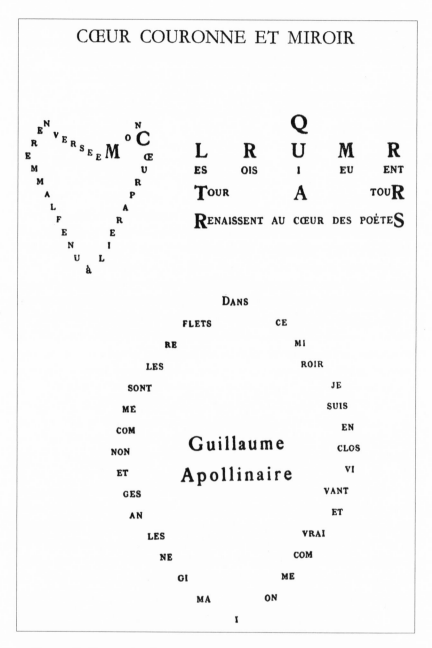

Fig. 20. Guillaume Apollinaire, "Coeur couronne et miroir" (from *Calligrammes*, 1918).

one must make and the habits informing those choices. The fact that this sentence does not continue also reinforces the analogy with cubist collage: these are three separate images on a page, like a still life, that have nothing in common. Instead of looking for the sentence's continuation, we must start reading the crown with the capital *L* at the left, forming words vertically, against convention, and joining them horizontally: "Les Rois QUi MeuRent" [Kings who die]. Each capital letter is meant to represent one of the points on the crown we assume is represented because the title indicates that this is so. As our eyes track down and up and down again in a zigzagging way (from the capital letter *L* to the small *es* in *Les*, and then up again to the capital *R* and down again to the small *ois* in *Rois*, etc.), the eyes' movement actually traces the outline of a crown with points. The second line, "Tour A touR" [by turns] rhymes with the first and seems like a logical continuation of the first, semantically speaking. At the same time, however, Apollinaire is playing with the meaning of *tour* as "tower," for the vertical lines of capital letters created at the extreme left *(L-T-R)* and right *(R-R-S)* are meant visually to resemble towers. Towers, kings, and crowns, all working together in the reader's mind, suggests an allusion to history, or to the past in general. The third line, "Renaissent au coeur des poèteS" [are born again in the hearts of poets] is Apollinaire's reference to his own activity as poet, resuscitating the past and incorporating it into the present. Although the visual images of the crown and the heart appear separately on the page, the word *coeur* occurs within the crown as well so that readers will link them together mentally.

Finally, the last image on the page is that of the mirror, with Guillaume Apollinaire's name written within. As is customary, we start reading at the top and proceed clockwise: "Dans ce miroir je suis enclos vivant et vrai comme on imagine les anges et non comme sont les reflets" [In this mirror I am enclosed alive and true, as one imagines angels and not as reflections are]. Initially, it may seem strange that Apollinaire equates truth with imagination ("vrai comme on imagine"), also that he calls the angels we might imagine "alive and true" (as opposed to reflections in mirrors, which are neither alive nor true). Apollinaire suggests that "true" reflections, that is, those taking place in the imaginations of readers, are more real than "false" reflections in mirrors. Reflections in mirrors, we all know, necessarily distort the object by reversing the image they reflect (Apollinaire has already alluded to reversals with the image of an upside-down flame).

Apollinaire's focus on truth and falsehood here recalls the playing with truth that occurs in collage, where "true" realities (bits of newspaper) are introduced into "false" painted representations of reality. Since angels exist only conceptually in our minds, and since Apollinaire calls imagined angels "true," he is suggesting that our conceptual reality is more alive and truer than our visual, everyday reality. As we know, this is the philosophy at the core of the cubist experimentation with faceting and simultaneous multiple perspectives.

Interestingly enough, the words "Guillaume Apollinaire" that appear in the mirror are not reversed, as we might expect if this were a true mirror image. This leads to some reflection about the relationship between words, images, reflected images, and imagination. First of all, Apollinaire does not furnish an image of himself, but allows us to imagine him through the words forming his name: Guillaume Apollinaire. This artistic choice would seem to echo, on a formal level, his claim that the imagination can furnish truth while reflections in mirrors cannot. Secondly, if the words are meant to represent, or take the place of, the poet (the real Guillaume Apollinaire), then the poet is not standing outside the text looking at the page (the mirror), for if he were, the words would have to be reversed in order to be "true." We conclude, then, that he is inside the page, looking out through the mirror at us; literally, he is "enclosed," as he says, in the mirror. Third, it is possible that Apollinaire is making a crucial distinction between words and images, anticipating Magritte and implying that words cannot "represent" a visual image at all.

Apollinaire's calligrams take much longer to read than verse or even prose poems, since we must not only read the letters and the way in which they interlock to form words, but we must also organize the words so that they make sense semantically. In the extended time of our reading, we are invited to contemplate the ways in which the verbal and visual material relate to each other, and how Apollinaire often alludes verbally to something his calligram performs on a formal level, as we have just seen. All of this connection-making required of the reader who encounters unconventional forms may today seem relatively unproblematic, since experimentation with unconventional forms is now the norm. In Apollinaire's time, however, such formal experimentation in the field of poetry was innovative and bold. Perhaps Apollinaire was not making such an outrageous claim in "The New Spirit and the Poets" when he philosophized that poetry, with its

move from rhymed versification to free verse and now to formal experimentation, would, along with the other remarkable innovations of his time, expand the possibilities for thought itself: "[I]nvestigation of form has assumed great and legitimate importance. Poets cannot but be vitally interested in this investigation, which may lead to new discoveries in the realms of thought . . ." (334). Formal experimentation such as Apollinaire's, where words combine with images that refer to each other in a myriad of complex ways, did, indeed, lead to radical shifts in thinking about the ways in which language might generate meaning.

Lichtenstein's "Comic Book" Paintings

Roy Lichtenstein's "comic book" paintings provide a different kind of verbal-visual interaction and make different kinds of demands on the reader. By parodying the comic strip, Lichtenstein draws attention to conventions of representation as well as cultural ideologies and stereotypes. Comic strips are only one of the many kinds of objects taken from the culture of mass production that Lichtenstein and other pop artists chose to depict, or "quote," in the early 1960s. Perhaps the most famous objects of all are Warhol's Campbell soup cans, but other important examples include Rosenquist's billboards, Johns's flags, Oldenburg's giant hamburgers, or Rauschenberg's collages of objects and images of contemporary culture. Lichtenstein was fascinated with, and reproduced, furniture and other material found in magazine advertisements (a kind of extension of Duchamp's readymades), claiming that it was above all their artificial appearance that intrigued him.[12] Given Lichtenstein's desire to comment on the artificiality of mass production, it is not surprising that comic strips would attract him with their stylization, limited color scheme, minimal indication of volume, impersonal treatment of the great themes of love and war, and the benday dot pattern required by the printing process.

The comic strips also provided Lichtenstein with a means of rejecting the inward, private emotional emphasis associated with abstract expressionism (because any emotion portrayed in comic strips is so conventional and impersonal), and they furnished him with a model to paint representational images in an artificial, highly stylized way that is neither abstract nor realistic. The limited color scheme of red, blue, yellow, black, white, and sometimes green was also a reaction against

abstract expressionism and its seemingly unlimited palette of color to convey emotion. Finally, the plain, straightforward style of lettering found in advertisements and comic strips (unlike, for example, the artful use of lettering in cubist, dadaist, or futurist collage) corresponded to the impersonality of the mass media that pop artists embraced. As Lawrence Alloway points out in his book on Lichtenstein, the artist's use of words in his paintings implicitly resists the modernist theory of "medium purity" by introducing elements from culture and advertising (low art) into easel painting, or what is supposedly high art (24). By "quoting," or referring intertextually, to a mass-produced comic strip in a single easel painting, Lichtenstein anticipates the postmodernist concern with questioning the distinction between what have conventionally been called high art and low art.

Lichtenstein's earliest comic strip paintings depicted recognizable characters such as Dick Tracy (1960), Mickey Mouse, and Donald Duck (1961), but he soon opted for the more anonymous characters found in love or war comics of the period. Unlike Rauschenberg, whose collage canvases contain fragments of recognizable realistic scenes or images of real figures such as John F. Kennedy, and unlike Warhol, whose silkscreens portray images of real objects such as Campbell's soup cans or real people like Marilyn Monroe, Lichtenstein has drained his images of literal reference so that there is no doubt that what we are seeing is something artificial, or, at best, the representation of a stereotype ("the representation of a representation," as Donald Judd has called them).[13] The women in Lichtenstein's comic strip paintings are all recognizable types, and they are always caught in the midst of some dramatic situation. One might even say that the genre preferred by Lichtenstein in these paintings is melodrama: exaggerated situations full of cliché, usually about amorous intrigues in which (1) the woman is left alone to suffer in silence *(Drowning Girl)*, (2) the woman wants to be alone to suffer in silence *(Eddie Diptych)*, or (3) the woman finds ecstatic fulfillment in coupledom *(We Rose Up Slowly)*. Just as Lichtenstein exaggerates and intensifies emotions in his canvases, he enlarges the scales of the paintings from tiny comic book size to full-blown wall size. The panels of *We Rose Up Slowly*, for instance, measure 68 inches by 24 inches and 68 inches by 68 inches.

Most often, although not always, the situation depicts anxiety and crisis, and what ultimately emerges is a sense of the incongruity between the subject matter (anxiety) and the cool, impersonal, mechan-

ical style in which it is portrayed. Lichtenstein seems to be parodying emotions at the same time that he comments on the mechanical perfection of mass-media reproduction. The emotions, though, are not those of real people; they are the stereotypical emotions of stereotypical, anonymous cartoon figures.

Lichtenstein's comic strip figures are always portrayed in contexts that are not too difficult to decipher. This contextuality is not surprising when one remembers that a real comic strip is composed of a sequence of several individual frames. Each individual frame, or scene, makes sense only in the context of the whole strip, which is meant to be read horizontally from left to right as in any conventional narrative. Similarly, just as individual frames are read in the context of the strip, each strip is only a fragment of a larger narrative, the one that develops over time in successive newspaper editions. By excerpting a single frame from an imagined strip and isolating it on the canvas, Lichtenstein invites us to reconstruct the situation and supply the contextual information we need for any reading to take place. Because we know the conventions of comic strips so well and because these are such stereotyped situations, we have no difficulty in imagining the required context. In the very act of imagining a context, we are, of course, depending on cultural ideologies and discourses.[14]

I turn now to three examples of Lichtenstein's comic strip paintings to explore the various ways in which his words and images interact and the reading conventions that come into play. The first example, *Eddie Diptych* (see fig. 21), is composed of two separate panels, the one on the left containing words and the one on the right containing a combination of words and images. In keeping with convention, we start reading in the upper-left-hand corner and discover that the words on the left serve as a narrative introduction to the situation portrayed on the right, with the "I" clearly referring to the daughter: "I tried to reason it out! I tried to see things from mom and dad's viewpoint! I tried not to think of Eddie, so my mind would be clear and common sense could take over! But Eddie kept coming back. . . ." We read four separate sentences on the left, each one, except the last, punctuated with an exclamation point. The lack of exclamation point and substitution of the ellipsis marks this sentence's difference from the others; it is also the only one that does not begin with "I." Instead of showing final resolution at the end of the sentence with a period, Lichtenstein uses ellipsis to indicate a lack of resolution that corresponds with the sentence's content, "But

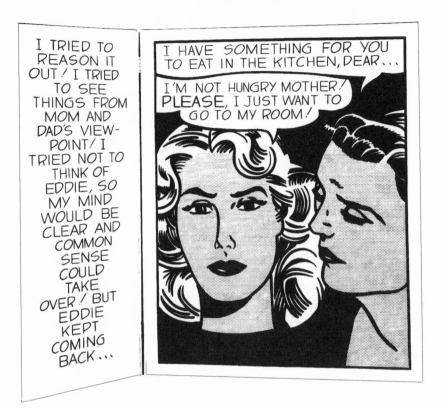

Fig. 21. Roy Lichtenstein, *Eddie Diptych*, 1962. Oil on canvas, 44″ × 52″ overall (2 panels). © Roy Lichtenstein. (Photograph courtesy of Leo Castelli Gallery.)

Eddie kept coming back. . . .″ In addition, the ellipsis trailing off to the right invites us to turn our eyes to the panel on the right for further reading.

Following the conventions of comic strips, Lichtenstein portrays speech by enclosing words in a balloon that points to the person speaking. In this example both people speak, although it is clear that the mother's speech precedes the daughter's because her balloon is on top (again, convention dictates that we read from top to bottom). Her words, "I have something for you to eat in the kitchen, dear . . ." trail off in ellipsis to indicate either a hesitation on her part (she is playing the role of the mother trying to be helpful but not knowing what to say) or

else an interruption on the daughter's part (given the fact that the daughter's balloon follows immediately). The wrinkles on the mother's forehead signify her concern for her daughter's plight, but she falls into the cliché of the middle-class mother who believes that feeding her children will cure all their problems, or at least keep their minds off their problems. The daughter, eyebrows knit in obvious emotion (although it is difficult to tell which emotion—sadness, anger, pain, frustration, or stubbornness), rejects her mother's irrelevant offer: "I'm not hungry mother! Please, I just want to go to my room!" The letters in the word "Please" are bolder than the others, boldface type being the sign of a more emphatic voice, and the exclamation point reinforces the sense of melodramatic intensity. This daughter just wants to be by herself so that she can think about Eddie, although she pretends the opposite and denies her desire in the panel on the left ("I tried not to think of Eddie"). While the left-hand panel indicates an attempt at a more rational mode of behavior with words like "reason," "clear [mind]," and "common sense," the right-hand panel portrays emotion.

It is interesting that the conventions of comic books call for speech to be represented by balloons containing words and pointing to the person speaking rather than by open mouths. Although both mother and daughter speak in *Eddie Diptych*, their mouths remain closed. Sometimes words enclosed in balloons are meant to represent thought instead of speech, which is done by connecting the balloon to the person thinking with a few mini-balloons, as in *Drowning Girl* (see fig. 22). Paradoxically, although the woman in *Drowning Girl* is thinking instead of speaking, Lichtenstein has painted her with an open mouth.

Drowning Girl is another of Lichtenstein's canvases of exaggerated emotion. In this painting the image occupies most of the canvas while the balloon's size is reduced to a very small area. Its size and position in the upper left portion of the painting balances the hand with rounded fingers emerging from the water in the lower right portion. The image depicts a female head surrounded by swirling water and Hokusai-like waves, her rounded shoulder and hand emerging from the waves. There are no straight lines in the picture: shoulder, fingers, hand, and hair all repeat the wave motif that dominates throughout. Even the balloon of words with its rounded contours fits pictorially into the overall design, as do the round mini-balloons that signify thought. Lichtenstein has painted tears underneath the woman's closed eyes so that the water on her face, associated metaphorically with the water surround-

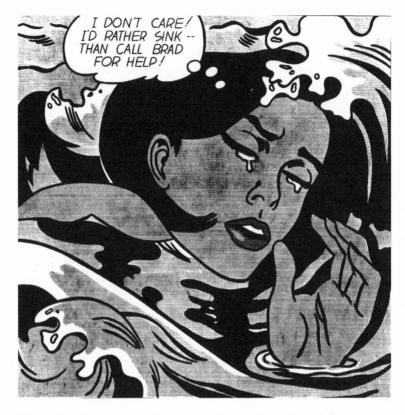

Fig. 22. Roy Lichtenstein, *Drowning Girl*, 1963. Oil and synthetic poly-mer paint on canvas, 67⅝" × 66¾". Museum of Modern Art, New York. Philip Johnson Fund and gift of Mr. and Mrs. Bagley Wright. © Roy Lichtenstein. (Photograph © 1999 Museum of Modern Art, New York.)

ing her, suggests that she is drowning in her own grief. Her thoughts, "I don't care! I'd rather sink—than call Brad for help!" reveal the stereo-typically distraught female so characteristic of comic strips of the period. Exclamation points at the end of sentences again serve to inten-sify emotion, while the relatively small, thin lettering seems to suggest a lack of strength or vigor, an inability to deal actively with the situa-tion ("I don't care"). The two dashes after the word "sink" may signify a time lapse (the passage of time between thoughts) or else the presence of something like a sniffle between thoughts. In either case the dashes

interrupt the sentence and create an effect of discontinuity that is at odds with the wavy continuity of the image.

Although the title promises a turbulent subject, the compositional elements of *Drowning Girl* are anything but turbulent. Her hair is absolutely in place, and her relaxed hand and head resemble the posture of a peacefully sleeping figure snuggled up against a pillow. Without the knitting of the eyebrows and the lines between the eyes and eyebrows, the face would appear calm—perhaps even eroticized. Everything in the painting suggests a calm, posed image, with no sign of danger and no potential for drowning. Lichtenstein has even used compositional elements to create depth in the traditional way (by overlapping forms) so that the reader's eye is easily directed into the painting without ambiguity or conflict.[15] In this painting, the verbal material seems at odds with the visual material.

In *We Rose Up Slowly* (see fig. 23), Lichtenstein has separated the words from the image by creating two separate panels to hold each. The panel on the right depicts a highly stylized embracing couple caught in the ecstasy of anticipation: eyes closed, lips parted, heads positioned for what promises to be a passionate kiss, they seem oblivious to the rest of the world. They are submerged in water, the blond locks of her hair echoing the ribbonlike wavy patterns of seaweed and underwater currents that Lichtenstein has painted in black, white, and fields of benday dots, a reference to the printing process. White bubbles scattered throughout reinforce the underwater quality and recall the benday dots, although they are printed on a much larger scale. Stylistically, Lichtenstein has included many of the conventions used in comic books to represent handsomeness or beauty, for instance, his thick neck and square jaw, or her long eyelashes, delicate nose, and full red lips. The panel is perfectly square so that neither horizontal nor vertical elements can compromise the overall wavy fluidity.

The panel on the left contains the words that serve as the image's caption: "We rose up slowly . . . as if we didn't belong to the outside world any longer . . . like swimmers in a shadowy dream . . . who didn't need to breathe. . . ." Unlike the two earlier paintings, the words of *We Rose Up Slowly* are not enclosed in a balloon and do not occupy the same physical space as the image. The convention of representing thought by connecting the balloon to an area near the thinker's head with a few mini-balloons (as in *Drowning Girl*) and the convention of representing speech by appending a directional indicator at the bottom

Fig. 23. Roy Lichtenstein, *We Rose Up Slowly*, 1964. Oil and magna on canvas, 68″ × 92″ overall (two panels). © Roy Lichtenstein. (Photograph courtesy of Leo Castelli Gallery.)

of a balloon (as in *Eddie Diptych*) are both absent here. As a result, it is impossible to know with any certainty who these words belong to, although one can assume, given the proximity of the impending kiss, that they represent thought, not speech. The juxtaposition of the two panels seems to indicate that these are the thoughts of one member of the couple; familiarity with the conventions of comic strips would lead us to associate the romantic, dreamy content of the words with the female rather than the male (regardless of the ways in which actual women and men behave).

Because the words of the sentence are separated into four fragments and visually divided from each other by ellipses, the impression created is one of slow abandon, timelessness, and weightlessness, with the end of the sentence trailing off into infinity. The same effect is obtained in the panel with the image. Although Lichtenstein has depicted his romantic couple in a close-up view and has cropped their heads and bodies so that the kiss occupies the very center of the frame, the pas-

sionate intensity of the moment paradoxically translates into the same timelessness, weightlessness, and abandon suggested by the form and content of the visible language in the other panel. Similarly, ribbons of swirling water currents, seaweed, and flowing waves of hair contribute to the overall sense of freedom from constraints. Even though the subject matter of the painting is designed to depict timelessness, Lichtenstein's use of the iconography of mass-produced comic strips plunges his painting right back into a specific time—the time we now associate with the popular culture of the 1950s and 1960s.

Verbal and visual discourse operate together in several different ways in this painting. At the simplest referential level, various elements in the image become recognizable thanks to the accompanying words, such as the fact that the couple seems suspended in water ("like swimmers") or that the darker ribbonlike patches of benday dots crossing the bodies may be shadows of seaweed or water currents ("in a shadowy dream"). Some of the words serve as ironical self-commentary on the status of the painted figures who literally do not "belong to the outside world" (outside the world of the painting, that is) and who literally do not "need to breathe." The verticality of the panel on the left with its vertical arrangement of words serves an important function as it forces the eye of the reader to plunge from top to bottom, contradicting the directionality indicated in the title and the opening fragment, "We rose up slowly." And finally, by juxtaposing verbal and visual signifying systems, Lichtenstein has underlined the essential difference between language, which is directional in syntax, and this specific visual image, whose subject matter, pictorial elements, and square frame all work together to subvert a fixed directionality of reading, emphasizing instead a harmonious, spatial simultaneity.

Although the images inside the frames of Lichtenstein's paintings are false in certain respects, they are true in others. Many critics have formulated theories about truth and falsehood in visual images; Roskill and Carrier have explored this issue in some detail, mapping out the different ways in which images can be true or false.[16] The authors contrast "correspondence" theories of truth (which stress truth of representation and concern themselves with likeness or verisimilitude of behavior) with "coherence" theories of truth (which stress the way the work of art offers an "insight" into "reality"). A coherence theory, for example, might focus on the way something is framed, such framing being the expression of political, social, and cultural interests of a class

of society. The authors' example of the engagement photographs of the Prince and Princess of Wales, in which the prince was positioned at a slightly higher level than the princess, makes this point clear. Although the image is false with respect to the facts (the actual heights of the two individuals), it is true in terms of the prevailing male ideologies of the time, which sought to establish the male as taller and physically dominating (and thus superior to) the female. The same image may thus be both true and false at the same time, depending on the criteria being used to evaluate it, that is, depending on the way it is seen, or framed.

It is in this respect that the images in Lichtenstein's paintings, with their reference to comic strips, can be said to be true. Not only do they reflect the way all art involves a reworking of other texts that exist previously, but they serve to emphasize the extent to which myths and fictions invade and play dominant roles in our daily lives. As metalanguages, his comic book paintings "work" precisely because we are so familiar with the stories they tell.

Afterword

Reading Relationally has staged and advocated a practice of reading that directs attention to readers' relationships with texts and to the ways in which our frames of reference and mediating practices shape the objects we investigate. By shifting emphasis from the object under scrutiny to the frame of reference, this book has demonstrated, through exemplary readings of literature and visual art, specific ways in which interpretation is contingent and dependent on cultural ideologies, reading conventions, and conventions of representation. This is the first meaning of the book's title. Significantly, the artistic praxis of many of the artists and writers explored in these pages grows out of an awareness of the spectator's anticipated response—and a desire to make that anticipated response play a part in the dynamics of the work of art.

This book has also staged and advocated a practice of reading that unsettles the rigid distinction between the fields of literature and visual art and calls into question their boundaries by *reading relationally* across the fields. This is the second meaning of the book's title. As such, this study participates in a larger cultural trend among artists, scholars, and thinkers who value looking beyond the powerful discourses of their specific disciplines in order to pursue and produce new understandings. The work of Foucault is very much to the point here. In his writings, he has investigated the relation between the knowing subject, knowledge, and discourses of power, explaining how power produces knowledge and determines what kind of knowledge is possible and what forms such knowledge will take:

> Perhaps . . . we should abandon a whole tradition that allows us to
> imagine that knowledge can exist only where power relations are
> suspended and that knowledge can develop only outside its injunc-
> tions, its demands and its interests. . . . We should admit rather that
> power produces knowledge . . . that power and knowledge directly
> imply one another. . . . [1]

Foucault maintains that not only the knowing subject but also the pos-
sible forms and domains of knowledge are themselves effects of power;
it is "power-discourse" that leads to the emergence of fields and cate-
gories of knowledge.[2]

One of the most pervasive discourses, or cultural practices, to have
conditioned perception is the institutional separation between the
fields of literature and art. In *Iconology: Image, Text, Ideology*, W. J. T.
Mitchell discusses the extent to which the boundaries separating the
fields of literature and visual art have been reinforced by Lessing's
well-known classification of poetry as a temporal art and painting as a
spatial art.[3] Mitchell problematizes the distinction made between the
fields by historicizing it, revealing it as a product of cultural practices
rather than a "natural" or "essential" distinction. In a provocative
analysis, he suggests that Lessing's space-time distinction was actually
motivated by matters of political economy and ideological concerns
about gender and power.

Like Mitchell's analysis, poststructuralist criticism and theory has
done much to loosen the grip of the powerful "master narratives" asso-
ciated with the individual disciplines, by which we generally mean any
story that is told in order to explain, account for, or legitimize a certain
set of data, such as stories of influence, stories of development, or sto-
ries of stylistic coherence. These master narratives have been largely
responsible for determining the parameters within which much discus-
sion takes place. But once we have understood such stories not as "nat-
ural" or "essential" bases for knowledge but rather as effects of partic-
ular discursive practices, there is no compelling reason to continue to
organize knowledge exclusively according to these patterns. Many the-
orists have worked to unmask the ways in which frames and narratives
give rise to authoritative yet ultimately limiting methodologies as well
as constraining and rigid systems of classification.

One brief example of just such a construct is the argument advanced
by New York's Museum of Modern Art to justify the existence of its

"Primitivism" exhibit in 1984–85. Claiming affinities between tribal and modern art, the catalog and the exhibit were constructed to support the claim for affinity, disregarding pieces that did not fit into this preconceived model. This very desire to establish similarities between the primitive and the modern is itself rooted in a humanist tradition that seeks to establish (narrative) continuities.[4] In a persuasive critique, James Clifford suggests that this story could have been told very differently, as a history of reclassification instead of a story of affinities:

> This other history assumes that "art" is not universal but is a changing Western cultural category. The fact that rather abruptly, in the space of a few decades, a large class of non-Western artifacts came to be redefined as art is a taxonomic shift that requires critical historical discussion, not celebration.[5]

An equally important "story" that is not told, according to Clifford, is the power and desire of the West to appropriate the world.

Instead of operating within the conventional continuities or modes of analysis of either literature or visual art, *Reading Relationally* has yoked together verbal and visual texts in an effort to bring different kinds of details into sharper focus, thereby altering and enriching our understanding of well-known texts. The book has proposed how we might change our thinking and thus our interactions with texts, and it has suggested that we unlearn habits we have acquired both by being aware of our responses and by attending to the conventions and ideologies that inform them.

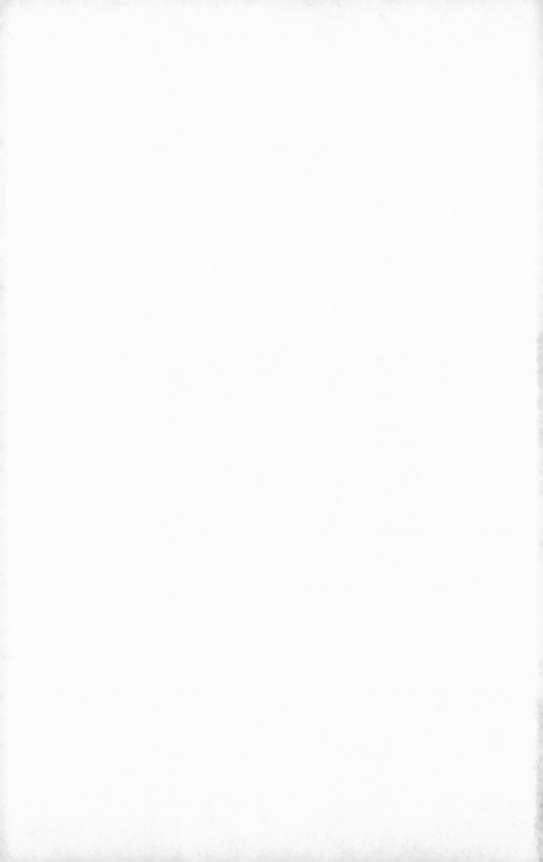

Notes

Introduction

1. For an excellent study on the dialectical relationships between graphics and the written or printed word in surrealist illustrated books, see Renée Riese Hubert, *Surrealism and the Book* (Berkeley: University of California Press, 1988).

2. Several theorists have problematized the historical separation between the verbal and the visual; see especially W. J. T. Mitchell's critique of Lessing's space-time distinction in chapter 4 of his *Iconology: Image, Text, Ideology* (Chicago: University of Chicago Press, 1986) as well as his *Picture Theory: Essays on Verbal and Visual Representation* (Chicago: University of Chicago Press, 1994). In the latter, Mitchell notes that the professional disciplines and the academic compartmentalization of knowledge have largely been responsible for the continuing perception of the fields as distinct entities. He examines the "rhetoric of purity" that has historically reinforced the distinction; he also describes some limitations in what he calls the pragmatic American "interartistic comparison" method that often takes for granted and reinforces that distinction (83–107).

3. For a discussion of the presuppositions behind naming a period style, see Wendy Steiner, *The Colors of Rhetoric: Problems in the Relation between Modern Literature and Painting* (Chicago: University of Chicago Press, 1982), 177–87. Steiner's book also contains a useful discussion of the history of the painting-literature analogy as well as several provocative examples of the application of structuralist and semiotic methods to interartistic comparison.

4. Like Barthes, who proclaimed the Death of the Author, Foucault holds that the author is not "outside" his or her text, does not precede it, but is rather a construct we find useful when we interpret texts; the author is one of our "projections, in terms always more or less psychological, of our way of handling texts: in the comparisons we make, the traits we extract as pertinent, the continuities we assign, or the exclusions we practice." Michel Foucault, "What Is an Author?" in *Language, Counter-Memory, Practice*, trans. Donald F. Bouchard and Sherry Simon (Ithaca: Cornell University Press, 1977), 127.

5. Mitchell, *Picture Theory*, 90.

6. Michel Foucault, "Nietzsche, Genealogy, History," in *Language, Counter-Memory, Practice.*

7. Roland Barthes, *S/Z,* trans. Richard Miller (New York: Hill and Wang, 1974), 10.

8. In her recent study, Ellen J. Esrock argues that theories of text processing have not sufficiently taken into account the reader's visual imaging. See *The Reader's Eye: Visual Imaging as Reader Response* (Baltimore: Johns Hopkins University Press, 1994).

9. Roland Barthes, "From Work to Text," in *Image-Music-Text,* trans. Stephen Heath (New York: Hill and Wang, 1977), 155.

10. Mitchell, *Picture Theory,* 87–88.

Chapter 1

1. Luce Irigaray, *This Sex Which Is Not One,* trans. Catherine Porter with Carolyn Burke (Ithaca: Cornell University Press, 1985), 76.

2. Susan Rubin Suleiman discusses the subversive potential and political force of parody at length in her *Subversive Intent: Gender, Politics, and the Avant-Garde* (Cambridge: Harvard University Press, 1990), and although she discusses Irigaray's notion of mimicry, she does not apply it to Duras's *The Ravishing of Lol Stein* because her frame of reference (comparing the pre- and post-Freudian male narrators of Duras's text and Breton's *Nadja*) calls for a different critical apparatus. While Suleiman is certainly correct to point out that Duras's narrator is not as obsessed with mastery as Breton's, a close reading of Duras's text reveals subtle shifts and modulations in the mode of narration that need to be taken into account. The fact that Duras's narrator insists in the opening pages that he "invents" and that he "does not know" may serve, in fact, to entice the reader to be more trusting and sympathetic, with the result that it is easier to be lured inadvertently into his story about Lol and forget later on that his authoritative pronouncements are highly personal interpretations, not truths. While I agree with Suleiman that "to be ironic about heterosexual passion . . . does not suit Marguerite Duras" (116), I do not believe that this is a book about heterosexual passion, but rather a book about a male desire to understand and "know." Although Duras's attitude is neither ironic nor sarcastic, she nevertheless plays with mimesis in a self-conscious way to expose the unconscious operations of that male desire.

3. Marguerite Duras, *The Ravishing of Lol Stein,* trans. Richard Seaver (New York: Pantheon, 1986).

4. "Cindy Sherman," in *1990 Current Biography Yearbook,* ed. Charles Moritz (New York: H. Wilson, 1990), 547.

5. Teresa de Lauretis, *Technologies of Gender: Essays on Theory, Film, and Fiction* (Bloomington: Indiana University Press, 1987), 2.

6. Mary Lydon, "The Forgetfulness of Memory: Jacques Lacan, Marguerite Duras, and the Text," *Contemporary Literature* 29 (1988): 357.

7. Martha Noel Evans, *Masks of Tradition: Women and the Politics of Writing in Twentieth-Century France* (Ithaca: Cornell University Press, 1987), 142.

8. In an interesting twist, Juliet Flower MacCannell has attempted to see Lol as a subject even within a narrative that constructs her as an object: "Her complaint, then, is that once she has rejected the narrative position offered her (to be 'love-sick' and jilted) she is granted no other—not in reality, not in fantasy. She has no options. . . . This is her lack—the one she is acutely aware of under the regime: hers is a narrative deficiency" (*The Regime of the Brother: After the Patriarchy* [New York: Routledge, 1991], 169).

9. Evelyn Fox Keller, "Gender and Science," in *Discovering Reality: Feminist Perspectives on Epistemology, Metaphysics, Methodology, and Philosophy of Science,* ed. Sandra Harding and Merrill B. Hintikka (Dordrecht, Holland: Reidel, 1983), 187–205.

10. Jane Flax, "Political Philosophy and the Patriarchal Unconscious: A Psychoanalytic Perspective on Epistemology and Metaphysics," in Harding and Hintikka, *Discovering Reality,* 245–81.

11. Susan Bordo, "The Cartesian Masculinization of Thought," *Signs* 11 (1986): 439–56.

12. It is worth pointing out here that Jacques's awareness of his own exclusion ("where I am not") is echoed by that other Jacques, Jacques Lacan, who writes, "Marguerite Duras turns out to know, *without me,* what I teach." "Hommage fait à Marguerite Duras, du *Ravissement de Lol V. Stein,*" *Cahiers Renaud-Barrault* 52 (December 1965): 9; emphasis added; translation mine.

13. Evelyn Fox Keller and Christine R. Grontkowski, "The Mind's Eye," in Harding and Hintikka, *Discovering Reality,* 207–24.

14. Quoted in Keller and Grontkowski, "The Mind's Eye," 217.

15. Quoted in Keller and Grontkowski, "The Mind's Eye," 207.

16. Keller and Grontkowski cite this passage from *New French Feminisms* incorrectly ("The Mind's Eye," 207).

17. Sarah Kofman, *The Enigma of Woman: Woman in Freud's Writings,* trans. Catherine Porter (Ithaca: Cornell University Press, 1985), 105.

18. Julia Kristeva, "Woman Can Never Be Defined," trans. Marilyn A. August, in *New French Feminisms,* ed. Elaine Marks and Isabelle de Courtivron (New York: Schocken, 1981), 137.

19. Marguerite Duras, "Marguerite Duras et la lutte des femmes," interview by Xavière Gauthier, *Magazine littéraire* 158 (March 1980): 17. Translation mine.

20. Michèle Montrelay, *L'Ombre et le nom* (Paris: Minuit, 1977).

21. Gerald Marzorati, "Imitation of Life," *ARTnews* 82 (1983): 85.

22. Douglas Crimp, "Cindy Sherman: Making Pictures for the Camera," *Oberlin College Bulletin* 38, no. 2 (1980–81): 89.

23. Craig Owens, "The Discourse of Others: Feminists and Postmodernism," in *The Anti-Aesthetic: Essays on Postmodern Culture,* ed. Hal Foster (Port Townsend, Wash.: Bay, 1983), 75.

24. In this context, we have only to remember Walter Benjamin's words about the power of film to alter perception, and especially his remarks about

reception in a state of distraction, to understand the full political implications of Sherman's artistic enterprise. Benjamin, "The Work of Art in the Age of Mechanical Reproduction," in *Illuminations*, ed. Hannah Arendt, trans. Harry Zohn (New York: Schocken, 1969), esp. 239–40.

25. Arthur C. Danto, "Photography and Performance: Cindy Sherman's Stills," in *Cindy Sherman: Untitled Film Stills* (New York: Rizzoli, 1990), 8–9.

26. Ken Johnson, "Cindy Sherman and the Anti-Self: An Interpretation of Her Imagery," *Arts Magazine* 62 (1987): 48.

27. Susan Sontag, *On Photography* (New York: Farrar, Straus and Giroux, 1977), 14.

28. Lita Barrie, "Art and Disembodiment," *Artweek* 21, no. 32 (1990): 23.

29. Judith Williamson, "Images of 'Woman'; The Photographs of Cindy Sherman," *Screen* 24, no. 6 (1983): 102–15.

30. In stressing the positive aspects of masquerade, Williamson also reminds us of the playful side of Sherman's art. Indeed, as Eleanor Heartney notes, "If Sherman's works are about the restrictive power of clichés and roles, they also have a much less remarked-upon playful side—they are manifestations of a universal urge to playact . . . to experience the multiplication of identity, not as emptiness, but as plenitude" ("Two or Three Things I Know about Her," *Afterimage* 15 [October 1987]: 18).

31. Vicki Goldberg, "Portrait of a Photographer as a Young Artist," *New York Times,* October 23, 1983, sec. 2, 29.

32. Andy Grundberg, "Cindy Sherman: A Playful and Political Post-Modernist," *New York Times,* November 22, 1981, sec. 2, 35.

33. Rosalind Krauss reads "horizontality" differently in her text included in *Cindy Sherman 1975–1993* (New York: Rizzoli, 1993). Drawing on Freud's idea that the vertical dimension is the axis of form and beauty, in which carnal instincts are sublimated, Krauss links Sherman with the avant-garde artists of the 1960s and 1970s who opposed verticality ("the fetish of high art"), "within which is inscribed all forms of sublimation, whether that be of *the beautiful* or of *the fetish*" (96).

34. Peter Schjeldahl, "The Oracle of Images," in *Cindy Sherman* (New York: Pantheon, 1984), 9.

35. Mary Ann Doane, "Film and the Masquerade: Theorising the Female Spectator," *Screen* 23, nos. 3–4 (1982): 82.

36. In other words, to use Michele Hannoosh's terms from *Parody and Decadence* (Columbus: Ohio State University Press, 1989), critics mistake the *object* of the photograph's parody (the male gaze) for the *model* of the parody (the woman in the picture).

Chapter 2

1. "Instead of continuing to valorize the finished object, emphasis is placed on *production* itself . . ." (translation mine). Philippe Sollers, in an interview with Ponge in his *Entretiens de Francis Ponge avec Philippe Sollers* (Paris: Galli-

mard/Seuil, 1970), 96. Other studies dealing with these issues include Michael Riffaterre, "Ponge tautologique ou le fonctionnement du texte," in *Ponge inventeur et classique* (Paris: Union Générale d'Edition, 1977), 66–84; Gérard Genette, "Le Parti pris des mots," *Romanic Review* 66 (1975): 283–87; Claudine Giordan, "Ponge et la nomination," *Poétique* 28 (1976): 484–95; and Serge Gavronsky, *Francis Ponge: The Power of Language* (Berkeley: University of California Press, 1979).

2. For an account of Ponge's relationship with the *Tel Quel* group, see Robert W. Greene, *Six French Poets of Our Time* (Princeton: Princeton University Press, 1979); as well as Jean-Marie Gleize, *Francis Ponge* (Paris: Seuil, 1988), especially 208–26.

3. Jean-Paul Sartre, "L'Homme et les choses," in *Situations I* (Paris: Gallimard, 1947), 245–93. All English translations from this text are my own.

4. Maurice Merleau-Ponty, *Phenomenology of Perception*, trans. Colin Smith (London: Routledge, 1962).

5. Francis Ponge, "Introduction au galet," in *Tome premier* (Paris: Gallimard, 1965), 196. My translation.

6. Jean-Marie Gleize and Bernard Veck (*Francis Ponge: "Actes ou textes"* [Lille: Presses Universitaires de Lille, 1984]), comment on the parallelism between a revolutionary action and Ponge's artistic intervention: "If the artist wants to intervene effectively . . . he must not be satisfied with substituting new representations for old. For from the very beginning, the true object of his intervention is not really representation (the image) but the conditions of representation, what he calls 'figures'; he works at modifying the possibilities of figuration . . ." (66). My translation.

7. John Berger, *Ways of Seeing* (London and Harmondsworth, Middlesex: British Broadcasting Corporation and Penguin, 1972), 7.

8. For an excellent study on the crucial role that verbal language plays in the interpretation of an image as well as in the mechanisms involved in the perception of an image, see Georges Roque, "The Role of Language in Seeing an Image," trans. Joan Brandt, in *Conjunctions: Verbal-Visual Relations*, ed. Laurie Edson (San Diego: San Diego State University Press, 1996), 85–106.

9. For a brief description of semantic materialism, see Sollers, *Entretiens de Francis Ponge*, 46–47.

10. Sigmund Freud, *The Interpretation of Dreams*, vol. 4 of *The Standard Edition of the Complete Psychological Works of Sigmund Freud*, ed. and trans. James Strachey (London: Hogarth Press, 1953), 295–96.

11. This is an example of what Suzi Gablik means when she says that Magritte "sought to eliminate the confusions and oversimplifications which are so deeply rooted in our habits of language that they are not even noticed." *Magritte* (Greenwich, Conn.: New York Graphic Society, 1970), 126.

12. Michel Foucault, *This Is Not a Pipe*, trans. James Harkness (Berkeley: University of California Press, 1982).

13. Rudolf Arnheim, *Visual Thinking* (Berkeley: University of California Press, 1969), 141.

14. Ponge, *Tome premier*, 405. My translation.

15. Francis Ponge, *Pour un Malherbe* (Paris: Gallimard, 1965), 203. My translation.

16. Francis Ponge, *Le Savon* (Paris: Gallimard, 1967). All English translations from this text are my own. For a perceptive recent article on this text, see Sydney Lévy, "A la recherche du savon perdu . . . ," *L'Esprit Créateur* 31 (1991): 41–50.

17. Judith E. Preckshot speaks of a "textual act [condemned] to eternal repetition of its initial stages." in her article, "The Pleasure of Soap or the Tale of the Text Perverted: Francis Ponge's *Le Savon*," *L'Esprit Créateur* 21 (1981): 48–59.

18. For an excellent analysis of "Le Pré," see Greene, *Six French Poets*, 82–97.

19. I see an analogy here between what I am describing as the activity of reading and what Derrida has described as Ponge's activity of writing. Just as the reader's act of reading sets the text (the "thing") into motion, so does Ponge's process of writing set a "thing" into motion. Derrida quotes Ponge on this point: "Once a thing has been given—no matter how ordinary it may be—I find that it always presents some truly particular qualities (. . .) those are the ones that I try to draw out and disengage." Derrida comments that this process "promises to engage in the production of events" (*Signéponge/Signsponge*, trans. Richard Rand [New York: Columbia University Press, 1984], 46).

20. Francis Ponge, "Les Mûres," trans. C. K. Williams, in *Francis Ponge: Selected Poems*, ed. Margaret Guiton (Winston-Salem, N.C.: Wake Forest University Press, 1994). "Les Mûres" appears in *Le Parti pris des choses* (Paris: Gallimard, 1975), originally published in 1942.

21. Although he does not comment on "Blackberries," Derrida quotes Ponge on the analogies existing between texts and things: "[T]he *written text* presents some characteristics which render it *very close to the thing signified*, in other words to objects in the external world" (*Signéponge/Signsponge*, 70, 72).

22. Perhaps this is the place to draw attention to Sydney Lévy's study "Knowing and Seeing in Francis Ponge" (in Edson, *Conjunctions*, 107–29), which discusses Ponge himself as a "reader." Starting from Ponge's physical reaction to seeing one of Braque's paintings, Lévy suggests that Ponge's work manifests and advocates a kind of embodied knowledge, a knowledge for and of the body that is unsayable. Clearly, there is no traditional separation between a knower and an object of knowledge here.

Chapter 3

1. Octavio Paz, *Marcel Duchamp: Appearance Stripped Bare*, trans. Rachel Phillips and Donald Gardner (New York: Viking, 1978), 77–80. Paz quotes Duchamp singling out Mallarmé as a hero: "Modern art must return to the direction traced by Mallarmé; it must be an intellectual, and not merely an animal, expression" (78). See also Mary Ann Caws, *The Eye in the Text: Essays on Perception, Mannerist to Modern* (Princeton: Princeton University Press, 1981).

2. In addition to Octavio Paz's extraordinary book on the *Large Glass*, see,

for example, André Breton, "Phare de la mariée," *Minotaur* 2, no. 6 (1935): 45–49; John Golding, *Marcel Duchamp: The Bride Stripped Bare by Her Bachelors, Even* (London: Allen Lane, Penguin, 1973); Michel Carrouges, *Les Machines célibataires* (Paris: Arcannes, 1951); Jean Suquet, *Miroir de la Mariée* (Paris: Flammarion, 1974); Arturo Schwarz, *The Complete Works of Marcel Duchamp* (New York: Harry N. Abrams, 1970); and Jean Clair, *Marcel Duchamp, ou, Le Grand Fictif: Essai de mythanalyse du "Grand Verre"* (Paris: Galilée, 1975). On the *Coup de dés*, see especially Robert G. Cohn, *Mallarmé's "Un Coup de dés": An Exegesis* (New Haven: Yale University Press, 1949); and Gardner Davies, *Vers une explication rationnelle du "Coup de dés"* (Paris: Corti, 1953).

3. Umberto Eco, *The Open Work*, trans. Anna Cancogni (Cambridge: Harvard University Press, 1989).

4. Herbert Molderings cites the philosophical writings of Henri Poincaré, French mathematician and physicist, as an important source for Duchamp. In his philosophical books written at the beginning of the twentieth century, Poincaré talks of a "general collapse of the principles" and a "serious crisis" in science, asserting that "things themselves are not what science can reach . . . , but only the relations between things." Quoted in Herbert Molderings, "Objects of Modern Skepticism," in *The Definitively Unfinished Marcel Duchamp*, ed. Thierry de Duve (Cambridge: MIT Press, 1991), 244.

5. Michel Foucault, "Theatrum Philosophicum," in *Language, Counter-Memory, Practice*, trans. Donald F. Bouchard and Sherry Simon (Ithaca: Cornell University Press, 1977), 173.

6. From the perspective of poststructuralist theory, such unifying categories of analysis, and in particular the *model*, are responsible for impeding the free circulation of thought. See, for example, the second version of Foucault's "What Is an Author?" in *Textual Strategies: Perspectives in Post-Structuralist Criticism*, ed. Josué Harari (Ithaca: Cornell University Press, 1979), in which he treats the concept of the author as he would any concept or model, describing the author as "a certain functional principle by which, in our culture, one limits, excludes, and chooses; in short, by which one impedes the free circulation, the free manipulation, the free composition, decomposition, and recomposition of fiction" (159). This version of Foucault's essay is slightly different from the one included in *Language, Counter-Memory, Practice*.

7. [(L)es choses existent, nous n'avons pas à les créer; nous n'avons qu'à en saisir les rapports; et ce sont les fils de ces rapports qui forment les vers et les orchestres.] Stéphane Mallarmé, *Oeuvres complètes* (Paris: Gallimard [Pléiade], 1945), 871. My translation.

8. Judy Kravis, *The Prose of Mallarmé* (Cambridge: Cambridge University Press, 1976), 194.

9. "[O]ne thinks one is seeing themes in the very spot where the nontheme, that which cannot become a theme, the very thing that has no meaning, is ceaselessly remarking itself—that is, disappearing." Jacques Derrida, "The Double Session," in *Dissemination*, trans. Barbara Johnson (Chicago: University of Chicago Press, 1981), 251. See also Jean-Pierre Richard, *L'Univers imaginaire de Mallarmé* (Paris: Seuil, 1961).

10. *Un Coup de dés* was originally published in *Cosmopolis* (Paris), May 1897.

11. Mallarmé's strategy of evoking rather than naming or narrating fulfills what he perceives as the very purpose of literature: "There must always be enigma in poetry, and it is the purpose of literature—there are no others—*to evoke* objects." [Il doit y avoir toujours énigme en poésie, et c'est le but de la littérature,—il n'y en a pas d'autres—*d'évoquer* les objets.] (*Oeuvres complètes*, 869; my translation).

12. Malcolm Bowie, *Mallarmé and the Art of Being Difficult* (Cambridge: Cambridge University Press, 1978), 123.

13. André Gide felt that Mallarmé composed a work that was simultaneously like a painting and a symphony. See Henri Mondor's preface to Davies, *Vers une explication rationnelle*, 18. Jean-François Lyotard, in *Discours, figure* (Paris: Klincksieck, 1971), notes that in *A Throw of the Dice*, Mallarmé reveals language's "capacity to be 'seen' and not just 'read/heard'; the capacity to figure and not just to signify" (62).

14. Roland Barthes, *The Pleasure of the Text*, trans. Richard Miller (New York: Hill and Wang, 1975), 24.

15. [L'Oeuvre pure implique la disparition élocutoire du poète, qui cède l'initiative aux mots, par le heurt de leur inégalité mobilisés. . . .] (Mallarmé, *Oeuvres complètes*, 366; my translation).

16. Marcel Duchamp, "The Creative Act," *Art News* 56, no. 4 (1957): 28–29. "All in all, the creative act is not performed by the artist alone; the spectator brings the work in contact with the external world by deciphering and interpreting its inner qualifications and thus adds his contribution to the creative act" (29). Elsewhere, Duchamp has said: "It is the *observers* who make the pictures" (*Marchand du sel: Ecrits de Marcel Duchamp*, ed. Michel Sanouillet [Paris: Le Terrain Vague, 1958], 173). In his foreword to Thierry de Duve's *Pictorial Nominalism*, John Rajchman notes the parallel historical "shuffling of the theoretical cards" that occurred in both the early twentieth century and the late 1970s with the category of the postmodern: "[W]e were abandoning a particular *idea* of art, its place in society, its connection to politics, the forms of critical thought and judgment it demands of us . . . " (viii). He suggests that it is in this context of the absence of agreed criteria that one must understand Duchamp's statement about viewers making the work of art (xvi). See *Pictorial Nominalism: On Marcel Duchamp's Passage from Painting to the Readymade*, trans. Dana Polan and Thierry de Duve (Minneapolis: University of Minnesota Press, 1991).

17. Jeffrey Weiss, in *The Popular Culture of Modern Art: Picasso, Duchamp, and Avant-Gardism* (New Haven: Yale University Press, 1994), reads this title as one of Duchamp's many jokes that must be read in its cultural context. He cites daily press reports revealing France to have the lowest birthrate in Europe; the government's response was to propose a heavy tax on unmarried men [*célibataires*], who were seen as the villains. But, as Weiss suggests, Duchamp's title is a joke referring to a "popular music-hall depopulation joke concerning marital infidelity, which held that it was the nation's bachelors, not its husbands, by whom most French wives actually produced their offspring" (141).

18. Marcel Duchamp, *The Bride Stripped Bare by Her Bachelors, Even,* a typographical version of the *Green Box,* ed. Richard Hamilton, trans. George Heard Hamilton (New York: Jaap Rietman, 1976). Duchamp himself compiled and published the notes in 1934 (he had already published five copies of the notes in 1914). Each note was reproduced in exact facsimile, and Duchamp arranged the notes in random order so that the arrangement varied from box to box (three hundred copies were made). We may conclude, then, that the randomness of the notes is an important factor to preserve. Unfortunately, in his typographic version of the *Green Box,* Richard Hamilton has ordered the notes according to what he conceives of as a logical order, placing the notes that do not seem to fit into the logic at the end. In the process, he has done away with the very element of randomness that Duchamp deliberately established.

19. For a sexualized reading of this work and a focus on issues of gender in relation to Duchamp's *oeuvre,* see Amelia Jones, *Postmodernism and the En-Gendering of Marcel Duchamp* (Cambridge: Cambridge University Press, 1994).

20. In a similar vein, Dalia Judovitz speaks of Duchamp's strategy of deferral as a strategy that "postpones the pictorial becoming of painting" and thus redefines the medium itself (*Unpacking Duchamp: Art in Transit* [Berkeley : University of California Press, 1995], 60).

21. In his introduction to *Marcel Duchamp: Artist of the Century,* Rudolf E. Kuenzli calls Duchamp's works "a set of strategies to explore the viewers' socially formed conventions and values; they are transforming machines which activate his spectators to creatively enter the field of play" (*Marcel Duchamp: Artist of the Century,* ed. Rudolf Kuenzli and Francis M. Naumann [Cambridge: MIT Press, 1989], 8).

22. Roland Barthes, *Writing Degree Zero,* trans. Annette Lavers and Colin Smith (New York: Hill and Wang, 1968), 75–76.

23. Jean-François Lyotard, *Les Transformateurs Duchamp* (Paris: Editions Galilée, 1977). English translations from this text are my own.

24. Octavio Paz, "Signs in Rotation," in *The Bow and the Lyre,* trans. Ruth L. C. Simms (Austin: University of Texas Press, 1973), 241.

25. Herbert Molderings discusses the influence of Poincaré's philosophical writings—which detailed a new skepticism in regard to science's claims to objective truth—on Duchamp. Molderings maintains that in this context, Duchamp's "aesthetic goal was to undermine faith in scientific thought" ("Objects of Modern Skepticism," 245). Jeffrey Weiss has historicized the *Large Glass* in the context of "cubist cerebrality" and "the illusion of knowing a lot of things" that was propagated by critics and artists alike at that time. In this sense, Duchamp's work serves to parody the primacy of a stated "system" or "theory" in cubist science: "The proper climate for the *Glass* is defined less by science than by popular and critical suspicions of cubism as a scientizing mystification . . ." (*Popular Culture,* 158). Roger Shattuck, in *The Innocent Eye: On Modern Literature and the Arts* (New York: Farrar, Straus and Giroux, 1984), adds a lighthearted touch to the critical seriousness surrounding Duchamp's work by comparing him to Alfred Jarry and the science of Pataphysics: "Jarry's sense

of reality as a cosmic joke of serious proportions never abandoned Duchamp" (291).

26. Jean Suquet humorously registers the problems encountered by readers in their efforts to follow the "narrative thrust" and make the machine run through a reading of the *Green Box:* "Perhaps I should sketch the psychological portrait of this moody creature, evoke its childhood air, its dubious color, but I don't have the time—and who cares about the moods of nuts and bolts when trying, monkey wrench in hand, to unlock movement?" ("Possible," in Duve, *The Definitively Unfinished Marcel Duchamp,* 89–90)

27. David Joselit notes that the relationship between the bachelors and the bride has to do with "penetration by the eye, with her being *mise à nu.*" However, "[t]he bride cannot be stripped because she is inaccessible to conventional vision: to see her requires inventing a new way of seeing that transcends the purview of the bachelors' gaze. Her *immensurability*—the impossibility of capturing her in representation—endows the bride with her special allure and drives the bachelors wild with desire" (*Infinite Regress: Marcel Duchamp, 1910–1941* [Cambridge: MIT Press, 1998], 124).

28. Lawrence D. Steefel Jr., *The Position of Duchamp's "Glass" in the Development of His Art* (New York: Garland, 1977), 64.

29. Amelia Jones has spoken of the "repressed sexuality of interpretation," seeing interpretation as "a fundamentally erotic exchange . . . driven by the desire to 'know'" that parallels the relation between analyst and analysand in the psychoanalytic paradigm. Her remarks are supported by Duchamp's own response to Jean Suquet's interpretation of the *Large Glass:* "After all, I owe you more than I can repay for your having *stripped bare my stripping bare* [Jones's emphasis]" (*En-Gendering of Marcel Duchamp,* 113).

30. Italo Calvino, *If on a Winter's Night a Traveler,* trans. William Weaver (San Diego: Harcourt Brace Jovanovich, 1981). This novel was originally published in Italian in 1979.

31. Katherine Hume notes that Calvino's emphasis on reading as an activity that promotes discussion and human communication "may account, in part, for the sunnier tone of this novel" and distinguishes this novel from his other work (*Calvino's Fictions: Cogito and Cosmos* [Oxford: Clarendon, 1992], 128).

32. Teresa de Lauretis, *Technologies of Gender: Essays on Theory, Film, and Fiction* (Bloomington: Indiana University Press, 1987), 75.

33. Warren F. Motte Jr., "Calvino's Combinatorics," *Review of Contemporary Fiction* 6, no. 2 (1986): 81–87.

Chapter 4

1. Historical documentation on this friendship and the first decade has been recorded in Roger Shattuck, *The Banquet Years* (New York: Random House, 1968); Pierre Cabanne, *L'Epopée du cubisme* (Paris: La Table Ronde, 1963); Marcel Adéma, *Guillaume Apollinaire* (Paris: La Table Ronde, 1968); Marie-Jeanne Durry, ed., *Alcools,* by Guillaume Apollinaire, 3 vols. (Paris:

Société d'édition d'enseignement supérieur, 1956–64); and Cecily Mackworth, *Guillaume Apollinaire and the Cubist Life* (London: John Murray, 1961).

2. In addition to *The Banquet Years*, Roger Shattuck's classic study, a history of the cultural climate of the 1890s is provided by Eugen Weber, *France, Fin de Siècle* (Cambridge: Harvard University Press, 1986). I have also relied on the essays by Alan Bullock ("The Double Image") and James McFarlane ("The Mind of Modernism") in *Modernism, 1890–1930,* ed. Malcolm Bradbury and James McFarlane (Harmondsworth, Middlesex: Penguin, 1976).

3. The convergences between revolutionary art and visionary physics, despite the absence of contact between the two fields, has been discussed in Leonard Shlain, *Art and Physics: Parallel Visions in Space, Time, and Light* (New York: William Morrow, 1991).

4. Picasso's close ties with anarchism have been documented by Patricia Leighten, *Re-Ordering the Universe: Picasso and Anarchism, 1897–1914* (Princeton: Princeton University Press, 1989).

5. William Rubin notes that the affinity of the *Demoiselles d'Avignon* with Cézanne's work has remained unquestioned since Alfred H. Barr's early statements, but adds that Barr exaggerated Cézanne's presence because "without Cézanne he could not envision the picture as the beginning of Cubism" ("The Genesis of *Les Demoiselles d'Avignon*," in *Les Demoiselles d'Avignon,* Studies in Modern Art, no. 3 [New York: Museum of Modern Art, 1994], 97). Without negating Cézanne's influence, Rubin cites El Greco as a powerful influence on the *Demoiselles*. There has been much recent discussion about locating Picasso within the context of Spanish art, and several critics have cited El Greco's *Apocalyptic Vision* (1608–14) as a source for *Les Demoiselles d'Avignon*. See Robert Lubar, "Narrating the Nation: Picasso and the Myth of El Greco," in *Picasso and the Spanish Tradition,* ed. Jonathan Brown (New Haven: Yale University Press, 1996), 27–60; John Richardson, "Picasso's Apocalyptic Whorehouse," *New York Review of Books,* April 23, 1987, 40–47; and Rolf Laessoe, "A Source in El Greco for Picasso's *Les Demoiselles d'Avignon*," *Gazette des Beaux-Arts,* 110, no. 1425 (October 1987): 131–36. Richardson, in particular, sees cubism as developing from El Greco's *Apocalyptic Vision*.

6. Lubar argues that Picasso transgresses the "authority of French national art," "bourgeois respectability," and the "moral highground of the nation" with his aggressively sexualized nudes, so that reading Picasso in the context of French art "ultimately diminishes the historical weight of his transgressive act" ("Narrating the Nation," 33).

7. "Les Fiançailles" was first published as "Fiançailles" in *Pan* 6 (November–December 1908). All English translations from this poem are my own. Studies treating "Les Fiançailles" include Breunig's analysis of changes in variants of the poem, "Apollinaire's 'Les Fiançailles,'" *Essays in French Literature* 3 (1966): 1–32; Jean-Claude Chevalier's stylistic analysis of certain segments, *"Alcools" d'Apollinaire: Essai d'analyse des formes poétiques* (Paris: Minard, 1970), 234–51; and Margaret Davies's study of key sections in *Apollinaire* (Edinburgh and London: Oliver and Boyd, 1964), 151–58.

8. James D. Herbert proposes that Picasso transgressed the French "grande tradition" of painting by allowing ethnic difference to disrupt the canvas's unity: "Picasso grafted African physiognomies onto European bodies, bringing the two into the closest of physical proximities" (*Fauve Painting: The Making of Cultural Politics* [New Haven: Yale University Press, 1992], 176).

9. Robert Hughes, *The Shock of the New* (New York: Knopf, 1981), 24.

10. Leo Steinberg, "The Philosophical Brothel," *October* 44 (1988): 7–74. Steinberg's use of the word *brothel* in his title refers to the critical evidence suggesting that Picasso represented prostitutes in a brothel in Barcelona. For a discussion of Picasso's painting in the context of concerns about cultural degeneration in France at the time, see David Lomas, "A Canon of Deformity: *Les Demoiselles d'Avignon* and Physical Anthropology," *Art History* 16 (1993): 424–46.

11. William Rubin interprets the masks in the Freudian sense of masking, where "emotions too painful to confront directly (here the artist's conflicted feelings triggered by the inherent savagery of sex and fear of death) are dealt with by substituting 'cover' images" ("Genesis," 105). Unlike Golding and others who have seen an African influence in the masks, Rubin sees the figures as more Oceanic in spirit. For a good summary of the conflicting interpretations of the influence of African art on the *Demoiselles* (tied to Picasso's visit to the Musée d'Ethnographie du Trocadéro in 1907), see Rubin, "Genesis," 103–8 and 214–21.

12. It should be pointed out here that these "realistic" elements I am enumerating are themselves conceptual in that they depend on familiarity with conventions.

13. Picasso, quoted in John Golding, *Cubism: A History and an Analysis: 1907–1914* (New York: George Wittenborn, 1959), 60.

14. James D. Herbert's description of the radical shift from Cézanne's painting to Picasso's *Demoiselles d'Avignon* bears a striking resemblance to the abrupt shift made by Apollinaire from the first to the second section of his poem: "Eternal Cézannean nudes become women for sale and the Arcadian backdrop for these five 'bathers' transmogrifies into the claustrophobic interior of a modern brothel" (*Fauve Painting,* 176).

15. See the discussion in Michel Décaudin, *Le Dossier d'"Alcools"* (Geneva: Droz, 1960), 204–7.

16. See Rubin, "Genesis," esp. 91–95. For Robert Lubar, this overlaying of styles is a radical, transgressive gesture that questions ideological structures and explodes unifying cultural discourses and myths: "Acutely aware of his outsider status as an Andalusian in Barcelona and as a Spaniard in Paris, Picasso viewed artistic nationalism with a critical eye from a mobile perspective. In juxtaposing traditional, modernist, and exotic signifiers in *Les Demoiselles d'Avignon;* in disrupting the temporal, rhetorical, and ideological constructions through which the discourse of nationalism was secured in French, Catalan, and Castilian art and art criticism, Picasso brought into focus the object of a true historical criticism—the writing of history" ("Narrating the

Nation," 59–60). It need hardly be pointed out that Apollinaire, too, illegitimate son of a Polish adventuress, was an "outsider."

17. [Les grands poètes et les grands artistes ont pour fonction sociale de renouveler sans cesse l'apparence que revêt la nature aux yeux des hommes] (Apollinaire, quoted in Breunig, "Apollinaire et le cubisme," *La Revue des lettres modernes* 69–70 [1962]: 19).

18. Octavio Paz, "'The Musician of Saint-Merry' by Apollinaire: A Translation and a Study," trans. Margaret Peden, *L'Esprit Créateur* 10 (1970): 278.

19. An analysis of the chronological sequence of Picasso's painting of *Les Demoiselles d'Avignon* is provided in Golding, *Cubism*, 54–57, and Rubin, "Genesis," 91–95.

20. E. H. Gombrich, *Art and Illusion: A Study in the Psychology of Pictorial Representation* (Princeton: Princeton University Press, 1972), 172.

Chapter 5

1. Renée Riese Hubert, *Surrealism and the Book* (Berkeley: University of California Press, 1988), 218.

2. Gaston Bachelard, for instance, has studied what he calls Lautréamont's "phenomenology of aggression," citing the wealth of aggressive animal imagery in *Les Chants* as the mark of sadistic and brutal impulses. (Bachelard, *Lautréamont* [Paris: Corti, 1939]). Like Bachelard, Paul Zweig has studied the violence of *Les Chants*, but instead of insisting on the dynamic impulses informing the component of aggression, Zweig sees violence as a strategy for ultimately achieving resemblance and a sort of equality (*Lautréamont, ou les violences du Narcisse* [Paris: Minard, 1967]). Similarly, in his study *Lautréamont et Sade* (Paris: Minuit, 1949), Maurice Blanchot discusses Lautréamont's obsession with his fellow creatures and the need to establish communion.

3. James Thrall Soby, in *Salvador Dali*, catalog of an exhibition at the Museum of Modern Art (New York: Museum of Modern Art, 1946), perceptively suggests a connection between this wandering of form in Dalí's painting and the influence of art nouveau (what Dalí called the "undulant-convulsive" style), especially given the fact that this style characterized the architecture of Antoni Gaudì that surrounded Dalí in Catalan Spain.

4. Lautréamont, *Les Chants de Maldoror*, trans. Guy Wernham (New York: New Directions, 1946), 65. The first French edition dates from 1869.

5. Marcelin Pleynet, *Lautréamont par lui-même* (Paris: Seuil, 1967), 114.

6. Ora Avni, *Tics, Tics, et Tics: Figures, Syllogismes, Récit dans "Les Chants de Maldoror"* (Lexington, Ky.: French Forum, 1984), 154. My translation.

7. In a perceptive analysis, Naomi Schor suggests that the current privileging of the detail be seen as part of the dismantling of idealist aesthetics. See *Reading in Detail: Aesthetics and the Feminine* (New York: Methuen, 1987).

8. Gilles Deleuze and Félix Guattari, *Anti-Oedipus: Capitalism and Schizophrenia*, trans. Robert Hurley, Mark Seem, and Helen R. Lane (Minneapolis: University of Minnesota Press, 1983), 287.

9. Salvador Dalí, *La Conquête de l'irrationnel* (Paris: Editions Surréalistes, 1935), 12–13. My translation.

10. Dalí cultivated such images as part of what he called his "paranoiac-critical" method, which means looking at one thing and seeing another. As critics have already pointed out, Dalí's methods really had nothing to do with paranoia, although surrealists were quite interested in Lacan's *De la paranoïa dans ses rapports avec la personnalité* (1932), published just three years before Dalí's own formulation of his "paranoiac-critical" method.

11. For an account of this kind of intertextuality, see Laurent Jenny, "La Stratégie de la forme," *Poétique* 27 (1976): 257–81.

12. Richard Terdiman, *Discourse/Counter-Discourse: The Theory and Practice of Symbolic Resistance in Nineteenth-Century France* (Ithaca: Cornell University Press, 1985).

13. Aimé Césaire, *Discours sur le colonialisme* (Paris: Présence Africaine, 1955), 45.

14. Julia Kristeva, *La Révolution du langage poétique; L'Avant-garde à la fin du XIXe siècle: Lautréamont et Mallarmé* (Paris: Seuil, 1974).

15. Georges Bataille, *The Accursed Share: An Essay on General Economy,* trans. Robert Hurley, vol. 1 (New York: Zone Books, 1988), 21, 33.

16. Julia Kristeva, *Desire in Language: A Semiotic Approach to Literature and Art,* ed. Leon Roudiez, trans. Tom Gora, Alice Jardine, and Leon Roudiez (New York: Columbia University Press, 1980), 71.

17. Robert Hughes, *The Shock of the New* (New York: Knopf, 1981), 238. Hughes is referring, of course, to the often-quoted passage from *Les Chants de Maldoror* about "the fortuitous encounter upon a dissecting-table of a sewing-machine and an umbrella" (263).

Chapter 6

1. Matisse's famous quotation from his 1908 article, "Notes of a Painter" ("Notes d'un peintre"), has contributed to this view: "What I dream of is an art of balance, of purity and tranquility, devoid of troubling or preoccupying subject matter, an art which could be, for every mental worker . . . a soothing balm, a mental calmative, something akin to a good armchair which eases his physical fatigue." Quoted in Roger Benjamin, *Matisse's "Notes of a Painter": Criticism, Theory, and Context, 1891–1908* (Ann Arbor: UMI Research Press, 1987), 208. Benjamin studies the period critics through 1908 and proposes that the "Notes" were "designed to reassure a public grown hostile since the advent of Fauvism" (xi). Matisse's article originally appeared in *La Grande Revue,* December 25, 1908.

2. Hilary Spurling, *The Unknown Matisse: A Life of Henri Matisse: The Early Years, 1869–1908* (New York: Knopf, 1998), 423.

3. Spurling, in *The Unknown Matisse,* describes how *Blue Nude: Memory of Biskra* scandalized the public at the 1907 Indépendants in March; it was said that Derain destroyed his own paintings of blue nudes afterward, and Picasso

worked with increased energy on *Les Demoiselles d'Avignon*. Like Rimbaud, Matisse was interested in Africa and the Orient; his trip to Algeria in May 1906 furnished him a storehouse of images, rhythms, and vivid light that were to play a role in his art.

4. Arthur Rimbaud, *Une Saison en enfer*, in *Oeuvres*, ed. Suzanne Bernard (Paris: Garnier, 1960), 225. All translations from this text are my own.

5. See, for example, Suzanne Bernard, *Le Poème en prose de Baudelaire jusqu'à nos jours* (Paris: Nizet, 1959); Wilbur M. Frohock, *Rimbaud's Poetic Practice* (Cambridge: Harvard University Press, 1963); John Porter Houston, *The Design of Rimbaud's Poetry* (Westport, Conn.: Greenwood, 1977); Enid Rhodes Peschel, *Flux and Reflux: Ambivalence in the Poems of Arthur Rimbaud* (Geneva: Droz, 1977).

6. Shoshana Felman, " 'Tu as bien fait de partir, Arthur Rimbaud,' Poésie et modernité," *Littérature* 11 (1973): 12. All translations from this article are my own.

7. Jacques Lassaigne, *Matisse* (Geneva: Skira, 1959), 54. My translation.

8. See the discussions in Alfred H. Barr Jr., *Matisse, His Art, and His Public* (New York: Museum of Modern Art, 1951), 136; and Albert Kostenevich, "*La Danse* and *La Musique* by Henri Matisse: A New Interpretation," *Apollo* 100 (1974): 508.

9. For an in-depth account of the Shchukin-Matisse relationship, see Albert Kostenevich and Natalia Semyonova, *Collecting Matisse*, trans. Andrew Bromfield (Paris: Flammarion, 1993).

10. This is not the first time Matisse reworked a painting to achieve more force. After completing his *Harmony in Blue* in June 1908, he repainted the whole painting red later that summer, and it became *Harmony in Red*. In response to a visitor who thought he had made a different painting, he replied, "It's not a different painting. I am seeking forces, and a balance of forces" (quoted in Spurling, *The Unknown Matisse*, 416).

11. It is tempting to see these women in relation to Matisse's *Blue Nude: Memory of Biskra*. Spurling has noted that the Biskra belly dancers were the only unveiled women in Algeria, "famous for their muscular bodies, their barbaric rhythms and general air of being tougher, fiercer and harsher than the Moorish women of the north" (*The Unknown Matisse*, 359).

12. J. Tugendhold, "The Salon d'Automne," *Apollon* 12 (1910): 31; and P. Skrotsky, "From Paris. The Autumn Salon," *Odessky Listok*, 267 (November 20, 1910) (quoted in Kostenevich, "*La Danse* and *La Musique* by Henri Matisse," 512).

13. John Hallmark Neff, "Matisse and Decoration: The Shchukin Panels," *Art in America* 63 (1975): 40.

14. Atle Kittang, *Discours et jeu: Essai d'analyse des textes d'Arthur Rimbaud* (Grenoble: Presses Universitaires de Grenoble, 1975), 47.

15. J. Marc Blanchard, "Sur le mythe poétique; Essai d'une sémiostylistique rimbaldienne," *Semiotica* 16 (1976): 67–86.

16. Michaux has claimed Rimbaud and Lautréamont as dominant influ-

ences on his own work. For a discussion of the dynamics of movement in Michaux's work, see my *Henri Michaux and the Poetics of Movement,* Stanford French and Italian Studies (Saratoga, Calif.: Anma Libri, 1985).

17. Jean-Pierre Richard, *Poésie et profondeur* (Paris: Seuil, 1955); Jacques Plessen, *Promenade et poésie* (The Hague and Paris: Mouton, 1967).

18. James Lawler has recently reversed this trend by focusing on Rimbaud's self-dramatization throughout his work. See *Rimbaud's Theatre of the Self* (Cambridge: Harvard University Press, 1992): "[T]he 'theatre' of my title [designates] the exceptional energy of a poet who invests himself with strange identities, enacts conflictual scenes . . ." (5).

19. Laurence M. Porter, in *The Crisis of French Symbolism* (Ithaca: Cornell University Press, 1990), discusses several strategies the poet uses to defend himself against hostile audiences (201), and this example seems to support his comments. What better way to defend oneself against a hostile audience than to become that audience!

20. This interpretation differs radically from the one proposed by Yves Bonnefoy in *Rimbaud par lui-même* (Paris: Seuil, 1961): "Homosexuality is acknowledged in these sentences, probably" (115).

21. Jean-Louis Baudry, "Le Texte de Rimbaud (fin)," *Tel Quel* 36 (1969): 35. My translation.

Chapter 7

1. W. J. T. Mitchell, *Picture Theory: Essays in Verbal and Visual Representation* (Chicago: University of Chicago Press, 1994), 91.

2. Octavio Paz, *Marcel Duchamp: Appearance Stripped Bare,* trans. Rachel Phillips and Donald Gardner (New York: Viking, 1978), 86.

3. Quoted in Calvin Tompkins and the Editors of Time-Life Books, *The World of Marcel Duchamp* (New York: Time Incorporated, 1966), 26.

4. Jeffrey Weiss, in *Popular Culture,* reads Duchamp's provocation within the context of the popular and critical aesthetic debates of the time concerning avant-gardism. Taking "incomprehension" as the dominant theme in the popular critical press, Weiss proposes that Duchamp's provocation be seen as an ironic reaction to that incomprehension.

5. Sidra Stich, *Joan Miró: The Development of a Sign Language,* catalog of the exhibition at the Washington University Gallery of Art, March 19–April 27, 1980 (Saint Louis: Washington University, 1980), 23.

6. For a perceptive analysis of Miró's gouaches in relation to André Breton's texts in *Constellations,* see Renée Riese Hubert, *Surrealism and the Book* (Berkeley: University of California Press, 1988), 130–38.

7. Margit Rowell, *Miró* (New York: Harry N. Abrams, 1970), 17.

8. Barbara Rose, *Miró in America,* catalog of the exhibition at the Museum of Fine Arts, Houston, April 21–June 27, 1982 (Houston: Museum of Fine Arts, 1982), 12–13.

9. Quoted in William S. Rubin, *Dada and Surrealist Art* (New York: Harry N. Abrams, 1968), 152.

10. Guillaume Apollinaire, *Oeuvres complètes*, ed. Michel Décaudin (Paris: Balland, 1965–66). Translations from Apollinaire's work are my own unless noted otherwise.

11. Guillaume Apollinaire, "The New Spirit and the Poets," in Francis Steegmuller, *Poet among the Painters* (New York: Farrar, Straus, 1963), 334.

12. Many critics have commented on this aspect of Lichtenstein's work. See, for instance, Lawrence Alloway's interview with the artist in *Roy Lichtenstein* (New York: Abbeville, 1983); and Robert Rosenblum, "Roy Lichtenstein and the Realist Revolt," in *Roy Lichtenstein*, ed. John Coplans (New York: Praeger, 1972), 115–36.

13. Donald Judd, *Arts Magazine* 38 (November 1963): 33; quoted in Diane Waldman, *Roy Lichtenstein* (New York: Harry N. Abrams, 1971), 10.

14. Wendy Steiner provides an illuminating discussion of Lichtenstein's narrative works in her *Pictures of Romance: Form against Context in Painting and Literature* (Chicago: University of Chicago Press, 1988), 153–83. She argues that Lichtenstein played with narrative precisely because "it is the crucial supplement to the image in the creation of value. It opens up that system of oppositions between self-enclosure and contingency that lie behind any artistic exploration of meaning . . ." (182).

15. Diane Waldman points out the "series of overlapping forms that direct one's attention into the painting: a wave uncovering the girl's hand at the wrist, the tip of her thumb touching her face, the top of her shoulder covering her hair, etc." (*Roy Lichtenstein*, 15).

16. Mark Roskill and David Carrier, *Truth and Falsehood in Visual Images* (Amherst: University of Massachusetts Press, 1983).

Afterword

1. Michel Foucault, *Discipline and Punish: The Birth of the Prison*, trans. Alan Sheridan (New York: Vintage, 1979), 27–28.

2. Simultaneously, as numerous contemporary theorists have shown, fields and domains of knowledge are susceptible to change through the emergence of counter-discourses.

3. W. J. T. Mitchell, *Iconology: Image, Text, Ideology* (Chicago: University of Chicago Press, 1986).

4. Foucault has analyzed at length this desire to totalize or explain the present by dissolving singular events into ideal continuities in "Nietzsche, Genealogy, History," in *Language, Counter-Memory, Practice*, trans. Donald F. Bouchard and Sherry Simon (Ithaca: Cornell University Press, 1977), especially 153.

5. James Clifford, *The Predicament of Culture: Twentieth-Century Ethnography, Literature, and Art* (Cambridge: Harvard University Press, 1988), 196.

References

Adéma, Marcel. *Guillaume Apollinaire*. Paris: La Table Ronde, 1968.

Alloway, Lawrence. *Roy Lichtenstein*. New York: Abbeville, 1983.

Apollinaire, Guillaume. *Oeuvres complètes*. Ed. Michel Décaudin. Paris: Balland, 1965–66.

Arnheim, Rudolf. *Visual Thinking*. Berkeley: University of California Press, 1969.

Avni, Ora. *Tics, Tics, et Tics: Figures, Syllogismes, Récit dans "Les Chants de Maldoror."* Lexington, Ky.: French Forum, 1984.

Bachelard, Gaston. *Lautréamont*. Paris: Corti, 1939.

Barr, Alfred H., Jr. *Matisse, His Art, and His Public*. New York: Museum of Modern Art, 1951.

Barrie, Lita. "Art and Disembodiment." *Artweek* 21, no. 32 (1990): 23–24.

Barthes, Roland. *Writing Degree Zero*. Trans. Annette Lavers and Colin Smith. New York: Hill and Wang, 1968.

———. *S/Z*. Trans. Richard Miller. New York: Hill and Wang, 1974.

———. *The Pleasure of the Text*. Trans. Richard Miller. New York: Hill and Wang, 1975.

———. "From Work to Text." In *Image-Music-Text*, trans. Stephen Heath, 155–64. New York: Hill and Wang, 1977.

Bataille, Georges. *The Accursed Share: An Essay on General Economy*. Trans. Robert Hurley. Vol. 1. New York: Zone Books, 1988.

Baudry, Jean-Louis. "Le Texte de Rimbaud (fin)." *Tel Quel* 36 (1969): 33–53.

Benjamin, Roger. *Matisse's "Notes of a Painter": Criticism, Theory, and Context, 1891–1908*. Ann Arbor: UMI Research Press, 1987.

Benjamin, Walter. "The Work of Art in the Age of Mechanical Reproduction." In *Illuminations*, ed. Hannah Arendt and trans. Harry Zohn, 217–51. New York: Schocken, 1969.

Berger, John. *Ways of Seeing*. London and Harmondsworth, Middlesex: British Broadcasting Corporation and Penguin, 1972.

Bernard, Suzanne. *Le Poème en prose de Baudelaire jusqu'à nos jours*. Paris: Nizet, 1959.

Blanchard, J. Marc. "Sur le mythe poétique; Essai d'une sémiostylistique rimbaldienne." *Semiotica* 16 (1976): 67–86.

Blanchot, Maurice. *Lautréamont et Sade.* Paris: Minuit, 1949.

Bonnefoy, Yves. *Rimbaud par lui-même.* Paris: Seuil, 1961.

Bordo, Susan. "The Cartesian Masculinization of Thought." *Signs* 11 (1986): 439–56.

Bowie, Malcolm. *Mallarmé and the Art of Being Difficult.* Cambridge: Cambridge University Press, 1978.

Bradbury, Malcolm, and James McFarlane, eds. *Modernism, 1890–1930.* Harmondsworth, Middlesex: Penguin, 1976.

Breton, André. "Phare de la mariée." *Minotaur* 2, no. 6 (1935): 45–49.

Breunig, L.-C. "Apollinaire et le cubism." *La Revue des lettres modernes* 69–70 (1962): 7–24.

———. "Apollinaire's 'Les Fiançailles.'" *Essays in French Literature* 3 (1966): 1–32.

Bullock, Alan. "The Double Image." In Bradbury and McFarlane, 58–70.

Cabanne, Pierre. *L'Epopée du cubisme.* Paris: La Table Ronde, 1963.

Calvino, Italo. *If on a Winter's Night a Traveler.* Trans. William Weaver. San Diego: Harcourt Brace Jovanovich, 1981.

Carrouges, Michel. *Les Machines célibataires.* Paris: Arcannes, 1951.

Caws, Mary Ann. *The Eye in the Text: Essays on Perception, Mannerist to Modern.* Princeton: Princeton University Press, 1981.

Césaire, Aimé. *Discours sur le colonialisme.* Paris: Présence Africaine, 1955.

Chevalier, Jean-Claude. *"Alcools" d'Apollinaire: Essai d'analyse des formes poétiques.* Paris: Minard, 1970.

Clair, Jean. *Marcel Duchamp, ou, Le Grand Fictif: Essai de mythanalyse du "Grand Verre."* Paris: Galilée, 1975.

Clifford, James. *The Predicament of Culture: Twentieth-Century Ethnography, Literature, and Art.* Cambridge: Harvard University Press, 1988.

Cohn, Robert G. *Mallarmé's "Un Coup de dés": An Exegesis.* New Haven: Yale University Press, 1949.

Crimp, Douglas. "Cindy Sherman: Making Pictures for the Camera." *Oberlin College Bulletin* 38, no. 2 (1980–81): 87–91.

Dalí, Salvador. *La Conquête de l'irrationnel.* Paris: Editions Surréalistes, 1935.

Danto, Arthur C. "Photography and Performance: Cindy Sherman's Stills." In *Cindy Sherman: Untitled Film Stills,* 5–14. New York: Rizzoli, 1990.

Davies, Gardner. *Vers une explication rationnelle du "Coup de dés."* Paris: Corti, 1953.

Davies, Margaret. *Apollinaire.* Edinburgh and London: Oliver and Boyd, 1964.

Décaudin, Michel. *Le Dossier d'"Alcools."* Geneva: Droz, 1960.

de Lauretis, Teresa. *Technologies of Gender: Essays on Theory, Film, and Fiction.* Bloomington: Indiana University Press, 1987.

Deleuze, Gilles, and Félix Guattari. *Anti-Oedipus: Capitalism and Schizophrenia.* Trans. Robert Hurley, Mark Seem, and Helen R. Lane. Minneapolis: University of Minnesota Press, 1983.

Derrida, Jacques. *Dissemination.* Trans. Barbara Johnson. Chicago: University of Chicago Press, 1981.

―――. *Signéponge/Signsponge.* Trans. Richard Rand. New York: Columbia University Press, 1984.

Doane, Mary Ann. "Film and the Masquerade: Theorising the Female Spectator." *Screen* 23, nos. 3–4 (1982): 74–87.

Duchamp, Marcel. "The Creative Act." *Art News* 56, no. 4 (1957): 28–29.

―――. *Marchand du sel: Ecrits de Marcel Duchamp.* Ed. Michel Sanouillet. Paris: Le Terrain Vague, 1958.

―――. *The Bride Stripped Bare by Her Bachelors, Even* [typographical version of the *Green Box*]. Ed. Richard Hamilton. Trans. George Heard Hamilton. New York: Jaap Rietman, 1976.

Duras, Marguerite. "Marguerite Duras et la lutte des femmes." Interview by Xavière Gauthier. *Magazine littéraire* 158 (March 1980): 8–21.

―――. *The Ravishing of Lol Stein.* Trans. Richard Seaver. New York: Pantheon, 1986.

Durry, Marie-Jeanne, ed. *Alcools.* By Guillaume Apollinaire. 3 vols. Paris: Société d'édition d'enseignement supérieur, 1956–64.

Duve, Thierry de, ed. *The Definitively Unfinished Marcel Duchamp.* Cambridge: MIT Press, 1991.

Eco, Umberto. *The Open Work.* Trans. Anna Cancogni. Cambridge: Harvard University Press, 1989.

Edson, Laurie. *Henri Michaux and the Poetics of Movement.* Stanford French and Italian Studies. Saratoga, Calif.: Anma Libri, 1985.

―――, ed. *Conjunctions: Verbal-Visual Relations.* San Diego: San Diego State University Press, 1996.

Esrock, Ellen J. *The Reader's Eye: Visual Imaging as Reader Response.* Baltimore: Johns Hopkins University Press, 1994.

Evans, Martha Noel. *Masks of Tradition: Women and the Politics of Writing in Twentieth-Century France.* Ithaca: Cornell University Press, 1987.

Felman, Shoshana. "'Tu as bien fait de partir, Arthur Rimbaud,' Poésie et modernité." *Littérature* 11 (1973): 3–21.

Flax, Jane. "Political Philosophy and the Patriarchal Unconscious: A Psychoanalytic Perspective on Epistemology and Metaphysics." In Harding and Hintikka, 245–81.

Foster, Hal, ed. *The Anti-Aesthetic: Essays on Postmodern Culture.* Port Townsend, Wash.: Bay, 1983.

Foucault, Michel. *Language, Counter-Memory, Practice.* Trans. Donald F. Bouchard and Sherry Simon. Ithaca: Cornell University Press, 1977.

―――. "Nietzsche, Genealogy, History." In *Language, Counter-Memory, Practice,* 139–64.

―――. "Theatrum Philosophicum." In *Language, Counter-Memory, Practice,* 165–96.

―――. "What Is an Author?" In *Language, Counter-Memory, Practice,* 113–38.

————. *Discipline and Punish: The Birth of the Prison.* Trans. Alan Sheridan. New York: Vintage, 1979.

————. *This Is Not a Pipe.* Trans. James Harkness. Berkeley: University of California Press, 1982.

————. "What Is an Author?" [revised version]. In *Textual Strategies: Perspectives in Post-Structuralist Criticism,* ed. Josué Harari. Ithaca: Cornell University Press, 1979.

Freud, Sigmund. *The Interpretation of Dreams.* Vol. 4 of *The Standard Edition of the Complete Psychological Works of Sigmund Freud.* Ed. and trans. James Strachey. London: Hogarth Press, 1953.

Frohock, Wilbur M. *Rimbaud's Poetic Practice.* Cambridge: Harvard University Press, 1963.

Gablik, Suzi. *Magritte.* Greenwich, Conn.: New York Graphic Society, 1970.

Gavronsky, Serge. *Francis Ponge: The Power of Language.* Berkeley: University of California Press, 1979.

Genette, Gérard. "Le Parti pris des mots." *Romanic Review* 66 (1975): 283–87.

Giordan, Claudine. "Ponge et la nomination." *Poétique* 28 (1976): 484–95.

Gleize, Jean-Marie. *Francis Ponge.* Paris: Seuil, 1988.

Gleize, Jean-Marie, and Bernard Veck. *Francis Ponge: "Actes ou textes."* Lille: Presses Universitaires de Lille, 1984.

Goldberg, Vicki. "Portrait of the Photographer as a Young Artist." *New York Times,* October 23, 1983, sec. 2, 29.

Golding, John. *Cubism: A History and an Analysis: 1907–1914.* New York: George Wittenborn, 1959.

————. *Marcel Duchamp: The Bride Stripped Bare by Her Bachelors, Even.* London: Allen Lane, Penguin, 1973.

Gombrich, E. H. *Art and Illusion: A Study in the Psychology of Pictorial Representation.* Princeton: Princeton University Press, 1972.

Greene, Robert W. *Six French Poets of Our Time.* Princeton: Princeton University Press, 1979.

Grundberg, Andy. "Cindy Sherman: A Playful and Political Post-Modernist." *New York Times,* November 22, 1981, sec. 2, 35.

Guiton, Margaret, ed. *Francis Ponge: Selected Poems.* Winston-Salem, N.C.: Wake Forest University Press, 1994.

Hannoosh, Michele. *Parody and Decadence.* Columbus: Ohio State University Press, 1989.

Harding, Sandra, and Merrill B. Hintikka, eds. *Discovering Reality: Feminist Perspectives on Epistemology, Metaphysics, Methodology, and Philosophy of Science.* Dordrecht, Holland: Reidel, 1983.

Heartney, Eleanor. "Two or Three Things I Know about Her." *Afterimage* 15 (October 1987): 18.

Herbert, James D. *Fauve Painting: The Making of Cultural Politics.* New Haven: Yale University Press, 1992.

Houston, John Porter. *The Design of Rimbaud's Poetry.* Westport, Conn.: Greenwood, 1977.

Hubert, Renée Riese. *Surrealism and the Book.* Berkeley: University of California Press, 1988.

Hughes, Robert. *The Shock of the New.* New York: Knopf, 1981.

Hume, Kathryn. *Calvino's Fictions: Cogito and Cosmos.* Oxford: Clarendon, 1992.

Irigaray, Luce. *This Sex Which Is Not One.* Trans. Catherine Porter with Carolyn Burke. Ithaca: Cornell University Press, 1985.

Jenny, Laurent. "La Stratégie de la forme." *Poétique* 27 (1976): 257–81.

Johnson, Ken. "Cindy Sherman and the Anti-Self: An Interpretation of Her Imagery." *Arts Magazine* 62 (1987): 47–53.

Jones, Amelia. *Postmodernism and the En-Gendering of Marcel Duchamp.* Cambridge: Cambridge University Press, 1994.

Joselit, David. *Infinite Regress: Marcel Duchamp, 1910–1941.* Cambridge: MIT Press, 1998.

Judovitz, Dalia. *Unpacking Duchamp: Art In Transit.* Berkeley: University of California Press, 1995.

Keller, Evelyn Fox. "Gender and Science." In Harding and Hintikka, 187–205.

Keller, Evelyn Fox, and Christine R. Grontkowski. "The Mind's Eye." In Harding and Hintikka, 207–24.

Kittang, Atle. *Discours et jeu: Essai d'analyse des textes d'Arthur Rimbaud.* Grenoble: Presses Universitaires de Grenoble, 1975.

Kofman, Sarah. *The Enigma of Woman: Woman in Freud's Writings.* Trans. Catherine Porter. Ithaca: Cornell University Press, 1985.

Kostenevich, Albert. "*La Danse* et *La Musique* by Henri Matisse: A New Interpretation." *Apollo* 100 (1974): 504–13.

Kostenevich, Albert, and Natalia Semyonova. *Collecting Matisse.* Trans. Andrew Bromfield. Paris: Flammarion, 1993.

Krauss, Rosalind. "Sculpture in the Expanded Field." In Foster, 31–42.

———. *Cindy Sherman 1975–1993.* New York: Rizzoli, 1993.

Kravis, Judy. *The Prose of Mallarmé.* Cambridge: Cambridge University Press, 1976.

Kristeva, Julia. *La Révolution du langage poétique; L'Avant-garde à la fin du XIXe siècle: Lautréamont et Mallarmé.* Paris: Seuil, 1974.

———. *Desire in Language: A Semiotic Approach to Literature and Art.* Ed. Leon Roudiez. Trans. Tom Gora, Alice Jardine, and Leon Roudiez. New York: Columbia University Press, 1980.

———. "Woman Can Never Be Defined." Trans. Marilyn A. August. In *New French Feminisms,* ed. Elaine Marks and Isabelle de Courtivron, 137–41. New York: Schocken, 1981.

Kuenzli, Rudolf E. Introduction to *Marcel Duchamp: Artist of the Century,* ed. Rudolf Kuenzli and Francis M. Naumann. Cambridge: MIT Press, 1989.

Lacan, Jacques. "Hommage fait à Marguerite Duras, du Ravissement de Lol V. Stein." *Cahiers Renaud-Barrault* 52 (December 1965): 7–15.

Laessoe, Rolf. "A Source in El Greco for Picasso's *Les Demoiselles d'Avignon.*" *Gazette des Beaux Arts* 110, no. 1425 (October 1987): 131–36.

Lassaigne, Jacques. *Matisse.* Geneva: Skira, 1959.

Lautréamont, Comte de [Isidore Ducasse]. *Les Chants de Maldoror.* Trans. Guy Wernham. New York: New Directions, 1946.

Lawler, James. *Rimbaud's Theatre of the Self.* Cambridge: Harvard University Press, 1992.

Leighten, Patricia. *Re-Ordering the Universe: Picasso and Anarchism, 1897–1914.* Princeton: Princeton University Press, 1989.

Lévy, Sydney. "A la recherche du savon perdu. . . ." *L'Esprit Créateur* 31 (1991): 41–50.

———. "Knowing and Seeing in Francis Ponge." In Edson, *Conjunctions,* 107–29.

Lomas, David. "A Canon of Deformity: *Les Demoiselles d'Avignon* and Physical Anthropology." *Art History* 16 (1993): 424–46.

Lubar, Robert. "Narrating the Nation: Picasso and the Myth of El Greco." In *Picasso and the Spanish Tradition,* ed. Jonathan Brown, 27–60. New Haven: Yale University Press, 1996.

Lydon, Mary. "The Forgetfulness of Memory: Jacques Lacan, Marguerite Duras, and the Text." *Contemporary Literature* 29 (1988): 351–68.

Lyotard, Jean-François. *Discours, figure.* Paris: Klincksieck, 1971.

———. *Les Transformateurs Duchamp.* Paris: Editions Galilée, 1977.

MacCannell, Juliet Flower. *The Regime of the Brother: After the Patriarchy.* New York: Routledge, 1991.

Mackworth, Cecily. *Guillaume Apollinaire and the Cubist Life.* London: John Murray, 1961.

Mallarmé, Stéphane. *Oeuvres complètes.* Paris: Gallimard, 1945.

Marzorati, Gerald. "Imitation of Life." *ARTnews* 82 (1983): 78–87.

McFarlane, James. "The Mind of Modernism." In Bradbury and McFarlane, 71–93.

Merleau-Ponty, Maurice. *Phenomenology of Perception.* Trans. Colin Smith. London: Routledge, 1962.

Mitchell, W. J. T. *Iconology: Image, Text, Ideology.* Chicago: University of Chicago Press, 1986.

———. *Picture Theory: Essays on Verbal and Visual Representation.* Chicago: University of Chicago Press, 1994.

Molderings, Herbert. "Objects of Modern Skepticism." In Duve, 243–65.

Montrelay, Michèle. *L'Ombre et le nom.* Paris: Minuit, 1977.

Motte, Warren F., Jr. "Calvino's Combinatorics." *Review of Contemporary Fiction* 6, no. 2 (1986): 81–87.

Neff, John Hallmark. "Matisse and Decoration: The Shchukin Panels." *Art in America* 63 (1975): 38–48.

Owens, Craig. "The Discourse of Others: Feminists and Postmodernism." In Foster, 57–82.

Paz, Octavio. " 'The Musician of Saint-Merry' by Apollinaire: A Translation and a Study." Trans. Margaret Peden. *L'Esprit Créateur* 10 (1970): 269–84.

———. *The Bow and the Lyre.* Trans. Ruth L. C. Simms. Austin: University of Texas Press, 1973.

————. *Marcel Duchamp: Appearance Stripped Bare.* Trans. Rachel Phillips and Donald Gardner. New York: Viking, 1978.

Peschel, Enid Rhodes. *Flux and Reflux: Ambivalence in the Poems of Arthur Rimbaud.* Geneva: Droz, 1977.

Plessen, Jacques. *Promenade et poésie.* The Hague and Paris: Mouton, 1967.

Pleynet, Marcelin. *Lautréamont par lui-même.* Paris: Seuil, 1967.

Ponge, Francis. *Pour un Malherbe.* Paris: Gallimard, 1965.

————. *Tome premier.* Paris: Gallimard, 1965.

————. *Le Savon.* Paris: Gallimard, 1967.

————. *Le Parti pris des choses.* Paris: Gallimard, 1975.

Porter, Laurence M. *The Crisis of French Symbolism.* Ithaca: Cornell University Press, 1990.

Preckshot, Judith E. "The Pleasure of Soap or the Tale of the Text Perverted: Francis Ponge's *Le Savon.*" *L'Esprit Créateur* 21 (1981): 48–59.

Rajchman, John. Foreword to *Pictorial Nominalism: On Marcel Duchamp's Passage from Painting to the Readymade,* ed. Thierry de Duve and trans. Dana Polan and Thierry de Duve. Minneapolis: University of Minnesota Press, 1991.

Richard, Jean-Pierre. *Poésie et profondeur.* Paris: Seuil, 1955.

————. *L'Univers imaginaire de Mallarmé.* Paris: Seuil, 1961.

Richardson, John. "Picasso's Apocalyptic Whorehouse." *New York Review of Books,* April 23, 1987, 40–47.

Riffaterre, Michael. "Ponge tautologique ou le fonctionnement du texte." In *Ponge inventeur et classique,* 66–84. Paris: Union Générale d'Edition, 1977.

Rimbaud, Arthur. *Une Saison en enfer.* In *Oeuvres,* ed. Suzanne Bernard. Paris: Garnier, 1960.

Roque, Georges. "The Role of Language in Seeing an Image." Trans. Joan Brandt. In Edson, *Conjunctions,* 85–106.

Rose, Barbara. *Miró in America* [exhibition catalog]. Houston: Museum of Fine Arts, 1982.

Rosenblum, Robert. "Roy Lichtenstein and the Realist Revolt." In *Roy Lichtenstein,* ed. John Coplans, 115–36. New York: Praeger, 1972.

Roskill, Mark, and David Carrier. *Truth and Falsehood in Visual Images.* Amherst: University of Massachusetts Press, 1983.

Rowell, Margit. *Miró.* New York: Harry N. Abrams, 1970.

Rubin, William. *Dada and Surrealist Art.* New York: Harry N. Abrams, 1968.

————. "The Genesis of *Les Demoiselles d'Avignon.*" In *Les Demoiselles d'Avignon.* Studies in Modern Art, no. 3. New York: Museum of Modern Art, 1994.

Sartre, Jean-Paul. "L'Homme et les choses." In *Situations I,* 245–93. Paris: Gallimard, 1947.

Schjeldahl, Peter. "The Oracle of Images." In *Cindy Sherman.* New York: Pantheon, 1984.

Schor, Naomi. *Reading in Detail: Aesthetics and the Feminine.* New York: Methuen, 1987.

Schwarz, Arturo. *The Complete Works of Marcel Duchamp.* New York: Harry N. Abrams, 1970.

Shattuck, Roger. *The Banquet Years.* New York: Random House, 1968.

———. *The Innocent Eye: On Modern Literature and the Arts.* New York: Farrar, Straus and Giroux, 1984.

Shlain, Leonard. *Art and Physics: Parallel Visions in Space, Time, and Light.* New York: William Morrow, 1991.

Soby, James Thrall. *Salvador Dalí* [exhibition catalog]. New York: Museum of Modern Art, 1946.

Sollers, Philippe. *Entretiens de Francis Ponge avec Philippe Sollers.* Paris: Galli-mard/Seuil, 1970.

Sontag, Susan. *On Photography.* New York: Farrar, Straus and Giroux, 1977.

Spurling, Hilary. *The Unknown Matisse: A Life of Henri Matisse: The Early Years, 1869–1908.* New York: Knopf, 1998.

Steefel, Lawrence D., Jr. *The Position of Duchamp's "Glass" in the Development of His Art.* New York: Garland, 1977.

Steegmuller, Francis. *Poet among the Painters.* New York: Farrar, Straus, 1963.

Steinberg, Leo. "The Philosophical Brothel." *October* 44 (1988): 7–74.

Steiner, Wendy. *The Colors of Rhetoric: Problems in the Relation between Modern Literature and Painting.* Chicago: University of Chicago Press, 1982.

———. *Pictures of Romance: Form against Context in Painting and Literature.* Chicago: University of Chicago Press, 1988.

Stich, Sidra. *Joan Miró: The Development of a Sign Language* [exhibition catalog]. Saint Louis: Washington University, 1980.

Suleiman, Susan Rubin. *Subversive Intent: Gender, Politics, and the Avant-Garde.* Cambridge: Harvard University Press, 1990.

Suquet, John. *Miroir de la mariée.* Paris: Flammarion, 1974.

———. "Possible." In Duve, 85–131.

Terdiman, Richard. *Discourse/Counter-Discourse: The Theory and Practice of Sym-bolic Resistance in Nineteenth-Century France.* Ithaca: Cornell University Press, 1985.

Tompkins, Calvin, and the Editors of Time-Life Books. *The World of Marcel Duchamp.* New York: Time Incorporated, 1966.

Waldman, Diane. *Roy Lichtenstein.* New York: Harry N. Abrams, 1971.

Weber, Eugen. *France, Fin de Siècle.* Cambridge: Harvard University Press, 1986.

Weiss, Jeffrey. *The Popular Culture of Modern Art: Picasso, Duchamp, and Avant-Gardism.* New Haven: Yale University Press, 1994.

Williamson, Judith. "Images of 'Woman'; The Photographs of Cindy Sher-man." *Screen* 24, no. 6 (1983): 102–15.

Zweig, Paul. *Lautréamont, ou les violences du Narcisse.* Paris: Minard, 1967.

Index